Weaving Arts
of the
North American Indian

Weaving Arts
of the
North American Indian

Frederick J. Dockstader

Thomas Y. Crowell
Established 1834

New York

A JAMES J. KERY BOOK

To the memory of

MATTHEW W. STIRLING

Scholar, humanist and athlete.
Above all, a warm-hearted friend who
gave generously of himself to all who
needed his help, and earned his respect.

Copyright © James J. Kery, Ltd. 1978
First published in 1978

ISBN 0 690-01739-1

Printed and bound in Spain by
Printer industria gráfica, sa
Tuset, 19 Barcelona Sant Vicenç dels Horts 1978
Depósito Legal B.15226-1978

Contents

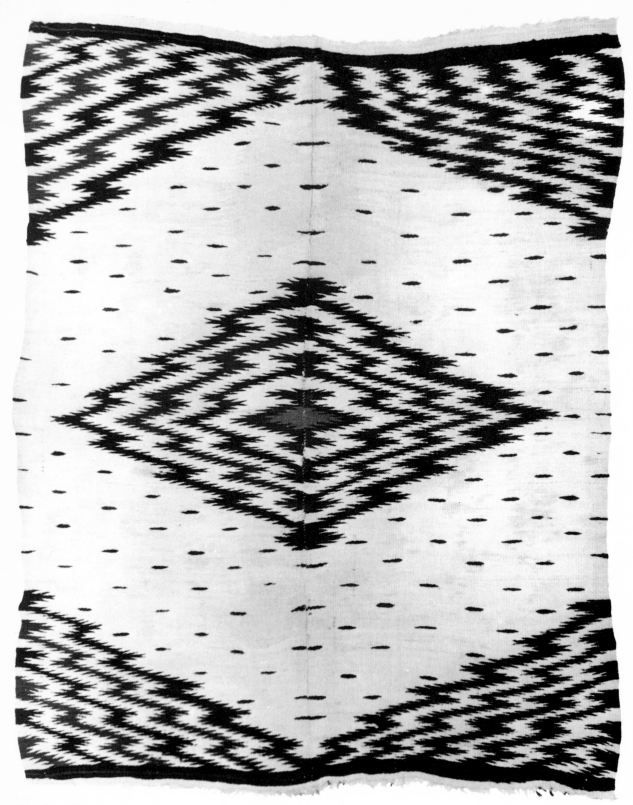

Wool Vallero blanquet

The beginning of Navajo weaving? A woolen two-piece *Vallero* blanket, suggesting the influence upon the Navajo "Chief's Blanket" corner development, and the later zigzag designs of the weave. Río Grande Valley, *ca.* 1850. 38×50 inches. Paul Schmolke photo; Maxwell Museum of Anthropology.

List of Color Plates

Preface

This book is intended as a general survey of the textile artistry of all of the indigenous tribes of North America. It is not a study-in-depth of the art of weaving, nor a technical investigation into the various processes followed throughout the continent. Rather, it is an effort to demonstrate the success of the Indian in mastering the art of producing woven textiles and garments so necessary to civilization, and the degree to which this knowledge was spread throughout North America.

There have been many volumes published on the arts of specific tribes or areas of North America, most of which touch in greater or lesser depth upon weaving. Often this art is given a secondary role, with only the native production of the Southwest receiving full consideration. It is of course true that the Indian weavers of that region do overshadow all others — indeed, to such an extent that most non-Indian people are not aware of the great wealth of weaving produced by other tribes. It is one of the major purposes of this volume to introduce the reader to this little-known resource.

Weaving, as herein considered, may be defined as the creation of a textile by the interlacing of various fibers with a mechanical device which facilitates and expands textile production, *i.e.*, a loom. For this reason, basketry, while certainly a form of weaving, will not be included, nor will those interwoven creations produced solely by means of plaiting, such as mats.

The area involved includes all of the United States and Canada but excludes the Arctic Eskimo. Not every tribe can be considered, of course, but it is to be hoped that the general areal treatment will insure the inclusion of every major group, as well as a thorough geographical attention. The time period covers the prehistoric development of weaving up to the present, with major attention given to the late nineteenth-early twentieth century, since this provides us with most of our data concerning early weaving techniques and their products.

The effort, then, is primarily to provide the reader with a useful volume — which brings together the strands, if you will, of historical, cultural, technological, commercial, and artistic considerations. No pretense is made for completeness; the field is far too great, and the inventive skills of the weaver too sophisticated, to permit that luxury.

To write such a book represents the summation of contributions from

many sources. The written record is acknowledged in the appended Bibliography. Consultation with many technically skilled friends over the past two decades lies at the heart of this work, and the specific assistance of many interested scholars, friends, and artists is warmly acknowledged. Among these are Azalea Stuart New, a skilled weaver, teacher, and friend who awakened my interest in the technology of weaving; Clyde Peshlakai and Pierce Kewanwytewa, who introduced me to the native mastery of Navajo and Hopi weaving, respectively; Jack Larsen, who opened my eyes to matters connected with the sophisticated promotion of weaving; and to Sallie Wagner, who, with Bill Lippincott was so directly responsible for the healthy revival among the Navajo of the ancient use of vegetal dyestuffs.

Scholars who directly or indirectly provided information and assistance include Kate Peck Kent, Joe Ben Wheat, Irmgard Weitlaner Johnson, Irene Emery, Mary Elizabeth King, Patricia Anawalt, and Ann Hedlund. To them I extend my grateful thanks, and even more so to Junius B. Bird; although predominantly active in Peruvian textile research, he has almost single-handedly demonstrated the true universality of the weaver's art, and the remarkable skills possessed by the early textile artists of the New World.

I am not a weaver; whatever claim I may lay to technical and esthetic proficiency is in the silversmith's occupation. I have always valued the making of textiles, and the skills requireded in their manufacture, and my interest in this art was born many, many years ago. But without the encouragement of Marion Stirling and Patricia Fiske of the Textile Museum, in Washington, D.C., I would not have had the audacity to invade this area of Amerindian art study. Their cordial welcome to the annual Irene Emery Roundtable Meetings of that institution gave me the needed resolve to proceed. For illustrations, I have turned to Carmelo Guadagno, of the Museum of the American Indian; to Marc Gaede, of the Museum of Northern Arizona; and to William D. Harmsen for the use of excellent photographs from their collections, and to Glen E. Henderson, Superintendent of Montezuma Castle National Monument, who went out of his way to provide special photography. To all of these friends, and to the many other sources whose contributions are acknowledged adjacent to their contributions, I extend my warm thanks.

And lastly, I cannot overlook the initial interest of James J. Kery, who first suggested the general idea from which this book developed; and the equally critical link in the process of words-into-type was provided by Elsa van Bergen, whose sharp editorial eye combined with a weaver's skill to spin these words, photographs, and thoughts into a well-woven manuscript. And most importantly, I am grateful for the day-to-day encouragement, sound counsel, and friendly criticism of my wife, Alice.

All errors, omissions, or other dropped stitches must be blamed on the loom of the author; those above did their best to help me avoid them.

December, 1977 FREDERICK J. DOCKSTADER

Weaving Arts
of the
North American Indian

1·The Fibers of Native American Weaving:
a historical background

The use of animal skins or hides to provide coverings for the body, protection from the weather, and containers for various personal possessions, must have developed very shortly after the first hunter captured his animal quarry. Taking the carcass, peeling off the hide, and wrapping it around one's body was an initial step; crudely sewing two hides together to form a tube or envelope was the second. This simple process eventually became more sophisticated, and subsequently, with the refinement of tanning techniques, these hide garments were given a slightly tailored cut — or at least, a more refined form, allowing the wearer comfortable clothing. As these merged into defined clothing styles, the human need for esthetics led to embellishment: this was achieved by various means, most notably by rubbing pigments onto the surface of the garment, or the application of color in specific designs by means of a brush.

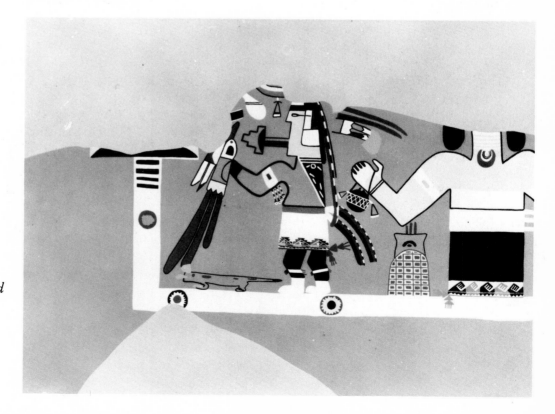

Reconstructed kiva mural. Ceremonial figures in woven kilt and dress with brocaded or embroidered decorations. Anasazi; Awátovi Pueblo, Arizona, ca. 1600. Watson Smith photo.

13

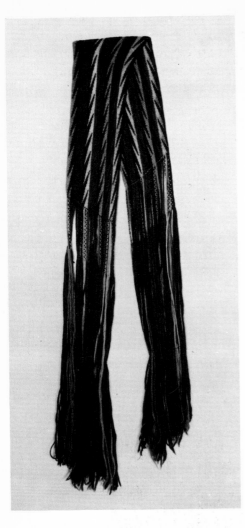

Loose finger-woven wool ceinture flèche *with beaded trim. Osage; Pawhuska, Oklahoma.* ca.*1890-1910.* Museum of the American Indian.

And shortly after the introduction of this very basic garment form, the ability to interlace fibers opened up the world of basketry, undoubtedly followed almost immediately by various forms of finger weaving — another form of non-loomed weaving. (These and other techniques are explored in greater detail in Chapter 2.) Although perhaps directed initially towards the limited production of belting, strips, and similar long, narrow objects, technical skill and experience slowly expanded to allow the creation of a wide variety of accessories. This form of interlacing probably progressed in complexity to the point where the true loom became inevitable; the finger weaver can go only so far in the production of textiles.

The earliest weaving was simply one-ply finger-woven netting, plaiting and braiding, and seems to have been known in North America at least as early as 1000 B.C. (Plaiting is the simplest, over and under cross-weave technique.) It was practiced for well over a thousand years before the introduction of the backstrap (or belt) loom, sometime between 500-750 A.D. This early loom created a warp tension by attaching one end of the warp to a tree, wall, or other stationary object, and the opposing end to

14

a rod which in turn was fastened to the weaver's waist. By leaning backward or forward, she can increase or decrease that tension.

This technique, however, is limited to the production of narrow-gauge textiles, and the need for wider cloth led in time to the invention of the more useful true loom, incorporating a rigid frame and heddle, which seems to have become widespread throughout the Southwest by no later than 1000 A.D. This time period was one of general transition rather than the abrupt and radical introduction of other techniques; the evidence certainly suggests that finger weaving yielded slowly to the more efficient belt loom, and that this in turn gave way to the true loom and its greater benefits.

This was not an overnight development, even in any one area. Crafts traditions change slowly, and this is particularly true of weaving. There must have been a period of experimentation following the introduction into any village of the new apparatus, with the passing of several years — perhaps even a generation — before it replaced earlier techniques. And even so, the older practice never completely died out; certainly almost all regions in which the true loom is primarily used today still continue to produce occasionally some textiles on either the belt loom or by finger weaving techniques.

The true loom offers three major benefits: much faster and more efficient production, the creation of wider sections of weave, and a greater

Twine-plaited cotton shirt. The sleeveless feature is similar to the modern vest in Plate 56. Anasazi; Tonto National Monument, Arizona. ca. 1250-1400. 26×26 inches. Arizona State Museum.

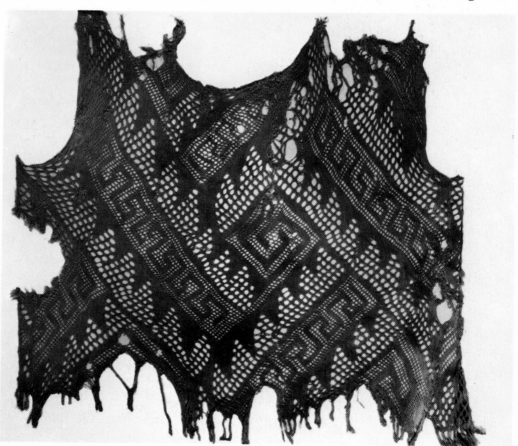

15

regularity in the finished textile. Various in-between steps may have preceeded it, but with the development of a frame for stretching the warp (vertical) threads, and a heddle to keep them separate, the true loom became an actuality.

Once this had been accomplished, ancient man was off to the creation of a tremendous variety of textiles. The many raw materials supplied by nature — plant fibers, including cotton, yucca, hemp, milkweed; the shredded inner bark of trees; animal hair and fur, even human hair; to mention only the most commonly seen — were all widely used for the purpose. Some materials were more effective than others; it is much easier to weave mountain sheep wool into garments than twisted corn husk, but each enjoyed a range, period, and style of human utilization, though not all were equally effectively loomed. It can be said, however, that every fibrous material available to ancient man was used somewhere, sometime, in the creation or embellishment of textiles.

Initially, these woven textiles were in all probability undecorated,

Weft-float pattern weave pouch; black and white cotton. (Detail, right) Anasazi; Montezuma Castle National Monument. ca. 1300-1600. $5\frac{3}{4} \times 12\frac{1}{2}$ *inches.* Photo courtesy Glen E. Henderson; National Park Service.

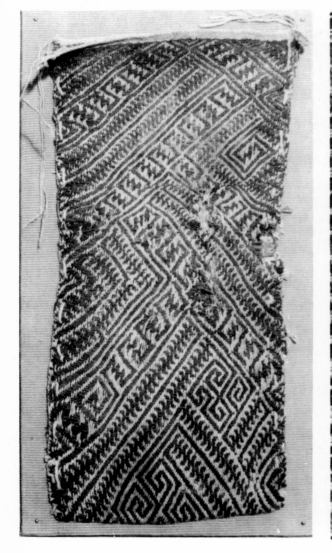 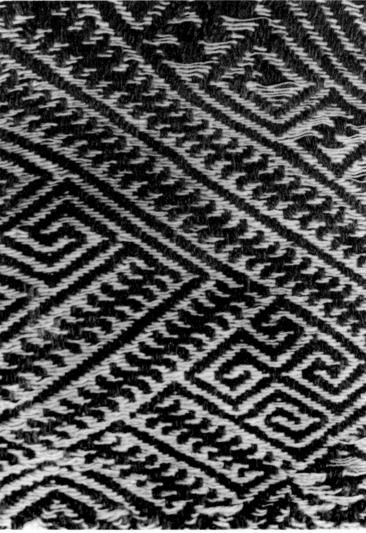

16

Painted black on white cotton manta *(shawl). Anasazi; Hidden House, Arizona.* ca. 1200-1300. *64×64 inches.* Arizona State Museum.

simple plain-weave squares intented for basic wrap-around purposes. But with increased experience and technical skill, these developed into a far more sophisticated design style, in which greater attention was given to the visual appearance, and eventually they became lavishly decorated as the demand required. The development of decorative technique seems to have paralleled that of the hide garments: color was rubbed onto the surface, then subsequently painted on, before it was finally achieved by means of skillfully weaving various pre-dyed fibers into fabric patterns. While this latter technique was a slow development, the ability to accomplish such elaborately woven designs was early in the history of man in North America, and can be demonstrated by some of the surviving fragments which have been recovered from excavations in the Southwestern United States.

Once body covering was comfortably achieved, it would seem that the weaver's attention next turned to coverings for beds, dwellings, floors, and walls. This must in all probability have been achieved through the production of matting which used various fibers, subsequently emerging into the manufacture of full-fledged blankets and rugs. These were probably plain at first, eventually taking on decorative qualities which in turn became more elaborate — indeed, as a source of color in prehistoric

life, the weaver held an important place. Few other crafts provided as much color in as controllable a form, with perhaps only pottery or painted wood offering an equal palette. Along with body painting and tattooing, and a wide variety of shell, stone, clay, and related jewelry, textiles therefore provided an outlet for the human need for personal decoration.

Since early garments lacked pockets, containers were an indispensable product of these weavers, and they were created in a wide variety of forms, sizes, and styles. Carrying bags, pouches, and similar objects were required for the storage and transportation of personal possessions and for everyday use. Some of these containers were of critical importance to the survival of the family group: they kept the hunter's equipment together, or the warrior's weapons immediately at hand; they protected the religious paraphernalia of the priest; and they held the woman's cooking, sewing, and craft tools. Others were valued as holders for creature comforts, game apparatus, or similar needs; most foodstuffs were carried in rawhide containers.

There is no way at this late date to accurately determine who was the weaver in ancient times; one can only assume on the basis of contemporary practice. Since this is an art deeply rooted in tradition, such

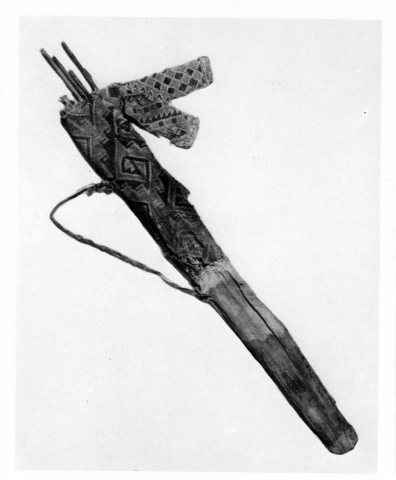

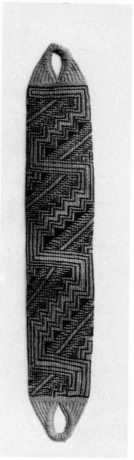

a basis of postulation seems fair. Thus it would seem most likely that prehistoric weaving was the woman's domain, since the process could be easily undertaken while taking care of the home, supervising the children, and pursuing her daily program. The man, charged with constant travel in search of game, trade needs, or other more mobile demands, could not as readily follow a confining craft activity. It is true that throughout the Pueblo region of the Southwest men are the weavers, alternating the work with agricultural duties; however, this is a very sedentary culture with a cyclical calendar, and it is possible to divide one's time comfortably into such a variety of activities.

Just when man first produced woven articles in North America is still an unsettled debate between scholars. The fragile nature of both baskets and textiles has caused all but a very few fragments to disappear into oblivion, and even many of these remaining bits of evidence have been recovered under circumstances which make them impossible to date with any accuracy. However, the present cumulated information suggests that twined and plaited basketry was a widely practiced art at least as early as 7500 B.C. in the Southwest. (Twining is the wrapping of outer strands around inner foundations.) Weaving undoubtedly followed fairly shortly

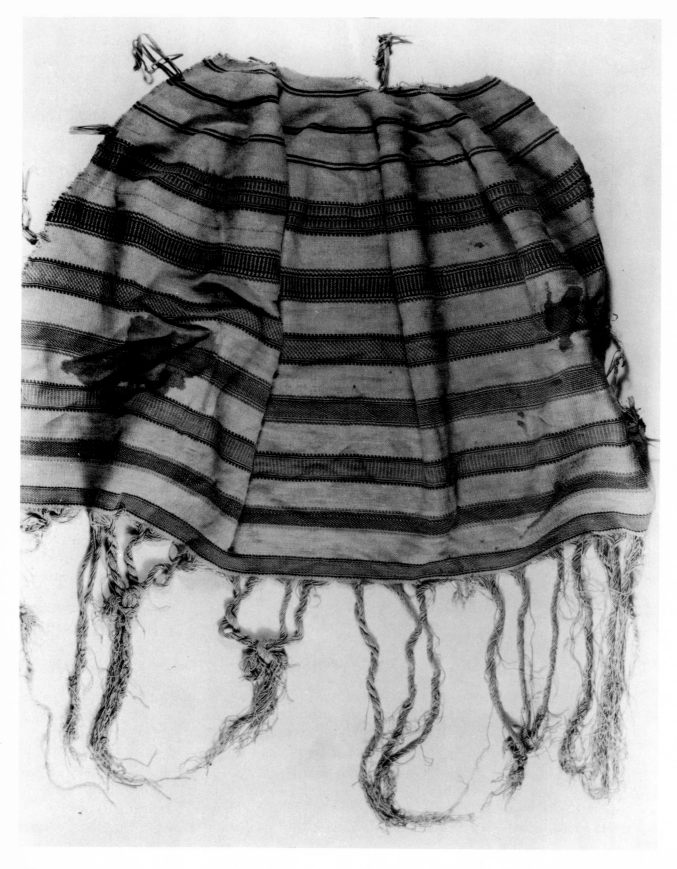

after, although no prehistoric examples have been found dating much earlier than *circa* 1000 B.C.

It is the dry climate of the Southwest which contributes to the preservation of such early evidence. While any sizeable quantity of surviving examples is not found elsewhere in North America, due largely to climatic conditions, certainly the art itself existed in many areas. There are many scattered specimens recovered from caves, rock-shelters, and other dry repositories which testify to the ability of the local weavers to use various fibers in the production of textiles — and some fragments of cotton which have been found suggest that there was a wide trade in this raw material.

The ability to introduce and control color in prehistoric times must have been well developed, although evidence is very limited in this area. Certainly those few specimens which have survived — perhaps a thousand sizeable examples are known, and of these only a handful are of more than eight to ten inches in size — offer striking evidence of the strong color range available to and incorporated by these people in the preparation of their textiles.

In a brief survey of the continent in prehistoric times, one may conveniently start with the Northwest Coast, following the pattern of the early migrants into the New World. Here, the damp climate has resulted in the disintegration of almost all organic evidence, although recently a few well-preserved specimens have been recovered in Washington state, dating from the very early historic period. These follow much the same pattern as contemporary Northwest Coast weaving in both style and design. An abundance of bones from grave sites also suggests that the use of dog hair for weaving is not an invention of modern times.

The antiquity of the famed "Chilkat blanket," as it is most commonly known, is not clearly established. (Discussed later: see Chapters 4 and 5.) Certainly the form and technical style indicate long ancestry, and the designs have undergone considerable changes, suggesting a fluidity in art fashion which would support the argument that this is not a newly introduced textile concept. But no truly prehistoric examples are known; one of the earliest to have been preserved is in the Peabody Museum, Salem, Massachusetts; it was collected sometime before 1832. While this is early for museum-collected specimens, it is not particularly so in the history of weaving; yet the technique, design, and style indicate that this was an art already long known to the Tlingit people.

The Plains region manifests very little evidence of a major weaving tradition; buffalo hair was the most common substance, but the cultural pattern of the prehistoric and early historic Indian seems not to have been one in which weaving was as important as the use of hides. It should be kept in mind, however, that the Plains Indian culture as we think of it today was of very recent dating in that area, and at best was of only a short duration, as world history goes — indeed, it was roughly equal to that of the United States itself. Therefore, the opportunity to develop a great weaving culture was somewhat limited. The needs were well served by

Drop-loom weave cotton pouch. Basketmaker; Canyon del Muerto, Arizona. ca. 700-900. 15¾ × 19¾ inches. University of Colorado Museum.

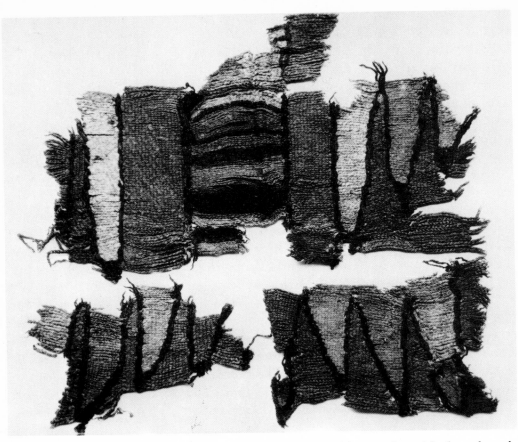

Fragments of woven textile: rabbit fur and canebrake fiber. Colors: black, red, and deep yellow; canebrake warp undyed. Spiro Mound; LeFlore County, Oklahoma. ca. 1400-1600. L: largest fragment, 12½ inches. Museum of the American Indian.

the use of hides obtained from the tremendous herds of bison which roamed the prairies, and this served as an effective barrier against further technological experimentation.

The Midwest and Great Lakes region (from which many Plains people originally separated to form their new free-roaming culture) reflects something of a similar short-lived pattern, but this did not produce an individualistic textile exemplar of any measureable significance. Perhaps the best-known indicator of weaving activity from the Great Lakes tribes is to be found in the colorful "yarn bags" commonly used for storing personal possessions and sacred ritual paraphernalia. The use of bast (see Chapter 5) for medicine or storage pouches certainly would seem to date from early times, but the technique of their manufacture is an early weaving form; the absence of any true loom work and the limited range of textile products from such weaving facilities as are now familiar in the region all support the impression of limited activity.

In the greater Southeast, there is ample evidence of one of the strong weaving traditions of North America. Although much of this is in fragmentary form, it removes any question as to the proficiency of the

artists from this part of the continent. Any examination of the collections recovered from the great Spiro Mound (also known as the Temple, or Craig Mound) in LeFlore County, Oklahoma, will clearly establish this point. Additional examples attesting to this high level of weaving have been recovered from some of the so-called "Mound Builder" sites in Ohio, Georgia, and Tennessee, as well as dry cave or rock-shelter locations in Arkansas. All of these date to *circa* 1200-1600 A.D. Color is rich and certainly was easily incorporated into the fibers used, which included essentially all of the local animal and plant materials common to the region. Weaves are intricate, although the type of loom, if any, is not clear.

And, finally, any preservation of textile remains from the Eastern and Northeastern United States also suffers equally from an adverse climate. Some fragments have been found in late archeological excavations —but most of these date only to the early Colonial period. There are sufficient examples of cloth (even if in badly deteriorated form) in New York and adjoining areas to confirm the belief that sophisticated and competent weaving was a familiar art. One of the most important proofs of this is to be found in the thousands and thousands of fragments of pottery which have been collected from prehistoric sites. A large proportion of these

Fragments of textile-impressed pottery. Oak Hill shellmound; Florida. ca. *700-1200.* American Museum of Natural History.

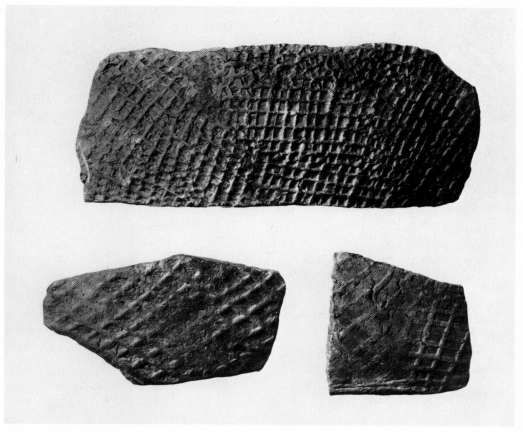

bear textile markings. Some show the effects of vessels which were formed by wooden paddles which in turn were wrapped by woven cordage; others have textile impressions all over the surface, suggesting that they may have been formed with a textile wrapping which was burned off in the subsequent firing. From whatever origin or manufacturing technique, these provide clearly distinguishable varieties of weaves. This was one of the early Indian areas to be influenced by European trade, and the contact was so intense that almost all native craftwork was rapidly supplanted by introduced goods. Although some activities managed to survive in diluted form, pottery almost entirely vanished and the sole weaving still continuing was in the occasional manufacture of belting, sashes, and similar narrow-loomed products.

With the entry of the White man, the whole panorama changed rapidly; some of the change was dramatic and sudden, some was subtle or indirect. The presence of European traders brought a significant increase in textile production, encouraged by the introduction to the Indian weaver of new raw materials, fibers and dyestuffs, and with these new objects came an exposure to new design motifs — most particularly *via* mission schools conducted by Spanish and French Catholic nuns for their converts. European-tailored costumes and textiles also provided models and affected new design styles, influenced changes, and even raw materials, as yardage was acquired by the native weaver and unraveled to supply re-spun fibers for specific needs.

But without question the most significant European influence on weaving was the introduction of sheep by the Spanish settlers and missionaries in the sixteenth and seventeenth centuries. Earlier, native cotton had been the weaver's basic material; with the acquisition of wool, cotton lost its popularity, since the heavier pelts of the sheep provided a greater yield of raw material. It was more effective for weaving, since it was ideal for the native loom; moreover, sheep were far easier to care for

Diagonal-weave bead choker and shell gorget incised with Underwater Panther design. Woven on tension loom as shown opposite. Potawatomi; Wisconsin. ca. 1800-1900. L: 14 inches. Museum of the American Indian.

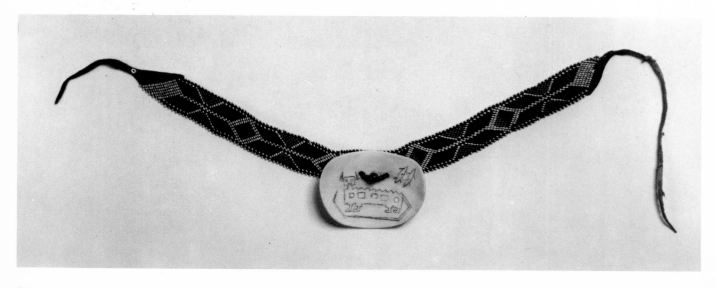

24

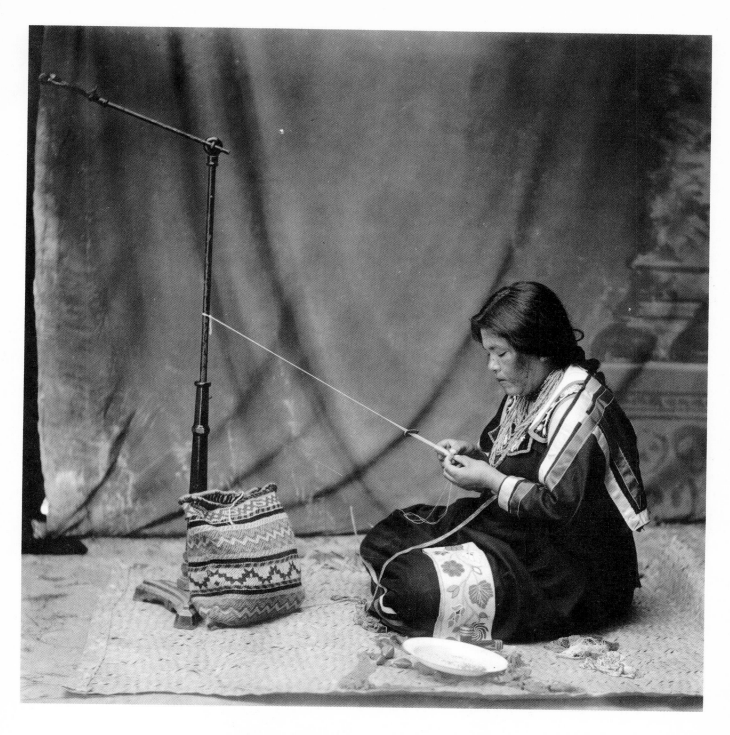

Woman using tension loom. Note the yarn bag in front of her. Chippewa; Wisconsin. ca. 1900. Field Museum of Natural History, Chicago.

than cotton plants and they also provided food as well as wool. It should not be overlooked that even though cotton was known throughout the Southwest in particular, its cultivation had spread into many neighboring areas, and had come to be an important part of early trade. Therefore, this transfer of attention from cotton to wool was felt throughout the entire continent.

The introduction of chemical dyestuffs increased the color palette of the

weaver, and in time, these almost completely supplanted the use of vegetal dyes. Painted textiles died out almost completely; those which did survive were largely the result of individual idiosyncracy. And the decoration of textiles by such means as moose hair, bird and porcupine quill, and other appliqué techniques more and more were replaced by silk or wool embroidery, brocading, and glass bead decoration. These latter were not only applied to the surfaces in decorative patterns, but were frequently interwoven into the fabric as the weaving proceeded, to give a more pleasing design or visual contrast.

With the increase in availability of materials and decorative resources, an inevitable result was elaboration of design. Fascination with technical skill also played its part, as well as the dictates of social status and political position. This in time became an important part of costume emerging from economic and social realities: one's clothing came to indicate one's position in society, precisely the same way as do the vestments of the Catholic prelate, or the policeman's uniform. Ritual costumes were woven for local use, and some tribes, *viz.* the Hopi, became specialists in their production.

The impressive costumes of the military had their influence upon men's clothing styles, and many of the "traditional" forms of American Indian dress and accessory designs seen in textiles of the seventeenth to eighteenth centuries can be directly traced to such origins. Ornamentation, most particularly the frills and fancywork of the French and British colonial garments of the period became dominant in the decorative vocabulary of the native weaver. A certain degree of

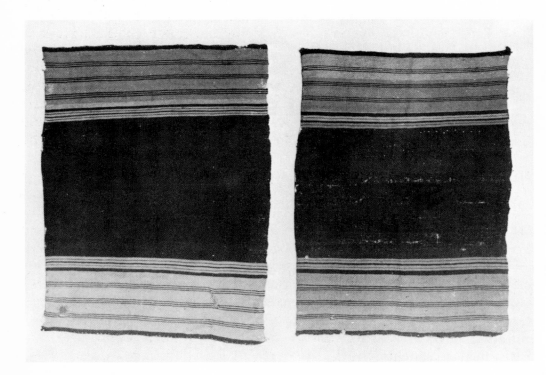

Old-style woman's woven wool dress. Red and indigo on black. Navajo; New Mexico. (front and back). ca. *1850-1860.* $48\frac{1}{2} \times 35\frac{1}{4}$ *inches.* Paul Schmolke photo, Maxwell Museum of Anthropology.

Bast fiber bag. Fox; Tama, Iowa. ca. *1900 15 × 18 inches.* Denver Art Museum.

government control emerged from the introduction of the Federal Trading Post system active from 1783-1822, in which government monopoly was intended to guarantee Indian access to supplies. This in time gave way to "free enterprise" as private traders replaced the federal system; but both groups were responsible for the introduction of a wide range of new materials, ideas, needs, and designs.

One of these new major influences of course was the simple fact of White domination. This had a tremendous impact, since any subordinate people are inevitably affected deeply by the customs, practices, and demands of the controlling agency. And in this, the Indian was no different. While some individuals tended resolutely to avoid contact with White people, preferring their own way of life, many willingly — even happily — accepted the manufactures and garments of the European, not only because they were plentiful, but even more because they represented the sum and substance of the dominant culture, and thereby bestowed a certain aura of relationship, if not power, to the wearer.

Mention should be made of one other important factor in garment adaptation. Social censure became more and more impressed upon the native over the years of contact. In hot climates, native people wisely tended not to burden themselves with clothing, often dressing with minimal cover. Missionaries were adamant in their opposition, and introduced garments which, while they fulfilled European demands of

Victorian modesty, were also ill-suited to the comfort and health of the wearers. And, although the Indian tended to continue to wear native-woven textiles in much the same manner, changes were introduced, not only for the purposes of modesty enforced by the outsiders, but more subtlety through the copying of decorative motifs, tailoring, and the use of pockets and buttons.

As a result, Indian weaving as such slowly disappeared from the frontier, as the trading posts pressed further into the interior. And, just as weaving had replaced animal hides for garments, new machine-made cloth supplanted the hand-woven textile; the ubiquitous Stroudcloth (named from its source in Stroud, England), became familiar to almost all of the Indian tribes of North America. This close-weave woolen cloth, also known as "trade cloth," was introduced in the early seventeenth century and rapidly spread throughout the continent. The rich, solid color and firm quality of the material was popular for both its appearance and its warmth. In time it became the standard fabric of most Indian peoples, although it was less commonly seen in the Southwest than elsewhere. Woven in rich red, black, navy blue, green, and occasionally olive green or purple, it was traded by the yard or by the bolt. It came with a loose-weave rainbow-colored selvedge which added to its attractiveness in Indian eyes.

This cloth was made into shawls, blankets, and various garments and accessories, further ornamented with beadwork, ribbon appliqué, silver, or quillwork. So widespread and popular was the material, that shortly after its appearance it had replaced three-fourths or more of the native weaving in the Midwest and eastern areas of the continent. By the middle of the eighteenth century, it is safe to say that ninety-nine percent of the native weaving of North America, outside of the Southwest, had become outmoded, due largely to the introduction of Stroudcloth. While it is true that European cotton cloth was an important trade introduction, primarily gingham, calico and cotton plainweaves, the proportion of substitution was apparently never as great as that of the huge quantities of Stroudcloth used by the Indian.

Subsequently those same outside forces which had been so directly responsible for the encouragement of weaving, and then its disappearance, made another about-face. The Santa Fe Railroad had completed its route through the Southwest, and began conducting its celebrated "Indian Country Tours" allied with the Fred Harvey Company, whose curio outlets made contracts with traders to guarantee tremendous numbers of Navajo blankets and rugs for their tourist and Eastern markets. The quantities produced as a result caused a deterioration in quality, and by the late 1890s traders realized the need to promote a better grade textile. Among the most influential were Lorenzo Hubbell, Clinton N. Cotton, John B. Moore, and Hermann Schweizer; the latter, as a buyer for the Harvey firm, held a key position in this upgrading effort, since he refused to buy poor quality weaving.

These men all urged increased attention to fineness of weave, fast color, and strong design improvements. That many, if not most, of the designs

were originally devised by the White traders (notably Cotton and Moore), prescribing what they felt were more saleable "Indian designs," was irrelevant. In fact, from this influence emerged many of the popular concepts of Indian art today, forming what are now regarded as "traditional Indian weaving designs." Furthermore, new socio-economic pressures were increasingly evident in this revival of Indian arts: the writings of such persons as Helen Hunt Jackson to secure fair treatment for the Indian did not go unnoticed, and this concern transmitted itself in turn to an interest in native art.

The entry of large numbers of tourists from the East meant large-scale demand, even though in numerically small dollar amounts. Although there were some individual connoisseurs responsibile for the buying and selling of high-quality products, they were relatively few. The bulk of the sales involved mediocre quality, produced in tremendous quantity; indeed, most of the pottery was purchased in the Pueblos by the wagonload, and weaving was simply bought by the pound, regardless of the quality of the weave. This tourist aspect of the market was a force which continues to be dominant in the Southwest today, unbroken save for a brief period during the two World Wars and the Depression.

By the turn of the century, the tourist market, which had been a force in the Indian market since the arrival of the first Europeans — and even earlier, when the customer was another Indian from a distant tribe — began to take on a quite different aspect insofar as weaving is concerned. On the positive side came an emphasis on quality and attention to design, improvement in textiles, better prices to the weaver, and an increase in recognition of the work of the Navajo artist. But a less happy result was introduced design dictation, the imposition of so-called "traditional symbols" many of which were taken from Oriental rugs of the Victorian era, and the demand for huge quantities of more-or-less identical textiles whose exact duplication was avoided only by the fact of individual difference, temperament, and technical skill.

Preoccupation with World War I brought this phase of weaving activity to a temporary halt; it did not recover until new economic and social forces surfaced with the "New Deal" of the mid-1930s. In one of those periodic abrupt reversals of policy which has plagued Indian-White relationship throughout United States history, the Government encouraged a return to traditional values and introduced major programs to revive the old crafts, among them weaving. Federal monies flowed into craft programs, in part through the WPA projects, guild programs were established to try to develop greater cooperative activity among crafts people, and standards were drawn up to insure the quality of the product. This, combined with a newly awakened realization that here was an important indigenous art form in which there remained a vitality, esthetic brilliance, and a cultural integrity, inspired a recognition and ever-widening enthusiasm.

The establishment by Congress of the Indian Arts and Crafts Board in 1935 as a branch of the Department of the Interior further supported these

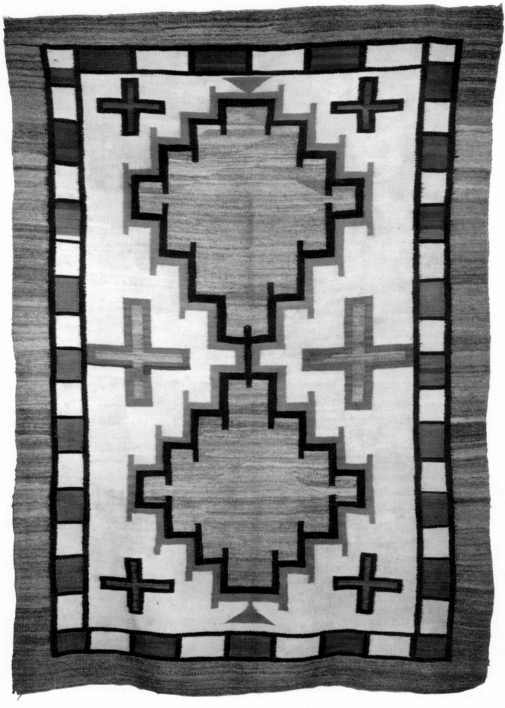

Tourist type wool blanket, developed by J. B. Moore. Navajo; Crystal, New Mexico. ca. *1900-1910.* Marc Gaede photo, Museum of Northern Arizona.

efforts. The Board introduced better wool for weaving, a more effective marketing system, more permanent and less garish dyestuffs, and gave increased attention to the needs of the White market. The reservations were scoured to find those older craftsmen who had retained their knowledge and could teach their skills to the younger people. Non-Indians interested in Navajo weaving used their relationships to the weavers to stimulate better quality, improved designs, and fostered

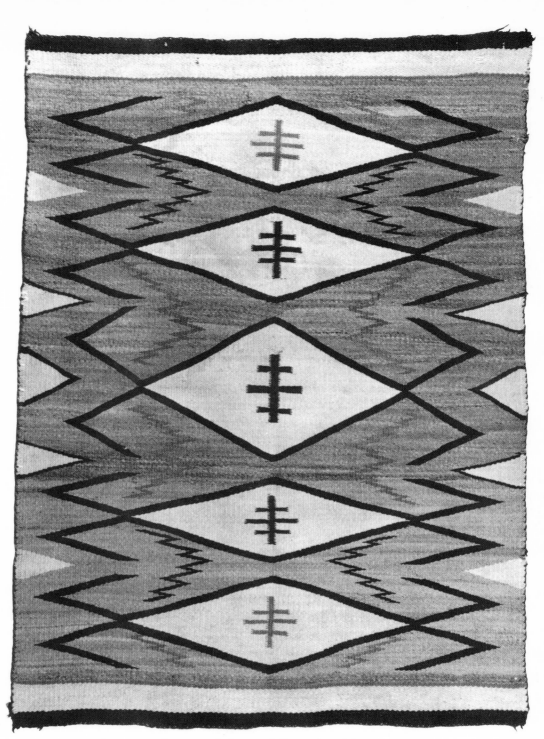

Tourist type wool blanket, period 1910-1920. Navajo, New Mexico. Marc Gaede photo, Museum of Northern Arizona.

a return to the use of vegetal dyes. These healthy activities combined to make an impact upon the Indian art world and its friends which still continues. Quality of weave and attention to design, as well as an increased sense of self-worth on the part of the artist were all part of this movement, together with greatly increased economic income. The weaving guilds tended to draw people together in a craft community, frequently resulting in greater exchange of ideas, awareness of changes in

the market, and improved access to raw materials, thereby promoting good weaving and allowing the weaver more time to concentrate upon production.

Museum exhibits offered the weaver an opportunity to visit and examine some of the older works or examples from other areas, thus widening the horizons of the visitors; and this greater prominence given to the textile arts increased the understanding of the White patron as well as to what constituted good weaving. Three of the most influential exhibits of the period included the *Exposition of Indian Tribal Art* in 1931, arranged by John Sloan, Amelia E. White, and Oliver LaFarge; held in New York City, it was one of the earliest to make a major impact upon the East. In 1938-1939, the show organized by Frederic H. Douglas for the Golden Gate Exposition in San Francisco opened the eyes of Westerners to the beauty of Indian artistry; two years later, Douglas collaborated with René d'Harnoncourt to assemble an ambitious *Exhibition of Indian Arts of the United States* at the Museum of Modern Art in New York City, with outstanding success.

Cultural czars were heard from, of course, as fashion made its own appraisal, and markets far from the weaving centers set their requirements. Some of these demands were excellent: top quality, tight weaving, fast color, and sound design. But others were less helpful: the dictates of romantic, White-fancied designs, whimsical patterns, or new, less-functional creations — usually combined with an almost mirror-like duplication to meet set standards merchandised in tremendous quantities. With these came another problem which has always haunted the native art world: the influence of the ephemeral nature of fashion. Once established, a traditional weaver tends to produce along much the same pre-set line. It is difficult, if not impossible, to make changes quickly, in spite of the fact that this is a hand operation. The unstable fashion world, mercurial by nature, mindless in practice, and with but fickle interests, often changes direction abruptly in pursuit of another fancy. This can, and frequently does, leave the native craftsman with an oversupply of a product directed towards a totally alien market. The frustration, bewilderment, and economic loss suffered by the artist whose creations are suddenly no longer wanted (by native and non-native alike), can readily be understood.

However, out of this cultural salmagundi came a sense of appreciation for Native American arts which has never completely died away; and by the mid-twentieth century an increased interest in folk and native arts led to an explosion of admiration and concern for Indian art throughout the United States and Europe. It is quite true that the advent of World War II brought this progress to a temporary halt; by and large there was little influence from that action upon the arts, with perhaps the sole exception of silversmithing. But with the return of the young men to their homes, a different attitude towards the outside world became evident. The need for education became more obvious, the drive for civil rights and equality of justice brought Indian people in closer contact with non-Indians, and

Opposite

1 Loose finger-woven wool ceinture flèche *with beaded trim. Osage.* ca. *1890-1910.* Museum of the American Indian.

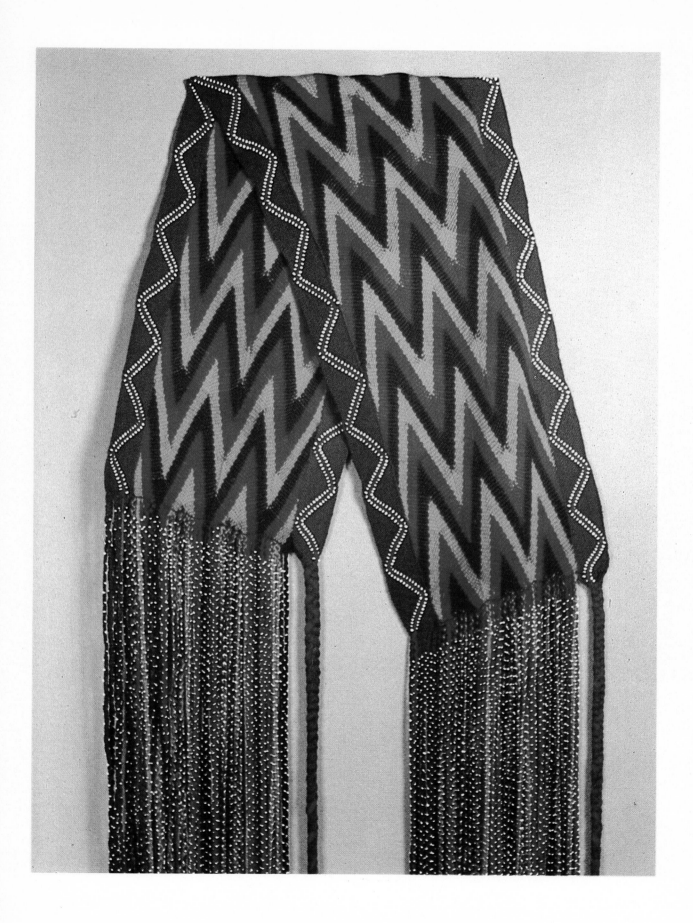

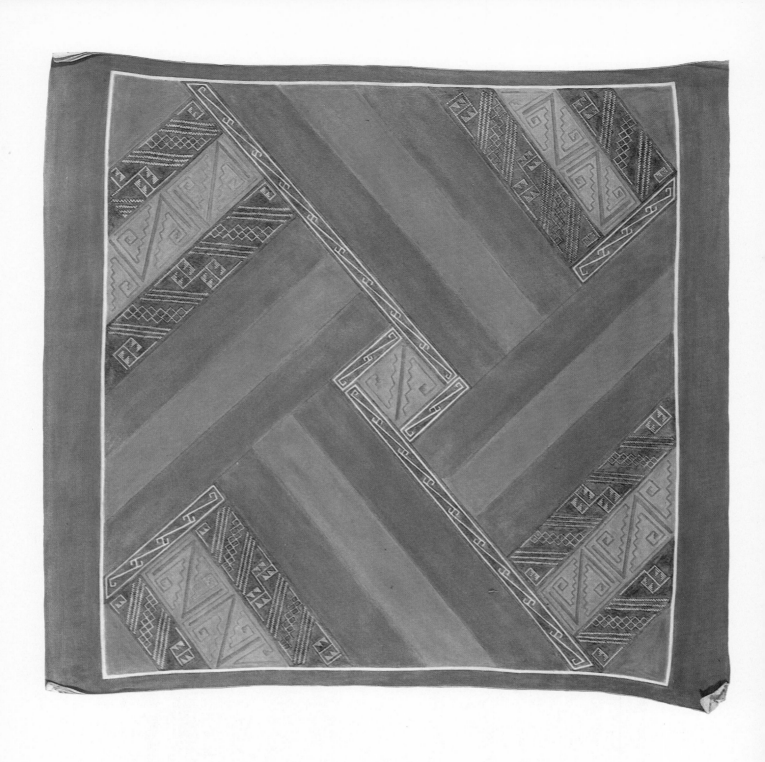

2 Painted cotton manta. *Anasazi. Painted Cave, Arizona. ca. 1250. 53×54 inches.*
Courtesy The Amerind Foundation; Ray Manley photo.

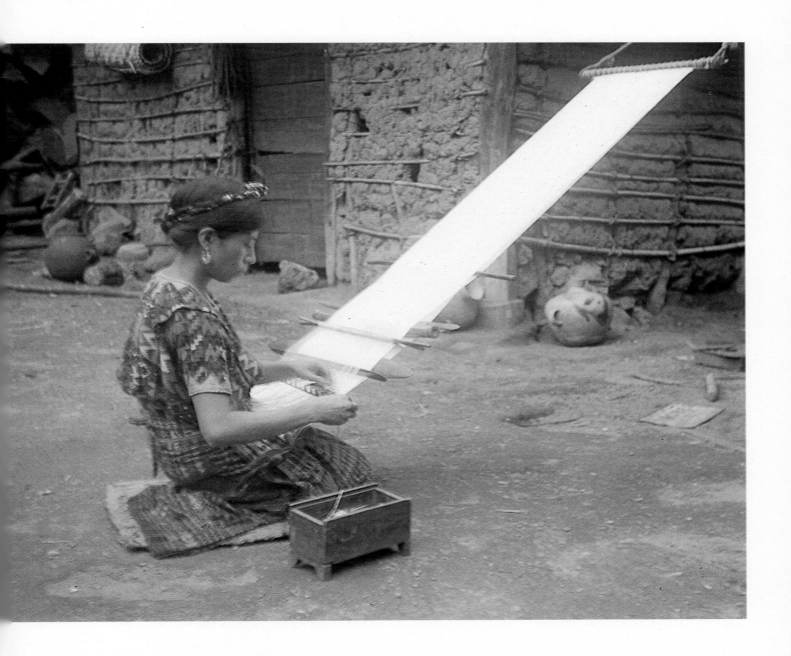

*3 Weaver at work on a backstrap loom. Quiché Maya. San Lucas Tolimán,
Guatemala. ca. 1960.* Alice W. Dockstader photo.

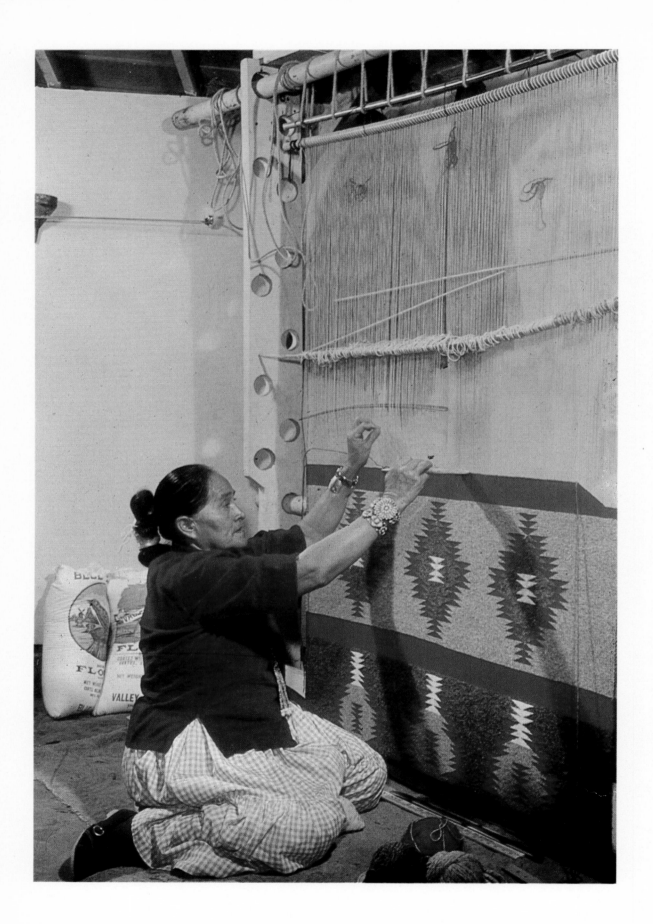

Opposite

4 Woman weaving a blanket on a vertical loom. Navajo, Arizona. ca. *1950.* Ray Manley photo.

5 Typical Plains Indian painted hide robe. Sioux, South Dakota. ca. *1875. 62×90 inches.* Museum of the American Indian.

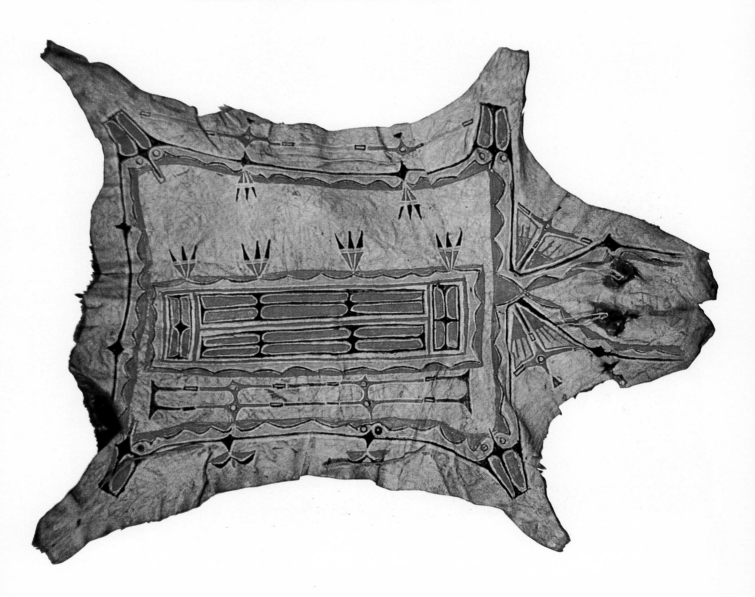

6 *Modern wool shawl. Hopi, Arizona.* ca. *1930. 24×26 inches.* Alice W. Dockstader photo.

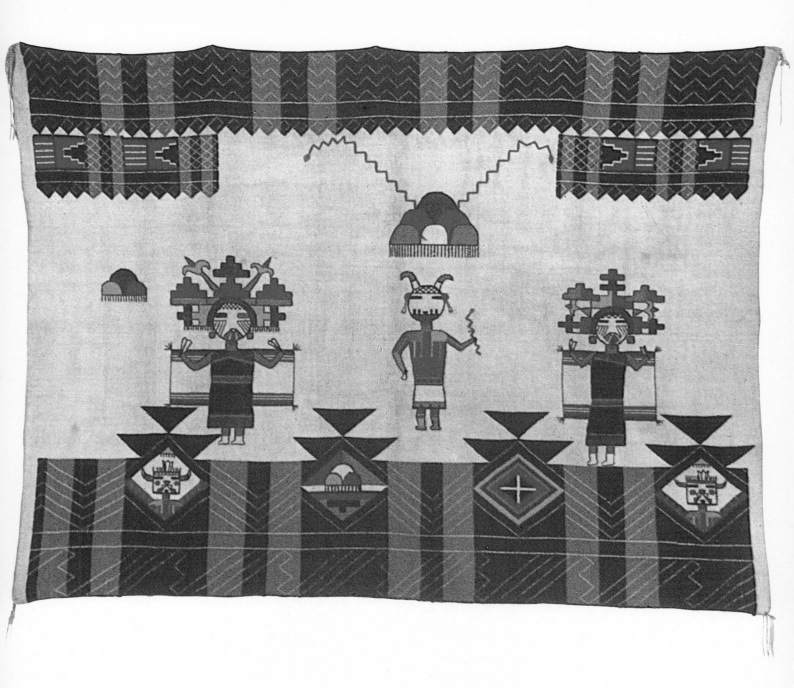

7 *Embroidered cotton shawl, with designs representing Álosaka and* Páhlik Mana.
The latter are wearing maiden's shawls similar to that shown in (a black-and-white)
photo on page 150. Ceremonial garments of this design, elaborately decorated, are
used in various formal religious occasions. Hopi, Arizona. ca. 1900-1920. 56×72
inches. Museum of the American Indian.

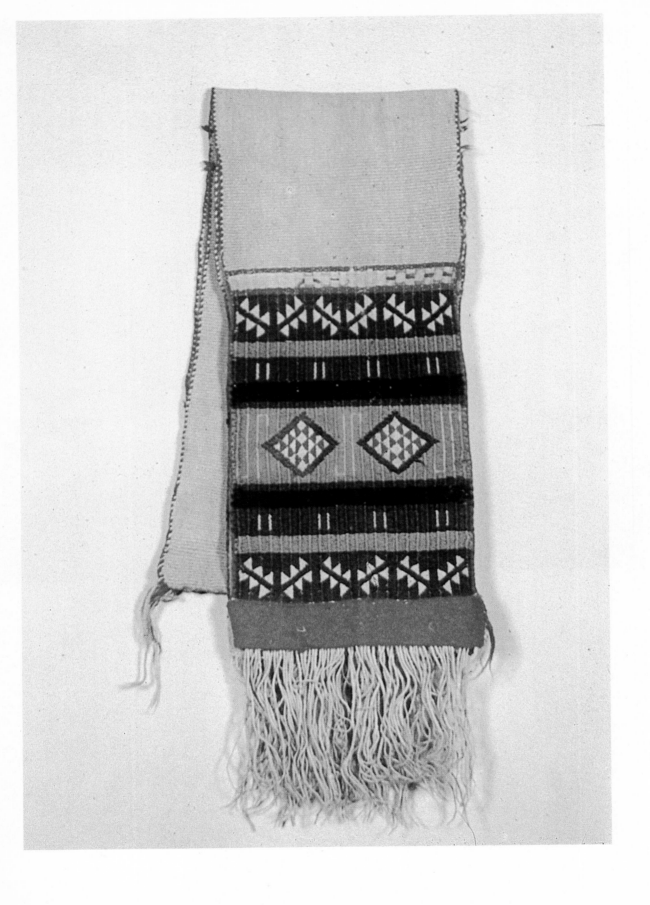

Opposite

8 *Brocaded cotton sash, primarily used for Kachina ceremonies. The design represents Wúyak-taiowa, from the Broad-faced Being. Hopi, Arizona.* ca. *1920. 10×40 inches.* Museum of the American Indian.

9 *Modern brocaded shirt. Hopi, Arizona.* ca. *1940. 26 ½×22 ¼ inches.* Cincinnati Museum of Art.

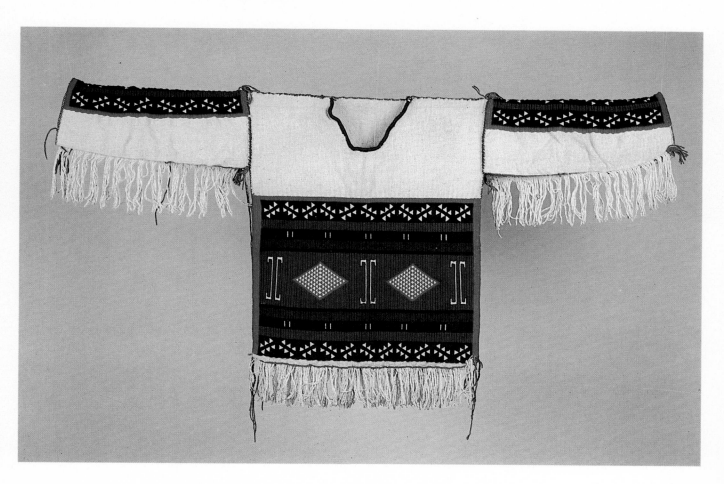

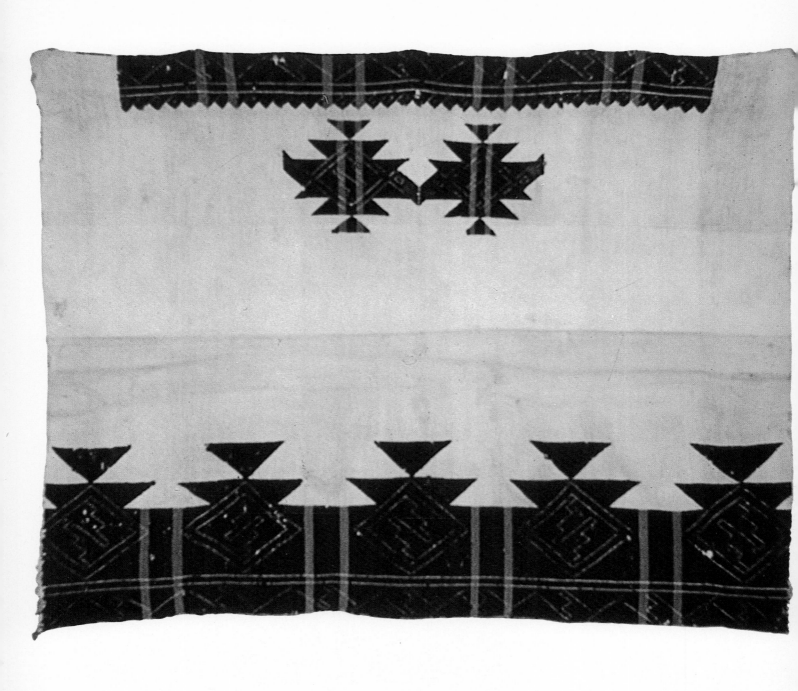

10 Woven cotton shawl, with typical Ácoma design in the field. Ácoma, New Mexico. ca. 1890. 50×64 inches. Museum of the American Indian.

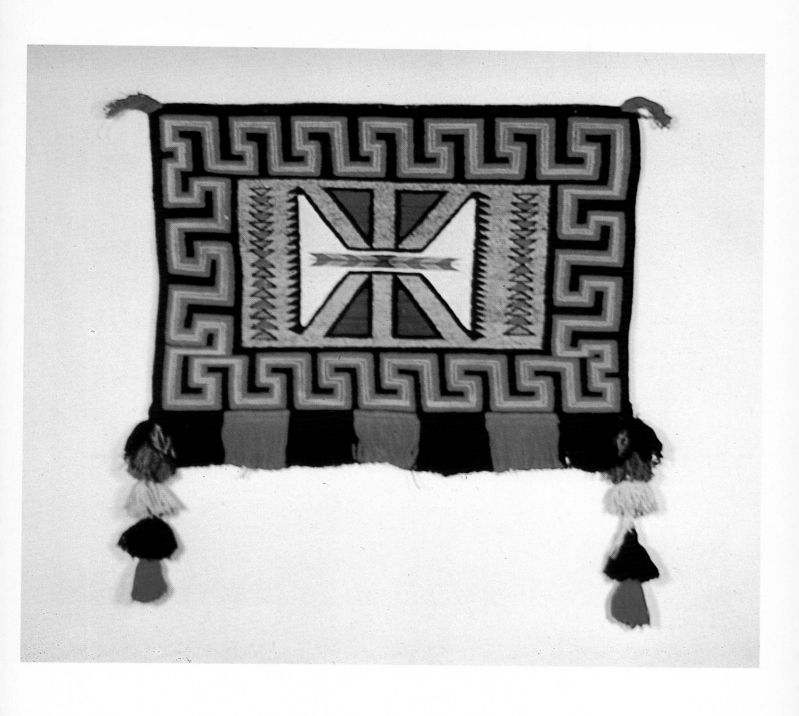

11 Germantown wool saddle blanket with fancy tassel decoration. Navajo, New Mexico. ca. 1900. 22×26 inches. Museum of the American Indian.

12 *Cotton shirt and embroidered wool decoration. Jémez, New Mexico. ca. 1880.*
Museum of the American Indian.

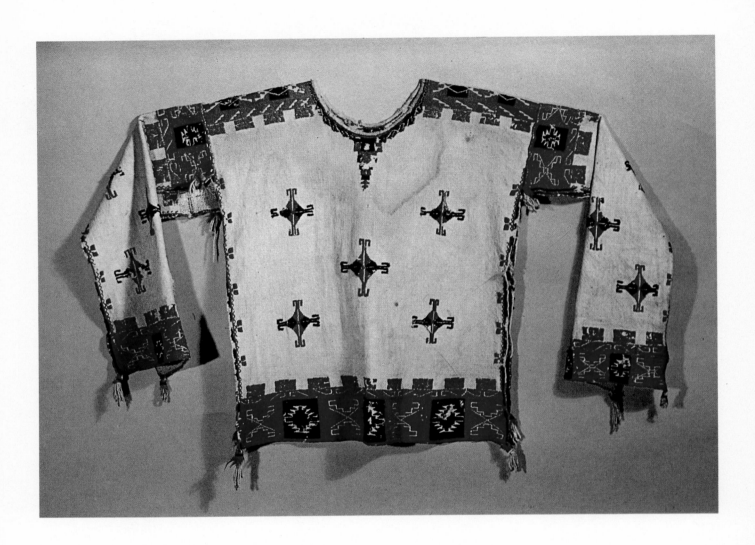

Opposite

13 *Old-style woman's wool dress. Red and indigo on black. Navajo, New Mexico.*
ca. *1850-1860.* $48\frac{1}{2} \times 35\frac{1}{4}$ *inches.* Maxwell Museum of Anthropology.

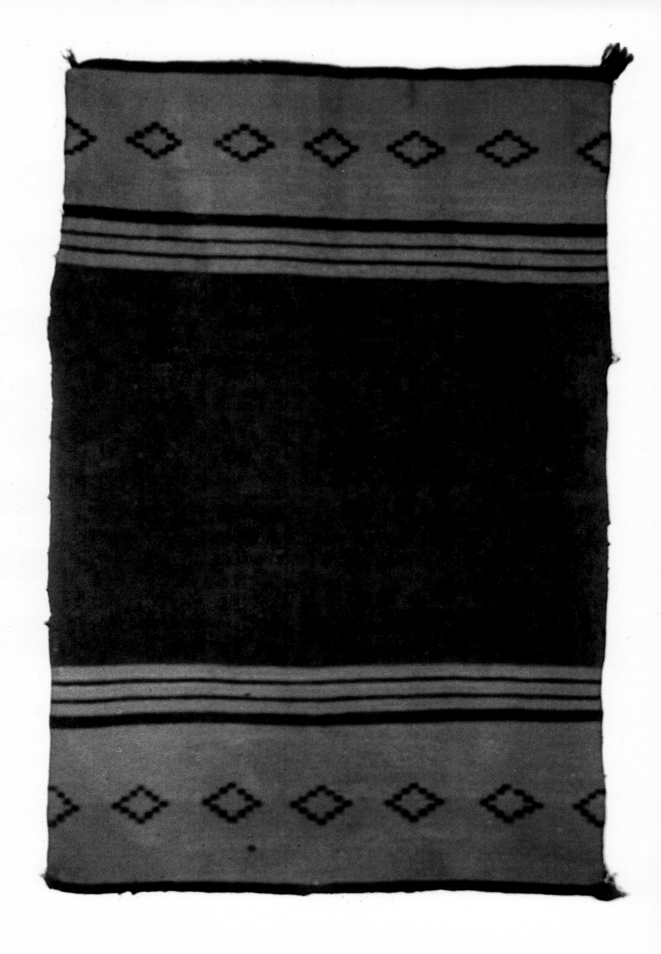

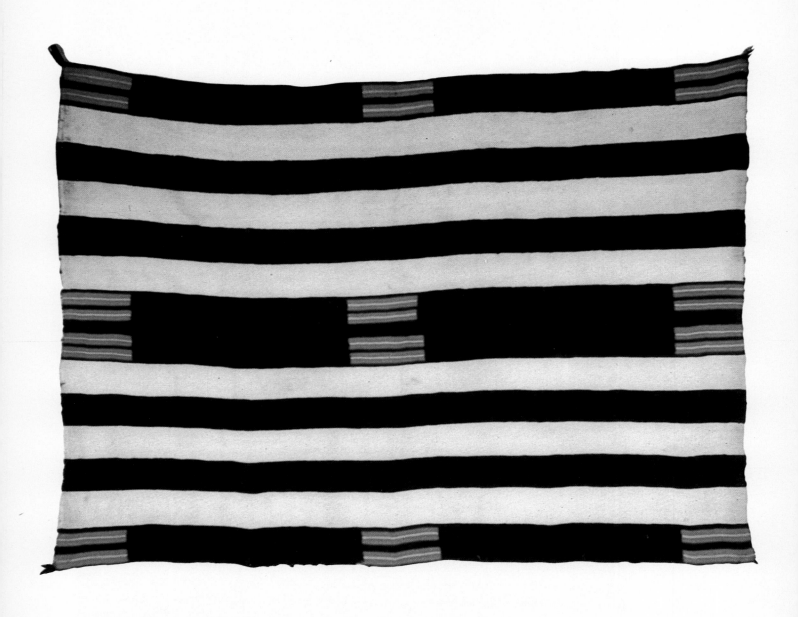

14 So-called Phase II design "Chief's Blanket." Navajo, New Mexico. Identical to Phase I, excepting small red sections have been added to the otherwise unbroken horizontal lines. Navajo, New Mexico. ca. 1860. Museum of the American Indian.

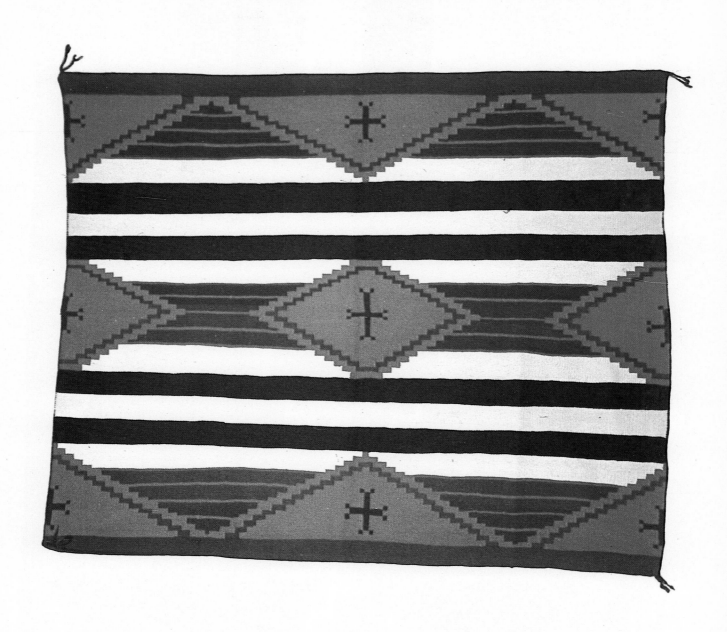

15 Phase III woolen blanket. Navajo, New Mexico. ca. 1870-1880. Museum of the American Indian.

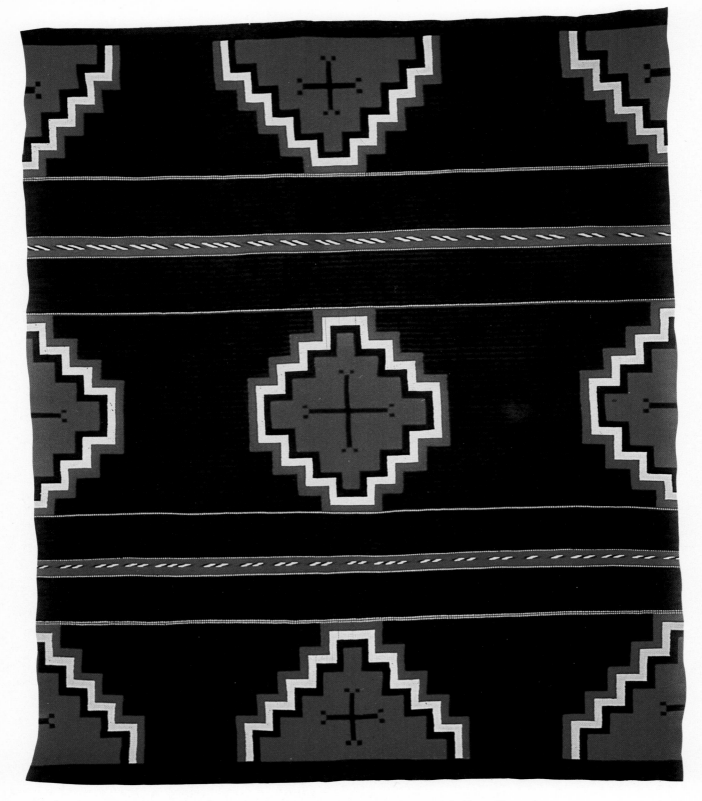

16 Classic "Chief's Blanket" of the form promoted by Lorenzo Hubbell. Collected by Col. J. T. Clarke in 1890. Navajo, Arizona. 77×91 inches. Museum of the American Indian.

out of this combined drive for a better life for minorities, cultural determination enjoyed a considerable benefit.

As a major part of this expansion, textiles slowly began to emerge as an important art force, and received a marked degree of attention; exhibits solely devoted to the art of hand weaving were held in museums and galleries, and weaving enjoyed a boom market, bringing many times the former selling prices for rugs and blankets — together with an increased recognition of the weavers as individual artists. Books were written about weaving, museums focussed even greater attention upon contemporary crafts, and prices ascended ever higher in the market. This was a new situation, and it levied a tremendous impact upon the Indian art world. A glance at the Bibliography provided herein will reveal the chronology of writing on the subject.

The results have been both good and bad. To the undiscriminating, any Navajo rug is a superior product, worth a large sum. This stems primarily

Contemporary textiles at "Hopi Craftsman" fair. ca. 1960. Museum of Northern Arizona.

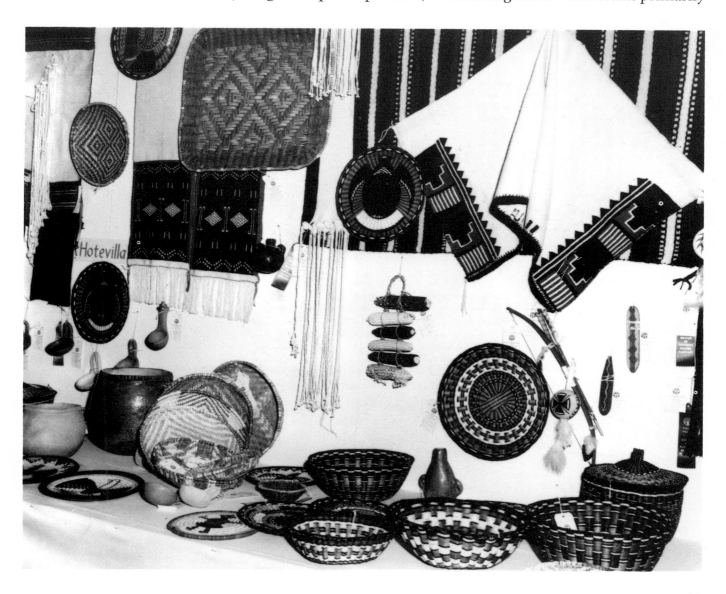

from the common equation of native weaving as synonymous with high quality. "If it is Navajo, it is well woven and will last forever," came to be an accepted cliché, totally ignoring the many important considerations which have a bearing upon any evaluation of craft work. On the other hand, the continual upgrading, close inspections, and general judgments through exhibition, coupled with the higher prices and intelligent selection by knowledgeable buyers did result in a product which today — at its best — is as fine a weave as has been produced by Navajo or Pueblo weavers at any time in Indian history.

In the Northwest Coast the so-called Chilkat weave has essentially died out; only a very few elderly women retained their knowledge of the technique, and although efforts were made to teach this art to younger women, its demise seems to be inevitable. A similar revival program was instituted in the Salish country, due largely to the initial efforts of White friends, which seems to have greater promise, although it is not yet certain how successful it will prove in the years to come. The Eastern weavers have shown far less interest in reviving their old skills; some individual practitioners of finger weaving and yarn bag work are active, but in the main this does not promise an equivalent reawakening as yet.

Actually, the major change has been in the market, not in the product. In older times, when textiles were produced for a knowledgeable native consumer, the market was relatively closed to outside influences. Today, ninety-five percent of the textiles woven on Indian looms are intended for the far less knowledgeable White purchaser. There are exceptions to this, of course: those experienced collectors who have made a study of the art, dealers who seek the best available textiles for their customers, and museum curators requiring specific examples for their permanent collections. Furthermore, the actual function of these weaves changed dramatically, and by much the same proportion. Earlier, blankets were to be worn or slept on; floor coverings (when used as such) were to be walked on, and so on. Most of the textiles purchased today will never be subjected to such use; rather, they will be displayed on the wall, in exhibition vitrines, or carefully stored away for occasional showing. But rarely are they actually used for the purpose originally intended.

And these concentrated concerns of revival, study, social status, pricing, and esthetics are often accompanied by psychological upgrading of sorts: collectors, dealers — and even museum personnel — frequently sensationalize the interpretations of given forms and designs in an effort to romanticise the specimen and add in some indirect way to the value of the object. The obsession to classify results in the attachment of names to these designs, forms, and styles which have little, if any, relationship to weaving realities. It should not be felt that this is all bad; it does add a degree of interest to the textile, perhaps a certain dignity to the artist, and often results in an atmosphere which greatly strengthens the role of weaving in human life. But when such pseudo-esoterica becomes an end in itself, it adds little luster to a noble art.

With the passing of Native American weaving from a product intended

initially for the weaver's immediate family, to the demands of the limited native market, to the non-Indian trader, and finally to the White consumer, the journey is almost finished. Where will the native weaver go next? The New Indian has not yet taken his rightful place as a primary consumer; at the moment he seems relatively content with the product of the commercial loom. But it seems certain that the time is not far off when contemporary Native American needs will return to major significance, as pride of self and personal values make their requirements felt. And then the cycle will be complete.

Tourist type wool blanket. Navajo; Crystal, New Mexico. ca. *1900-1910.* Paul Schmolke photo; Maxwell Museum of Anthropology.

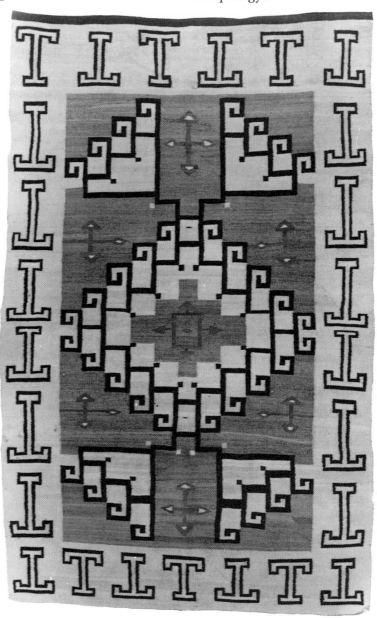

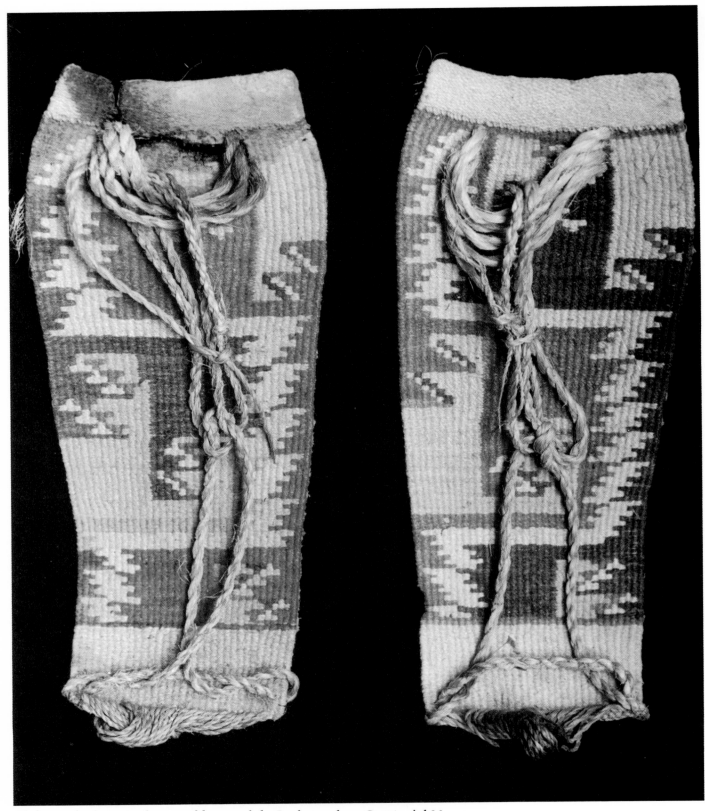

Elaborately decorated yucca-fiber sandals. Basketmaker: Cañón del Muerto, Arizona. ca. 500-700. *L: 9½ inches.* University of Colorado Museum.

2·The Warp of Technique:
method and manner in weaving

The physical forces which dictate the sizes, shapes, colors and designs of textiles are fairly simple: the raw materials which are available, the nature of the fibers and their flexibility, the dyestuffs or basic coloring, and the treatment of those fibers — especially the presence or absence of a loom. In addition are a very few special conditions, as for example, on the Northwest Coast, where Chilkat blankets are woven from pre-drawn designs, thereby affecting the freedom of the weavers.

The raw materials used by North American weavers were essentially those animal-vegetable-mineral substances supplied by a benevolent

Closed-loop weave bag, containing a ball of bark-fiber strips for weaving. Bluff-dweller; Allred Bluff Rockshelter, Larue, Arkansas. ca. 750-1000. L: $3\frac{1}{2}$ inches. Museum of the American Indian.

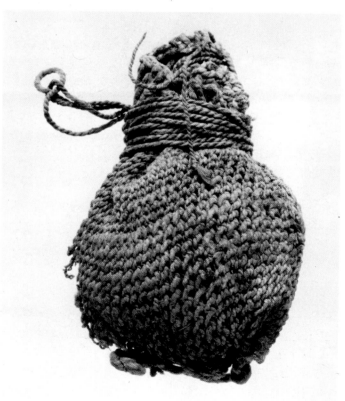

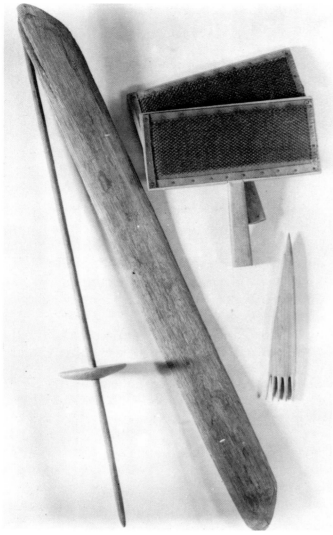

Beater made of wooden rods, for cleaning and removing seeds from raw cotton bolls, and to aid in straightening fibers. Although this drawing is of a prehistoric example, such beaters were in common use in the Southwest until the introduction of metal-tined cards in the mid-1880s. Anasazi; Arizona. L: 23 inches.

Left

Weaving implements: spindle and whorl; batten; comb; pair of cards. Navajo; Arizona. Marc Gaede photo, Museum of Northern Arizona.

nature. Animal hides were used as weaving cordage; they were slit and stripped, then twisted or separated to form the fibers which were re-worked into a fabric. Fur, however long or short, stout or delicate, was also incorporated into twisted threads for weaving, and the hair from a variety of animal (and humans) was likewise spun into weaving fibers.

Vegetable plant substances were also split, stripped, often pounded to separate the fibers, and used for spinning; or they were boiled, squeezed, and crushed to provide dye pigments. Minerals yielded colored pigments for use in producing dyes.

The textures of all of these fibers dictated to a major degree the resulting textiles: henequén, yucca, or split bark, for example, cannot be woven into

as finely worked textiles as those made from cotton, wool, or hair. As a result, the products from these coarser fibers were normally used for gross purposes — the less flexible matting and heavy coverings. Other effective plant fibers included apocynum (Indian hemp), cotton, milkweed, moss, nettle, rush, elm — to mention only a few. Wool of the mountain sheep, wild goat, and buffalo were commonly used, as were various hair-like materials, including human, deer, moose, and horse, and the fine fur from rabbits, raccoons, muskrat, and other small animals did not escape notice. Some bird feathers and down are found intermixed with other fibers used in weaving.

While some of these fibers could be used naturally, most of them had to be prepared for weaving. This process could be as simple as washing and cleaning, or it could involve a far more complex preparation. At first, simple fan-shaped beaters were devised to separate the seeds from the cotton bolls and align the thin fibers. Later this close unity was achieved by beating or picking, and then by carding — a process whereby the fibers were brushed or pulled in one direction by the use of any of several toothed implements. These may first have been simply rough-surfaced objects, natural substances (perhaps even cactus), or complex instruments devised solely for the purpose. Today metal-tined "cards" are used in pairs to produce the most effective results.

Once the carding process has achieved its result and the fibers lie in parallel form, they must be twisted so as to combine them into longer lengths, yielding greater strength and a more even diameter. This twisting could be done laboriously by hand, or by means of a mechanical aid, such as a spindle. The latter was far more efficient, since it allowed the weaver to tightly blend the fibers into a more usable thread.

The spindles were sticks of various thickness and length depending upon the coarseness of the fibers. These were usually round and smooth, and the fibers were initially attached by winding a few of them around the shaft. As the rod was rotated with the fingers, more fibers were added; they easily blended with the previous fibers and produced an ever-lengthening thread. Maintaining an even rotation of a single stick is difficult; the addition of a disk (or balance wheel), commonly called a "spindle whorl," provided momentum and balance and assured a more even, tightly twisted thread.

That these whorls were important objects in the life of the weaver is clearly demonstrated by the great attention given to their manufacture and esthetic designs. Many varieties and sizes are known, all made in direct proportion to the physical requirements of the fibers to be spun, the size and length of the spindle, and whether the purpose was for ceremonial or everyday use. Made of wood, stone, clay, or metal, many of these are true *objets d'art*. Their range is tremendous; many were often very small, for fine-weave fibers, or extremely large for coarser substances. The twists which result are basically of two types: the S twist (so named because the thread twist looks like the letter S when viewed vertically), which is most common in the Americas; and the Z twist (appearing as the letter Z when

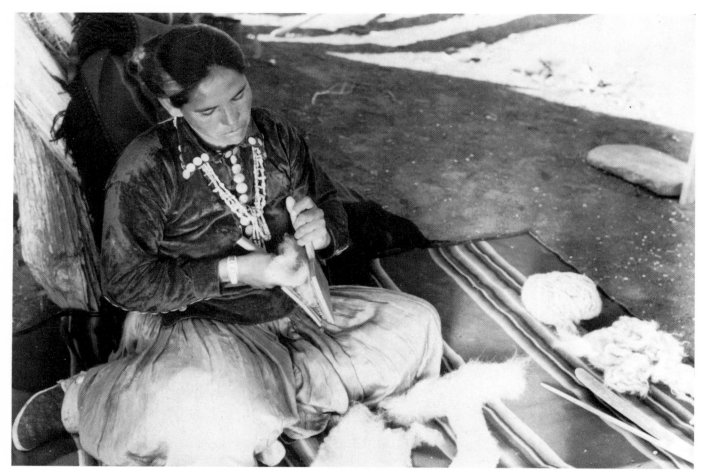

Carding wool with modern metal-tined weaving cards

the fiber is viewed vertically). This twist identification is important, for it can allow identification of a given period or area in certain instances.

The results of spinning could also be improved upon by "reversing" the process regularly: if the twisted thread was combined with another similarly twisted fiber, but in reversed direction, the fibers lock together evenly, and result in a smooth fabric, lie together well, and provide greater overall strength to the finished weave.

Just as a textile is the sum of its parts, so is the fiber or thread which makes up that textile. It is composed of hundreds and thousands of tiny, short fibers of varying lengths which have been twisted together to interlock and yield a thread long enough to weave into a simple or complex textile. In this process, long fibers are of course more effective than short ones, and one benefit of the spinning process was the added length it made available to the weaver. However, even short fibers could be used by careful carding and spinning. This is the secret of the superiority of some fibers over others — the degree to which they can be spun, interlocked, and extended into long evenly threaded lengths.

These spun cords are then in turn combined in several ways to extend

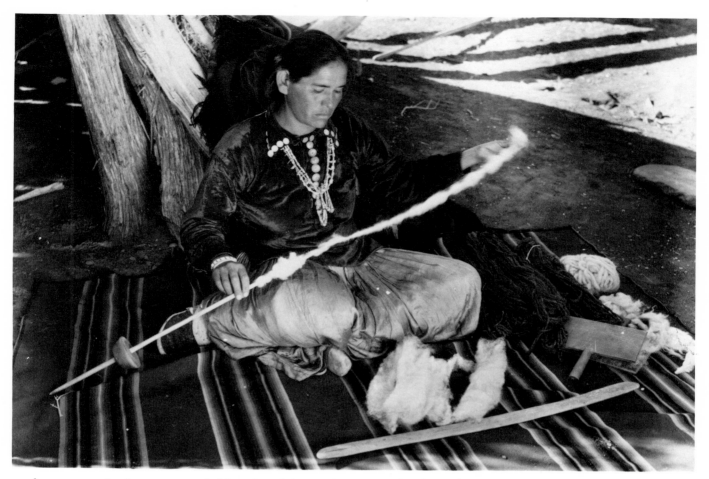

and woman spinning raw wool. Navajo; Arizona. Marc Gaede photo; Museum of Northern Arizona.

their usefulness — not only in length, but in width, by inter-locking — thereby creating the art of weaving. One of the very earliest forms of weaving was the simple looping of cords to create a net; by manipulation of cording, knotless netting provided much of early man's nets for fishing, carrying pouches, and similar loosely interlocked devices. The next step was to knot the joins to provide a firmer, more effective product. Neither of these techniques required a loom or other equipment, although a net gauge was usually employed to assure a more regular opening size in the net loops.

Following this simple method of intertwining of fibers came a slightly more complex process which was apparently the next step towards the creation of true textiles. In this form of weaving, the spun fibers were suspended from a common source: a central core, a bar, or a suspended pole. The threads were intertwined by the fingers alone; no supplemental device was used, hence the term *finger weaving*. A variety of products were made by this technique: bags, pouches, and most commonly, sashes or belting. A variety of weaves was possible by this method, depending wholly upon the manner in which the threads were intertwined: multiple

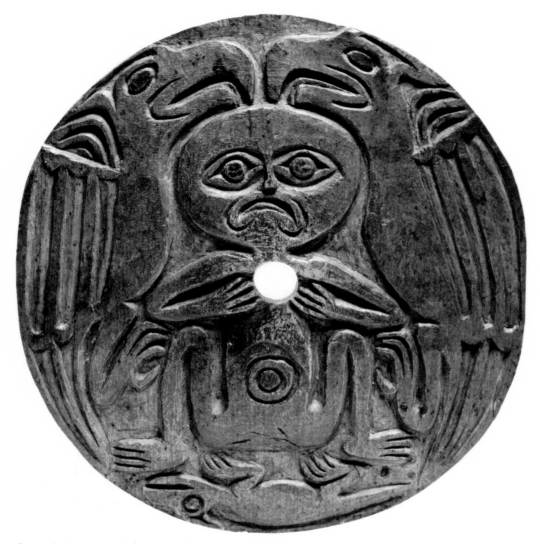

Carved maple wood spindle whorl. Cowichan; Vancouver Is., British Columbia. ca. 1875. D: 8½ *inches.* Museum of the American Indian.

threads in varying combinations gave different designs.

Although this undoubtedly developed out of a trial-and-error process, it became a universal technique and today is largely used in plaiting most mats or similar coarse weaves. This should never be thought of as a primitive technique; that it is capable of producing remarkably sophisticated designs and fabrics is clearly demonstrated in the famous Chilkat blankets of the Northwest Coast, which are the result of this basic process. In this weave, the suspended yarns are given strong tension by the use of weights (usually stones secured by cording or small pouches) attached to groups of warp threads, thereby allowing the weaver greater control. The fabric is produced by a weft-twining technique, in which the ribbing, or raised elements, are created by three-strand weft-twining.

However, a truly taut warp could not be effectively obtained by this process, and in time (and doubtless through considerable experimentation) a better invention was developed: the body-tautened backstrap or belt loom, also called waist loom. We do not know whether this was independently developed in the North American Southwest or

was introduced from outside; the best evidence suggests that it was probably brought up from Mexico sometime between 500-700 A.D. It is well accepted by scholars that it was well established in the Southwest by no later than 700 A.D., and that it preceded the true loom by about two hundred and fifty years in North America. There are some who argue that it was known even earlier in the Southwest.

The backstrap loom is essentially a two-pole implement in which the far end, commonly called the warp beam, is attached to an overhead beam, tree, pole, or to the wall. The pole nearest the weaver, called the breast beam, is attached to a wide belt or strap, which in turn is fastened around the waist of the weaver — hence the term backstrap or belt loom. The two major loom poles are joined to each other by the warp threads, usually a single strong heavy strand which is wound back and forth around the beams. As the weaver works, either from a sitting or kneeling position, she is able to keep the warp strings taut by the tension of her body position; she increases or decreases it at will simply by moving closer or farther away from the distal end. It is interesting to note that most Pueblo weavers do not use the waist belt principle; instead, their loom is approached vertically; the loom poles are fastened to the ceiling, and to blocks (or a beam) securely set in the floor. On occasion, these blocks are placed so that the loom is horizontal. Fastenings of both types have been

Partially finished cedar-bark mat, showing use of the single-bar suspension loom. Salish; British Columbia. University of British Columbia.

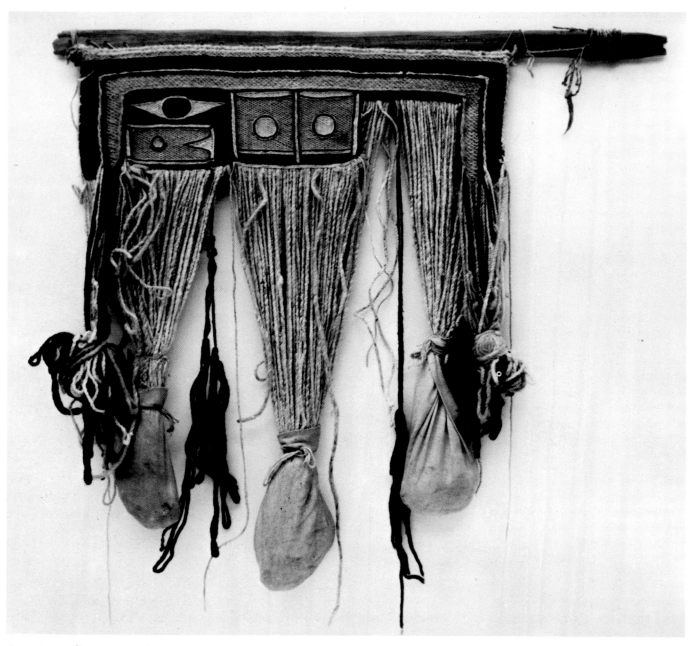

Leggings of woven mountain goat wool on suspension, or weighted, loom. Chilkat; Tlingit, Alaska. ca. 1880. W: 18 inches. Museum of the American Indian.

found in archeological sites, indicating this as an ancient practice.

The backstrap loom employs a heddle — the most distinctive feature of a loom. In the Southwest, this is a simple rod with string loops, each of which holds a warp thread. When the heddle is pulled towards the weaver, all of the threads attached to it are separated from the main warp, and a weft thread is inserted into the opening called the shed. This latter is held open by a shed rod. A batten, or sword, is a flat, wide stick which

opens the warp; it and a small comb beats down or tightens the weave. These few basic implements allow the weaver an unlimited variety of weaves. The weaver inserts the batten between the two sets of warp threads and turns it sideways, thereby creating an opening through which the weft thread is passed from right to left. Whether shuttles or bobbins were used in ancient times is not certain; today some weavers employ a shuttle rod, consisting of a short round stick, around which the weft thread has been wound. Many weavers simply use their fingers to insert the weft thread and work it along the fabric. A specially designed carved wooden shuttle with open ends is known among the Northwest Coast, Oregon, and northern California people; it is primarily used for net weaving, rather than loom work.

Raising the warp threads by means of the heddle allows the following weft thread to be inserted in the pre-arranged combination so as to produce the desired weave design, and so on. Color changes are readily inserted by simply using a different color weft thread. The weaver proceeds in an upward direction; when the fabric is too high for a comfortable reach, the loom tension is released, the finished fabric is rolled up on the lower beam, and the loom is re-tightened for further weaving.

Once this device became well known, it spread widely throughout the region, and became the fundamental technique for the production of narrow-strip weaving. Technically, it allowed a wide variety of design styles and belting forms. It also made the requirements for evenly spun threads far more pronounced, thereby increasing the demand for suitable fibers and more careful spinning. There were several other advantages to this loom which became a welcome addition to the homes of the Native American: it could be rolled up and stored in a very small area and left there until the weaver cared to resume her work. It was easily transported when the family moved to new quarters; work could be picked up where it had been left without loss of efficiency, and small amounts of fibers could be introduced easily into the weaving process. The loom was readily reversed to allow the weaver to work from the other side, if she wished, and the warp length of the fabric could be released from the warp beam as the finished work was rolled up on the breast beam. With the backstrap loom, the weaver could produce even, straightedged textiles with regularly spaced designs, and it permitted use of much firmer fibers than the suspension loom. The result was a great variety of belting, strips, and long lengths of finely woven, precisely designed textiles.

However, at some time in the two or three hundred intervening years, some weavers realized that while the backstrap loom had many advantages, there were two major drawbacks: it was not well suited to the production of wide sections of cloth, nor could it conveniently accommodate heavy fibers. The manufacture of a large textile, such as a blanket or a shawl, required the weaver to produce several long strips and then sew them together. The net result of this technique was never as satisfactory as provided by a one-piece textile, and the time required to

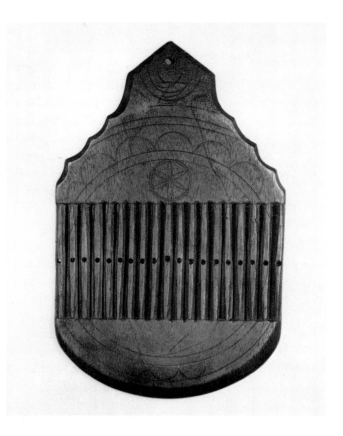

join these strips was an added nuisance, as well as demanding extreme care to avoid bumpy, irregular edging.

The obvious answer was a larger loom. However, this in turn required far greater tension than the weaver could give simply by her body strength; some independent fastening had to be devised. It also demanded a way to assure even edges and greater control over the complete width and length of the fabric. At some time during this period, the true loom came into being; whether by incidental development or overnight invention of some genius, we do not know. But by about 700 A.D. in the American Southwest, the use of two quite large (in proportion to the backstrap loom) loom poles were set horizontally or vertically, held in place by cording to allow an increase or decrease in tension, and then connected by warp threads wound as closely or as loosely as desired.

Two carved wooden weaving heddles. (Left) Double horse's heads. Fox; Iowa. ca. 1875. 6×8 inches. (Right) Incised geometric design. Kickapoo; Oklahoma. ca. 1900. 5×8¼ inches. Museum of the American Indian.

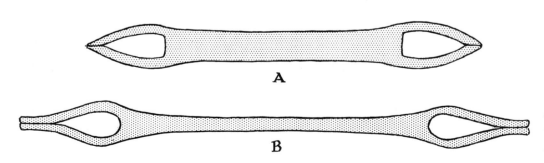

Wooden net shuttles. (A) Eskimo; Nome, Alaska. (B) Karok, California. L: 10 inches.

Heddle and shed rods were used, as was a larger batten, but the body of the weaver was now entirely free from the loom; she was able to move as she wished during the weaving process.

Most weavers sat or knelt in front of the loom, as with the backstrap loom, and wove from the bottom upwards. The batten was used in the very same manner, excepting it was much longer than previously, and the fabric required greater use of the comb for a tight weave. The heddle rods were longer, as were all other objects used in the process. Moving back and forth in front of the loom allowed the weaver to maintain a straight, level weave as she progressed; however, some weavers found it much easier to simply sit in one spot in front of the loom, and weave upwards as far as one's arms could conveniently reach. This inevitably produced a somewhat triangular area of finished weaving, requiring the weaver to move to one side or the other and complete the missing sections. When these latter were subsequently joined, an oblique join-line was created — the familiar "lazy line" found so regularly in most Navajo weaving.

The obvious convenience of this loom is immediately apparent. It could be placed almost anywhere one wished: all that was required were two straight trees, perpendicular stone walls, or a similar support to which the upper and lower beams could be securely fastened. The length and width of the resulting fabric was determined only by the distances between the loom poles and the width of the warp stringing.

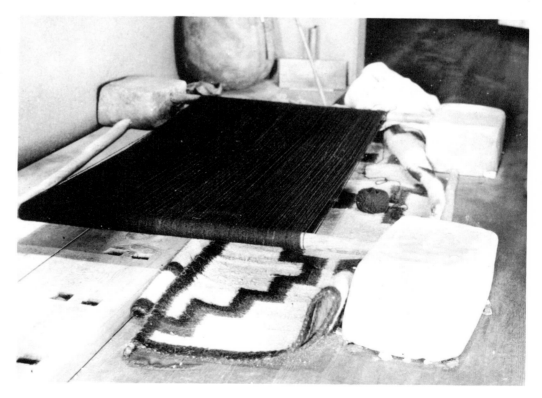

Horizontal "loom blocks," of sandstone, as used in a Pueblo kiva for winding warp threads. Hopi; Arizona. Marc Gaede photo, Museum of Northern Arizona.

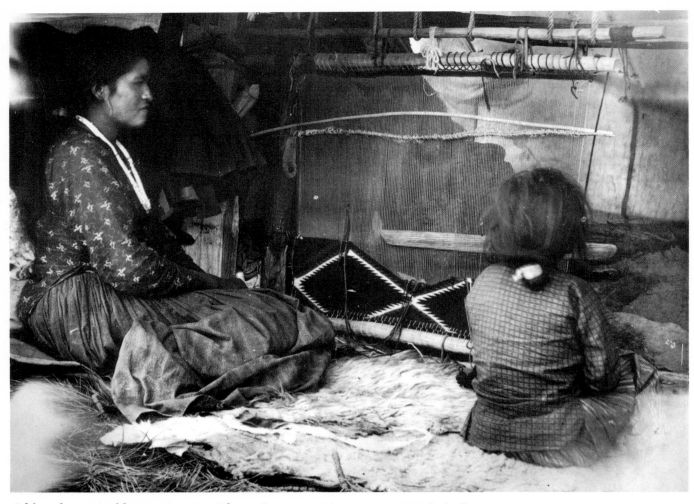

Old-style vertical loom. Navajo; Chaco Canyon, Arizona. ca. *1900.* S. A. Barrett photo, Museum of Northern Arizona.

Once developed to a useful level, knowledge of the true loom seems to have spread rapidly, and by 1000 A.D. it seems to have been in fairly common use throughout the Greater West, and with it, large-scale weaving became practical. Such a loom could easily handle widths of several feet, as against the eight to ten-inch width of the average backstrap loom (and in truth, most of the belting was more commonly in the four to six-inch width). This could also produce far greater lengths of woven material, since the large loom bar could accommodate greater amounts of finished fabric.

Judging by the prehistoric and very early historic examples which have survived, the "standard" North American textile was square or slightly rectangular, probably measuring about three by four feet, although larger sizes must certainly have been woven on occasion. Some of the surviving textiles are smaller, and were created out of two or three narrower strips joined together. In Central and South America, the rectangular shape

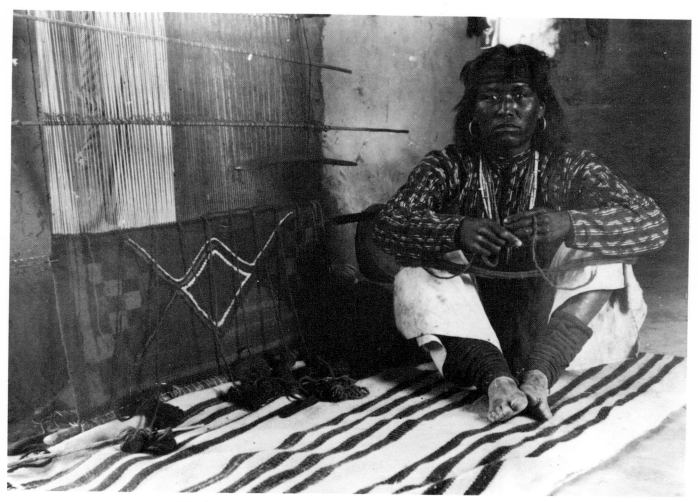

Hopi weaver with a partially completed blanket on the loom. Note the design; not all "Chief's Blankets" were woven by the Navajo. Hopi; Arizona. ca. *1890-1900.* Museum of Northern Arizona.

seems to have been more common in prehistoric weaving, and in far larger sizes — often up to fifteen or twenty feet in length.

An added feature was the large quantities of weaving which the true loom made possible. This increase made weaving a more important part of trade and may have been responsible for a degree of standardization of materials used. Experimentation with various fibers and varieties of weaves was another natural result. The simple over-and-under basic plain weave probably continued to be the primary technique, but the repertory of the weaver quickly expanded to include patterns called gauzes, twills, brocades, drawn weft, and many other variant forms. Non-fiber materials may also have been included, such as feathers, shell beads, and related decorative elements.

Color had not been absent from early weaving, of course. At first, it was probably painted upon the finished fabric, either in stripes or geometric patterns, applied by the brush then familiar to potters: the

yucca-fiber brush. It was applied with extreme care; but in view of the relatively unlimited "canvas" which the artist had to work on, seems to have been enthusiastically used. Red, black, green, and yellow were predominant, produced from local plant and mineral pigment recipes. The hues varied somewhat according to the basic formula, but the sources seem to have become fairly standardized over a quite wide area. None of these were brilliant in their hue; they tended to be pastel or muted. When they were subsequently applied to the fibers before weaving they allowed a firmer design, since the danger of "bleeding" was removed; and with the use of effective mordants gave a more permanent color — although it is quite true that fading was a primary problem throughout the period of vegetal-based dye.

With the coming of the Europeans into the North American area, weaving underwent three major changes almost overnight. As we have seen, undoubtedly the most important was the introduction of sheep. The wool from these animals became a staple which has remained predominant to the present time and almost entirely replaced cotton and all other fibers used in the art. There were some exceptions, but these were minor. A second dramatic influence was the added color palette which became available; at first expressed in the use of those colors available to the European and widely used in the dress of the day, this became even more pronounced with the invention of aniline dyes in 1856, and their introduction about 1880 into the Southwest, apparently by Benjamin F. Hyatt, a trader at Fort Defiance, Arizona. The Indian weavers immediately took to the new stronger colors which not only gave greater brilliance to their textiles, but of even greater importance, speeded up the weaving process.

At this same time, Germantown yarn, a brightly colored, pre-dyed, well-spun fiber from Germantown, Pennsylvania, became a standard color source in Arizona and New Mexico, and reached a zenith with the famous "eye dazzlers," appropriately named for their rainbow-hued designs. (See plate 21.) Commercial dye firms, such as DuPont and the Diamond Dye Co., experimented with coloring and introduced packaged dyes of various types, and for a time flooded the Indian country with a whole new spectrum. These enjoyed a mixed response; some were widely accepted, some were tried and rejected, while a few proved not to be commercially practical, and were subsequently withdrawn by their originators.

Drawing upon the accumulated styles of the past, adding to these the new ideas achieved through trade, and vitalizing these in turn with the newly acquired color hues, the artists embarked upon a great voyage of esthetic exploration.

Eventually, a balance developed between the use (or the over-use) of packaged dyes, pre-dyed fibers, and native vegetal-base color which continues to the present time. Some less successful color experiments with dyes derived from animal materials, mineral pigments, and plant stuffs failed, and some were outright catastrophes, for example the use

Woven blanket of bayeta *(Spanish for baize, a closely-woven woolen yardage brought from England to the New World in vast quantities. It was often re-spun to provide a fine, tightly twisted weaving thread.) Navajo; New Mexico. ca. 1860. Museum of the American Indian.*

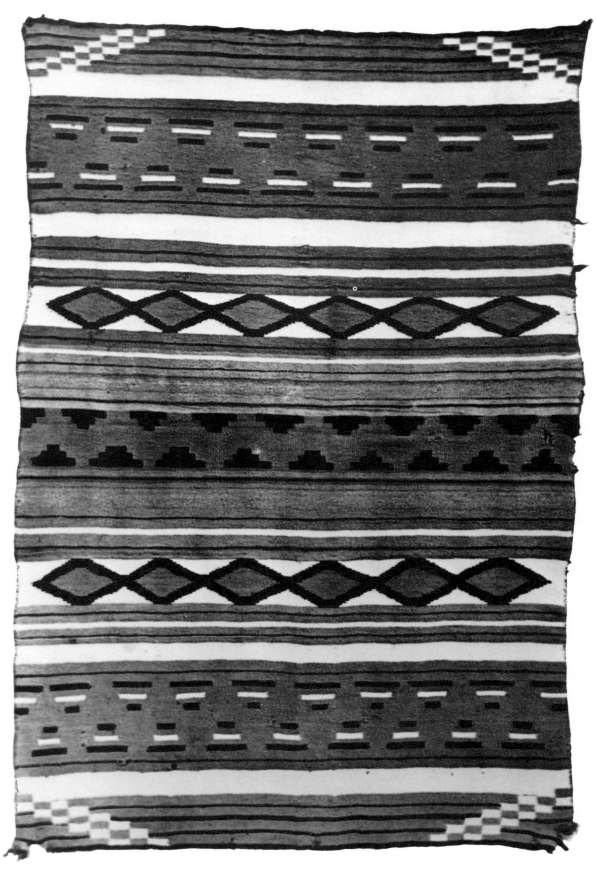

of crêpe paper soaked in water to dye fibers. Ink was also occasionally used as a dye, with indifferent success. Recipes for these several good-bad-and-indifferent colorings became part of the weaver's lore, and were handed on from generation to generation, jealously guarded as private secrets.

It should be pointed out that there were many good points to be considered in judging these new commercial dyes. While the collector market favored the vegetal-dyed product, this was an extremely time-consuming technique, in which only the very top weavers could receive a commensurate financial reward; the general run of weavers was not able to spend the time needed for vegetal-dye work in proportion to the income they received for their work. A further important consideration is the fact of permanence; no vegetal dye could retain its color in the face of the illumination which commercial dyes can withstand. And lastly, it must be admitted that, whatever the feelings of romantic collectors, the Indian weavers themselves welcomed the strong, vibrant colors far more than their older, softer (perhaps duller, in their view) hues. And in any consideration of traditional art, this last point is one to consider carefully.

A final introduction of the European was, in time, the horizontal loom. This latter, in which the fabric is woven horizontally, rather than vertically as is the case of the Navajo true loom, is universally used throughout the world for large-volume production. It employs all of the panoply of the weaver — "flying shuttle," bobbins, foot treadles, complex heddle arrangements, and eventually, with the crest of industrial application, power machinery. It is used by the Chimayó weavers of the upper Río Grande as well as commercial weavers in Mexico, and is one of the distinguishing characteristics between Indian "traditional weaving" and the more contemporary production.

Indeed, this whole developmental process whereby the Native American learned that fibers could be extracted, extended, colored, and combined into long fibers and then formed into a fabric, is a remarkable example of experiment and patient logic. From the simple twisting of coarse fibers to make a rope, through trial-and-error working with the basic interlacing of the fibers, to sophisticated techniques used to provide early man with the finest fabrics, coloring them to add attractive design elements, and then weaving them into a tremendous variety of textures has come all of the grace, color, beauty and vitality of native textiles which are so highly regarded today.

3·The Social Weft:
effects of weaving upon Indian life

Just as the technical requirements of material and equipment dictated the form, shape, and style of textiles produced by the weaving arts, so did the rules of society affect the end creation. The initial need, of course, was for clothing to cover and protect the body; probably formed originally in a plain weave, they were made in varied weights for warmth and protection. However it seems likely that very shortly after garments became an accepted product of the loom, social forces became a controlling factor.

Certainly when large-scale weaving became practicable, costumes, containers, coverings, and blanketing underwent dramatic changes; and although the process allowed far more freedom in manufacture, the results still had to supply the needs of the society. Since the latter changed more slowly and less willingly than the technology, any adjustments were necessarily those of the weaver accommodating the consumer.

One of the primary social forces was, of course, tradition. Just as in our own society today, preferences were for the well understood, tried-and-true designs; only the occasional "radical" weaver abandoned custom to create a departure from the accepted norm. That society had succeeded in the past, in part *via* the use of such customary practices, was regarded as sufficient vindication to require their continuation. Indeed, traditional changes seem to have been more pronounced in nomadic cultures than in sedentary ones; part of the reason may be that the closely knit village people have a greater and more immediate awareness of change, they are more conscious of the vulnerability of their culture to change and tend to resist more strongly. A nomadic, spread-out group, on the other hand, is less conscious of changes, since each person or small group is exposed to new ideas in something of a social vacuum, isolated from all others; being necessarily resilient to survive, there is less fear of novelty — they are exposed to new ideas almost daily.

This difference is clearly demonstrated in the social history of the Navajo *vs.* the Hopi; the former are well-known as among the most adaptive people among North American Indian tribes, while the Hopi, on the other hand, are renowned for their resistance to innovation. The consequences, in part, of this difference are spelled out more fully in Chapter 5.

A second, but no less critical, factor in social demand is religion.

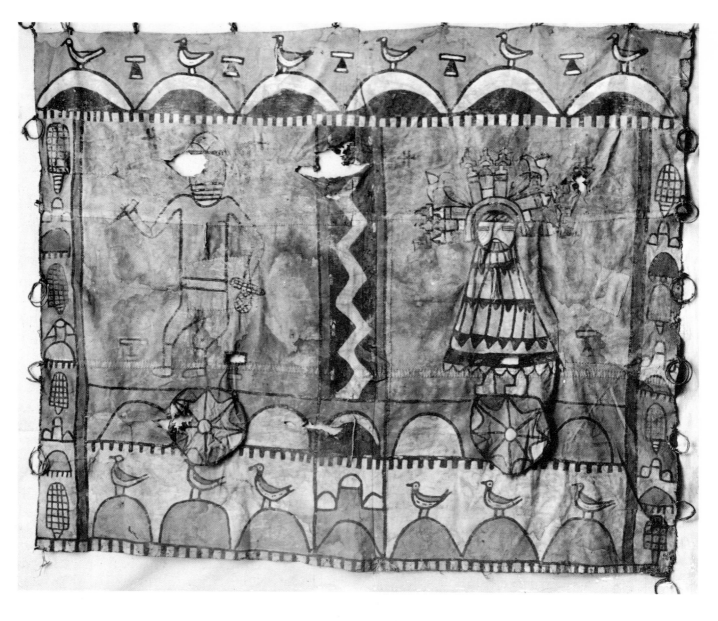

Ceremonial designs and symbols were needed for sacred garments; without them, man was less able to demonstrate his respect for, and relationship to, his God. In many cultures, it was perfectly acceptable for the individual who had attained sufficient socio-religious status or privilege to take on the role of the deity, and enjoy complete acceptance as such. An example of this was the position of the famed Great Sun of the Natchez, who seems to have been so regarded by his followers. Another common custom was the position of an individual, or perhaps shaman or priest, who acted as a go-between; though not a deity, that person nevertheless did take on a certain sacred aura — the Hopi tradition of impersonating supernatural beings called *Kachinas* is an excellent example of this concept. And lastly, there is the situation whereby the lay individual wears specific garments when attending or participating in

Painted cotton kiva screen, used as a backdrop for the Pálulukonti Ceremony. Heads of the Water Serpents are thrust through the openings. Hopi; Oraibi, Arizona. ca. 1880-1900. Field Museum of Natural History, Chicago.

religious ceremonies. In this relationship, the garments tend to bestow a religious ambiance, if not actual sanctity, to the wearer, thereby rendering the ritual more visually and psychologically impressive and satisfying.

Each of these approaches came in time to require a special combination of paraphernalia, costume, and ritual performance; some of this was elaborate, some was relatively simple. But almost universally, the personator, priest, or worshipper wore some form of sanctified, prescribed garments, which were usually woven — often with decorative symbols or designs. Thus, the manufacture of these garments became an important product of the weavers, and the position of the weaver was in turn one of major consideration. In fact, this religious relationship may be a fundamental reason why Pueblo weavers are men.

Generally speaking, in native arts, religious designs and symbols are created by, and known only to, the men of the tribe. Realistically speaking, of course, most of the women will be perfectly well acquainted with these designs, but in accordance with custom they coöperate with the traditional fiction and rarely admit that knowledge, simply as a convenient social gesture to internal harmony. In this context, designs executed by women tend to be geometric or linear in form, whereas male-oriented art is usually realistic, naturalistic, or religiously symbolic.

Depending upon the conservative or religious bias of a culture, many designs may not be used freely; they are restricted to a given time, place, or event, and are rigidly proscribed — either on a basis of initiation into the tribe, society, or group — or on a basis of social relationship or sex. Ceremonial *Yei* designs, for example, were supposedly used only by the medicine men among the Navajo; when a venturesome woman wove a rug in 1896 which included many of these figures, a shock wave went through the entire tribe. It was confidently expected that she would go blind. And a few years later, when Hosteen Klah wove a rug depicting the sacred sandpainting designs, it caused an equally profound reaction and censure.

The origin, development, and complete corpus of tribal designs is difficult to analyze. One can only make some generalizations which may, or may not, have depth. It seems true that there do exist certain interrelated "design families" which are found more commonly in one region than another.

Many designs, however realistic in form, have no other "meaning" than the resemblance to a natural form. Thus a motif that resembles a leaf, or an arrowhead, and may indeed be called a "leaf" or an "arrowhead" by the artist, might also be accurately described not as meaning to *be* a leaf, but simply to have a leaf-like appearance, *i.e.*, a design which "looks like a leaf," but without any subtle or esoteric significance. Some motifs become a chronological record: changing over the years with tribal fashion and style, they are often traceable to these origins, and provide a cultural history of a given folk.

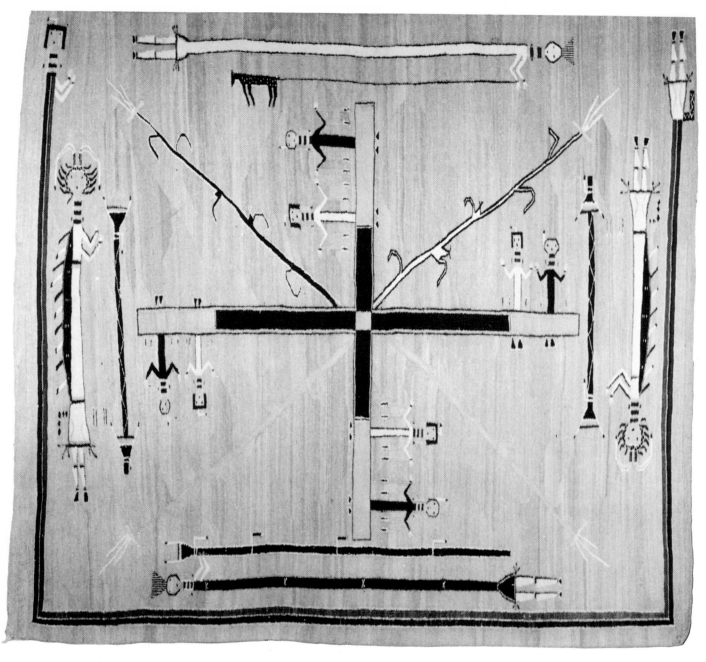

Other designs are indeed symbolic, *i.e.*, possessed of a precise significance or "meaning". This aspect of Indian art is perhaps the most widely misunderstood of any — from the very beginning of Indian-White relationships the eager preoccupation of the European with the assumed mystical significance of native design forms has overshadowed all other considerations. It is quite true that many motifs (particularly in the religious field) do have a significance to the initiated. These may be portrayals of deities, important places, concepts, or episodes critical in the life of the society or group. Some of these will be cryptic, and can be interpreted only by an initiate, while others may be quite self-evident to

Woven wool sand-painting design rug, by Hosteen Klah. Navajo; New Mexico. ca. 1920-1925. 54×54 inches. Wheelwright Museum.

any reasonably informed person. An example of the former is the *kachina* sash design in Plate 8, obvious only to the initiated; a more readily-recognized motif is that in Plate 49, which would be recognizable to anyone simply as a decorative statement.

But it is equally true that more designs are purely realistic representations, depicting as accurately as possible the original subject, but lacking any other esoteric significance. These stay relatively the same throughout the years, although they may travel from one tribe to another; the religious symbols tend not to be interchangeable, and rarely are recognized beyond the limits of the parent group. As ritual societies come and go these can appear or disappear, affecting only that initiated society.

Related to, and almost equal in importance to religion is the indication of social relationships and individual position in the society. Designs and garments frequently are accurate indicators of the status of members of any society, and the Native American was no different from anyone else in this regard. Self-esteem, the regard of others, and the political power which emerges from such recognition, have always been critical in the well-being of a group, and such symbolic insignia were freely woven into the garments and costumes of the Native American. The regard for the well-known "Chief's Blanket" of the Navajo is one example, even though

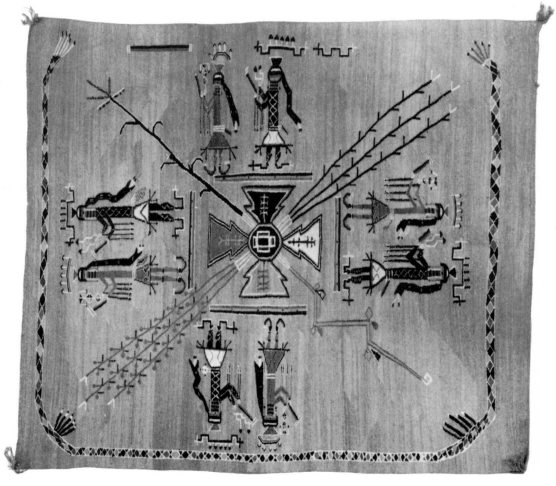

Sand-painting design rug, by Hosteen Klah. Navajo; New Mexico. ca. *1925. 50×50 inches.* Museum of Northern Arizona.

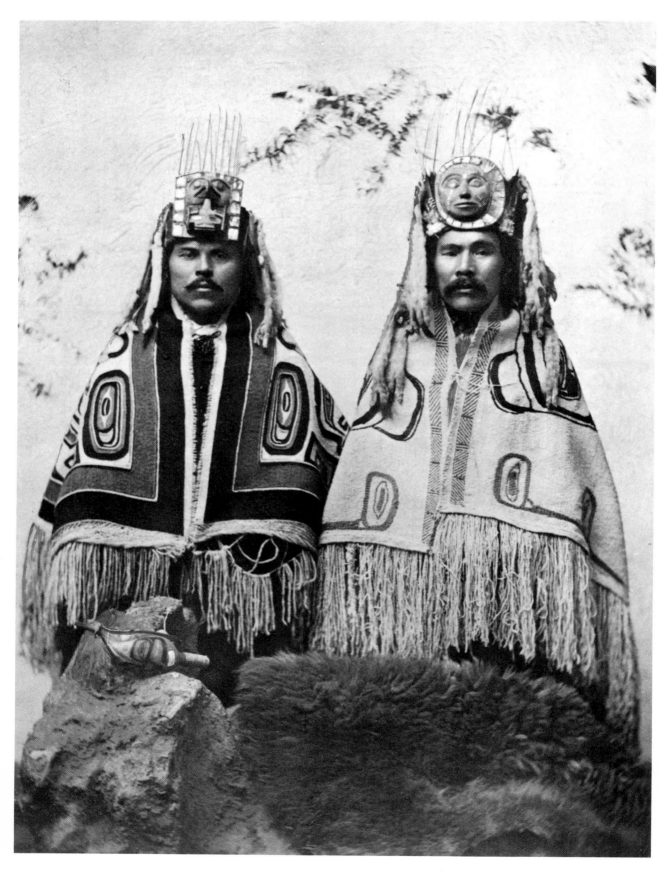

Man's black-and-white wool blanket; (right) Boy's wool blanket. Hopi; Second Mesa, Arizona. ca. 1930. Marc Gaede photo, Museum of Northern Arizona.

Opposite

Two wealthy men dressed in ceremonial regalia and woven "Chilkat" robes. (Left) Tom Price, and (right) John Robson, both well-known sculptors. Haida; Skidegate, British Columbia. ca. 1901. University of British Columbia Museum.

it was never subjected to such politically restrictive use; the Chilkat robe of the Northwest Coast is another example of status garment.

In both instances, it should be realized that cost had much to do with this preëminence. These blankets were always expensive, regardless of the tribe or the time, and only the very wealthy could afford them. This in turn not only reserved their use for persons of major position within the tribe, but their possession likewise conferred that distinction.

As do all craftsworkers in any culture, weavers not only entwine their thread, they also help to knit their culture together more closely. The importance of such individuals to the social unity cannot be overestimated. The place of the priest or shaman, chief or headman is of critical importance in any group, and their success often lies not only in what they are actually able to do, but upon the way in which they are perceived by their followers. And part of this ability to excite a following depends greatly upon visual factors — which gives the craftsman an important role. While it is true that in many groups, the major individual of importance may dress in rags, appear unkempt, or perhaps deliberately underdress as a measure of pseudo self-abnegation, in most cultures the type of costume (if not its elaborate decoration) is a primary part of the position of the wearer in the society.

75

While many motifs were traditional or hereditary, others were copied or incorporated into the texture of the object — and many in time became so popular and frequently used as to become "traditional," as with Saltillo motifs adopted into Navajo blankets. Some were adapted simply through admiration of the original; others were sufficiently different to allow the viewer to make discrete identifications between one tribe and another. For example — and it must be understood that these are very, very generalized observations — Northwest Coastal Indian design tends towards a totemic form. They always (*i.e.*, usually, but not invariably) have a totemic element in their basic organization. At base, then, the "meaning" of such art tends to relate to an animal or plant, real or mythological, which has a close relationship to the human. Southwestern art usually has less totemic significance, with a much more geometric, anthropomorphic, or zoömorphic base. It may be completely abstract in concept, normally expressed in flat rather than two-dimensional form. Indian people of the Northeast (and the Southeast) incorporated animal and human forms into their art, as well as floral; many of these seem to have been greatly affected by European design. Much of this is largely drawn from the chronology of our own knowledge of Indian art as much as it is from the actual fact of the art itself.

Many of these designs which became traditional or of a long-established duration also became "property." The Indian artist felt an ownership of design which was respected by all others; indeed, there was something of a tribal copyright which could be broken only by consent of the owner, and payment of a fee or gift. This tradition often allows us to identify the origin of some designs in those cultures where there are surviving members of the tribes who have a knowledge of the history of the art within the group. The weaver must keep in mind the symbols and insignia which have been handed on from one generation to another as a meaure of the continuity of the group. Thus they become, in a very real sense, the visual historians of the people, along with the other artist-recorders. Their designs register an identification of status, the degree of formality which one can expect in a given costume, tribal membership (for the aid of both internal and external identification) and relative rank within that membership, and in many instances of political priorities, the preëminancy of families or individuals.

Native Americans were no different from other people in that prestige was an extremely important factor. Not only did this involve social and political power; it also was a religious matter of considerable weight. To lead the people well and assure their survival required all of the resources which the individual leader could summon. To this end, his appearance was important, and his costumes were no mere shallow trappings — his self-confidence and the credibility he enjoyed among his followers were crucial to his success. Therefore, those people who could design and produce garments enhancing that visual appearance were in considerable demand. Those more skilled individual artists did not go unnoticed, and it is quite likely that some became specialists of sort in the design, weaving,

and marketing of such garments which indicated the status or position of the wearer.

These should not be regarded as an inconsequential part of the the weaver's output. They improved his position within the tribe, and may have enriched his personal income; but even more, the designs and

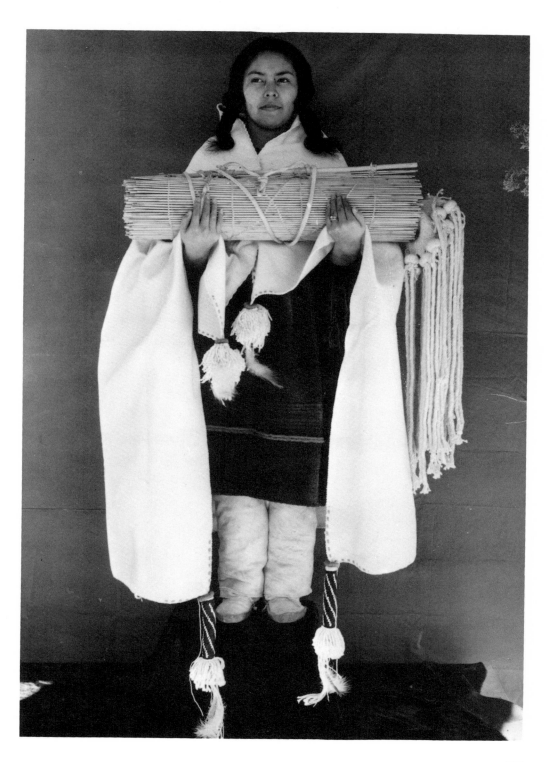

A young bride with her trousseau. Hopi; Arizona. Marc Gaede photo; Museum of Northern Arizona.

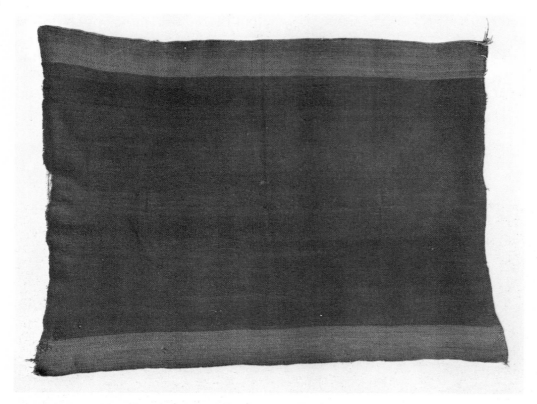

Old-style woman's wool dress; brown and indigo on black. Hopi; Arizona. ca. *1800-1825. 39×52 inches.* Fred Harvey Collection photo.

symbols which had to be kept in mind provided a reservoir of tradition. He was responsible for the preservation of the significance of the various visual motifs used in the manufacture of traditional garments, and as younger weavers learned to produce textiles, they also learned the significance of the designs they wove, thereby assuring the continuum of the society.

The giving of gifts is one of the most universally observed customs of mankind — to the gods, to lovers, friends, relatives, children, or to society at large, even to enemies — and a socially approved method of sharing one's possessions with others is to be found almost everywhere.

Another socio-sexual factor is the relationship between the sexes: a weaver could use her technical and esthetic skills to attract — or reward — a lover. And a further interesting role of the weaver is the old-time Hopi custom whereby the groom wove his bride's trousseau — both as measure of his devotion and proof of his eligibility as a good provider — which endowed her with one of the most elaborate wedding gifts in the Americas. She received two large white cotton blankets or *mantas*. One was slightly smaller than the other; after being worn at her wedding, this one was treasured carefully, to be used again only as her shroud. The other, also worn at the ceremony, might later be embroidered or cut up to serve as material for kilts or other costume

Blankets gathered together for distribution at a potlatch. *Kwakiutl; Fort Rupert, British Columbia. 1881.* American Museum of Natural History.

needs. She was also given a beautifully braided white-cotton "wedding sash" of unique design which was stored in a reed-mat wrapping.

She might be given a black-wool dress and, to hold it in place, a belt woven of green, red, and black cotton, and a pair of buckskin legging-moccasins, depending upon the industry of her husband. Today, since fewer Hopi men have continued to weave, such gifts are often woven by the grooms's male relatives, and such time-consuming gestures are becoming increasingly infrequent.

The formal give-away customs of the Southern Plains people are no less firmly established than are the carefully orchestrated *potlatch* rituals of the Northwest Coast or the Pueblo *Kachina* dances where the actual presentation is by a third party; as in our resort to Santa Claus, each reflects just such a social convenience.

These may represent a time-honored way to re-distribute wealth, establish status, and give thanks to others, or they may be an effort to cement relationships and to release tension between people. Often they are purely to give honor or recognize individual merit. But each is conducted in a rite which involves public display and recognition of the donor and the recipient.

Whatever the purpose, in all of these complex practices, one of the principle gifts is almost invariably textiles. One can read countless records of Northwest Coast *potlatch* meetings, for example, and find blankets prominently listed in the gift inventory; these are usually stacked up in front of the person responsible for the ceremony. Northern Plains people make certain that everyone knows who is giving or receiving a specific item, and Southern Plains donors ostentatiously display their shawls and blankets prior to making their gifts. All of these are simply proof of the generosity of the host, and an honor to the recipients. But in all of these rituals, textiles — and especially blankets — have held one of the most important places, and this recognition of their value has apparently been true for a long, long time.

The fabric of any given culture, then, is not only one of warp-and-weft of various animal-vegetable-mineral fibers, but it is also an interweaving of technical-social-religious forces which combine to bind the people together in a strong unit through the medium of man-made craft objects, in which textiles are a vital part.

And much study is yet to be done on the actual degree of influence of European ideas and tastes upon American Indian weaving motifs, although attention has been given from time to time to limited aspects of the problem. Most emphasis has been on the effects of the introduction of domestic sheep, aniline dyes, or the power loom and its economic impact, and it is obvious that native weavers were exposed to these forces early in Indian-White relations. But other more subtle factors invite consideration, such as the dominating effect of Victorian taste, and and the intense, if short-lived, interest in Oriental art, then popular in England and the United States. Subsequently, many of the settlers who traveled west carried "Turkish rugs" with them. In the Southwest, these provided Navajo weavers with one of their major ideas of what was acceptable to the White, and they incorporated many intricate Oriental motifs into their weaving designs — a practice reinforced by the direct efforts of equally Victorian-minded White dealers.

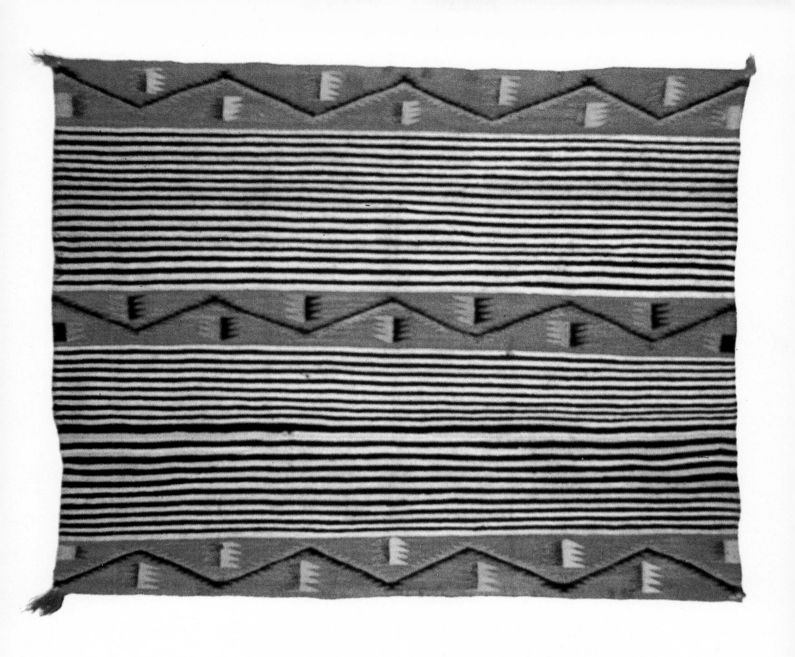

17 Regular "Chief's Blanket" design, intended for use by women. Navajo, New Mexico. ca. 1875. Museum of the American Indian.

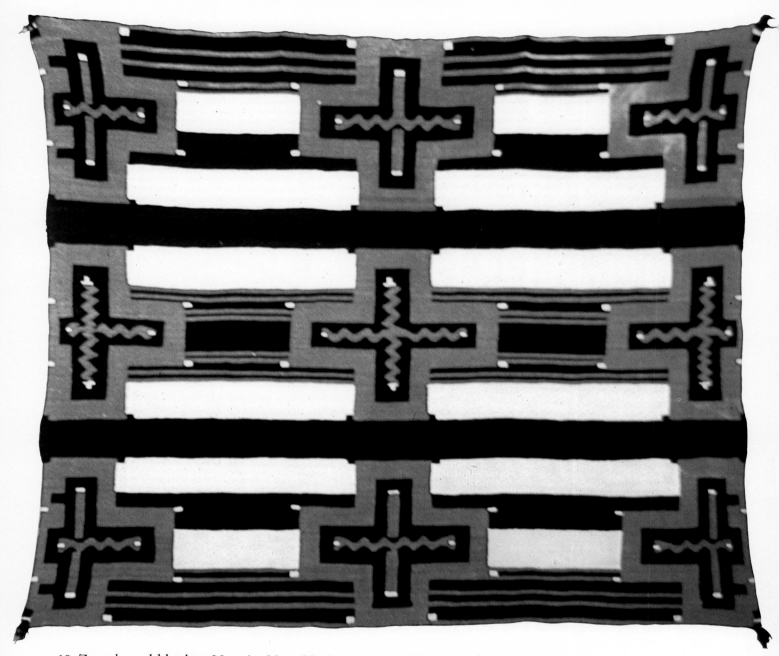

18 Zoned wool blanket. Navajo, New Mexico. ca. 1860. Museum of the American Indian.

Opposite

19 Woven bayeta wool blanket. Navajo, Arizona. ca. 1875. 36×48 inches. Museum of the American Indian.

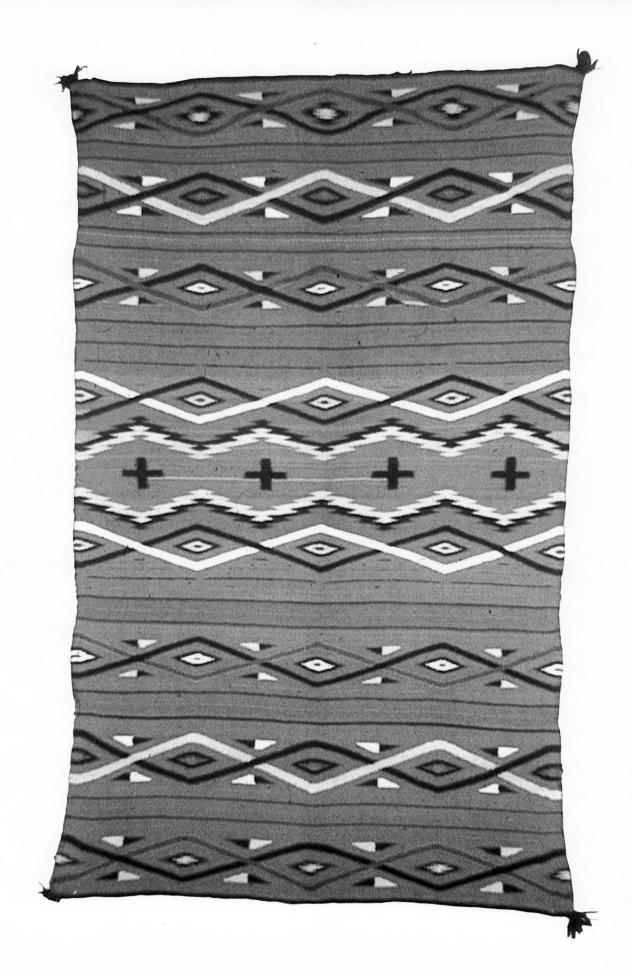

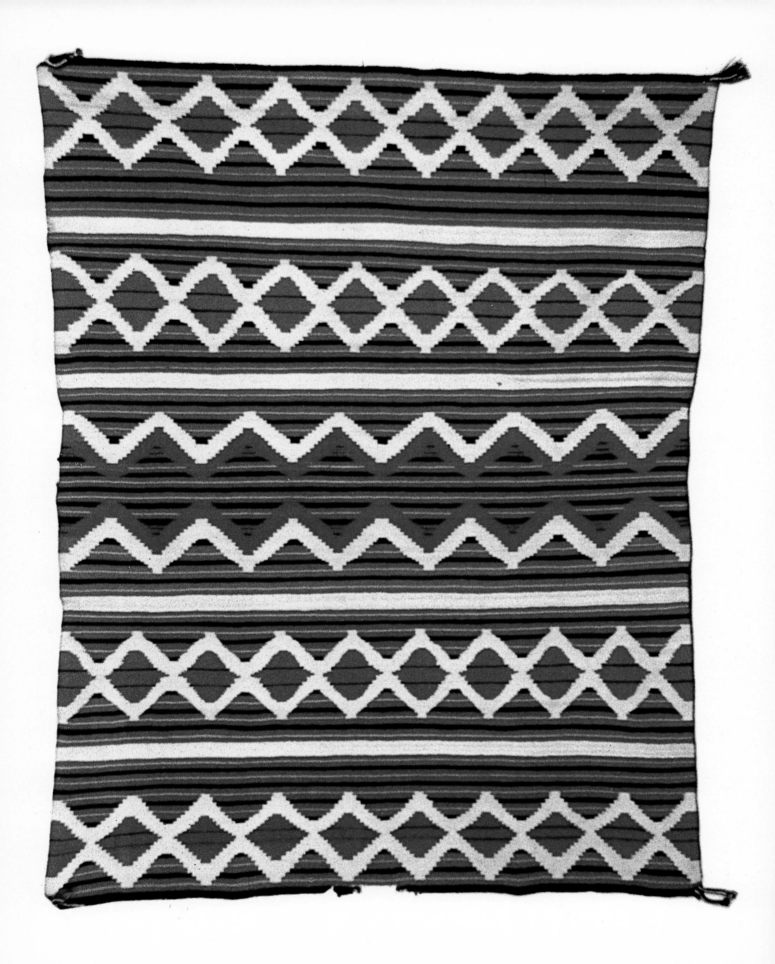

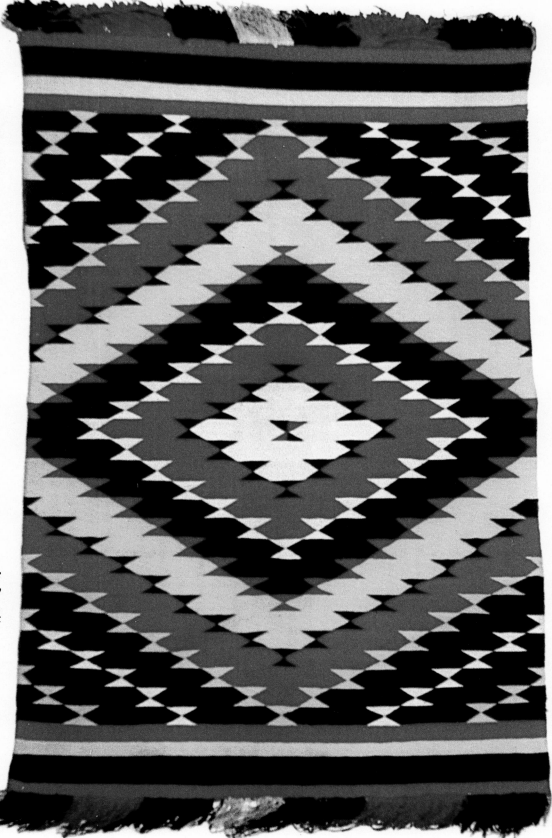

Opposite

20 *Germantown wool table runner. Navajo, New Mexico.* ca. *1890-1900.* *34×46 inches.* Museum of the American Indian.

21 *Germantown "eye dazzler" rug. Navajo, New Mexico.* ca. *1890-1900.* *56×76 inches.* Museum of the American Indian.

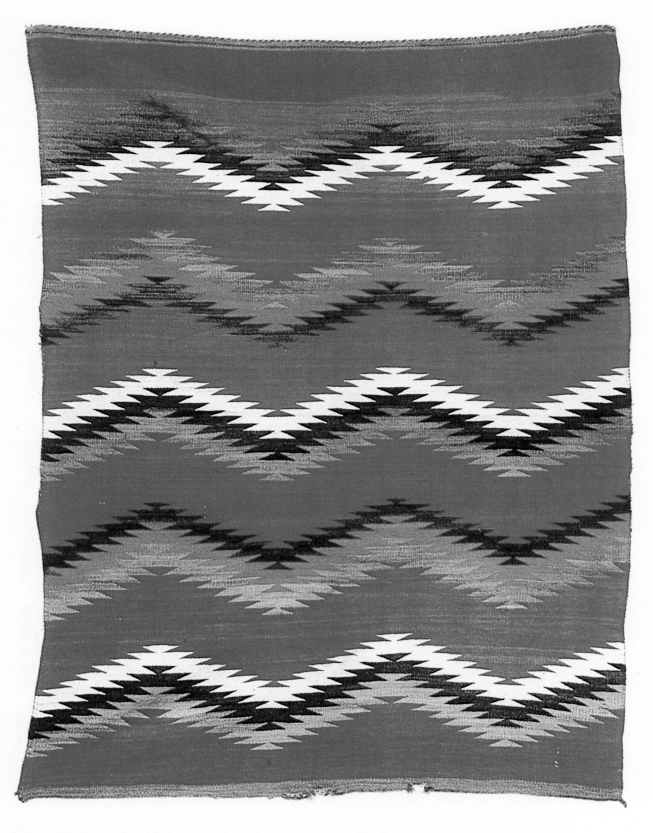

22 *Germantown "eye dazzler" throw. Navajo, Arizona. ca. 1900. 36×46 inches.*
Museum of the American Indian.

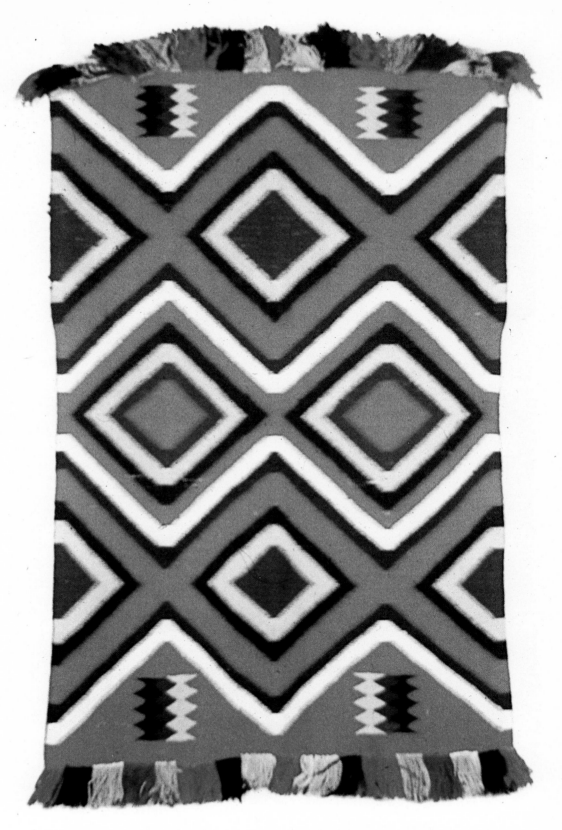

23 Wool blanket. Navajo, New Mexico. ca. *1900-1910. 36×48 inches.* Museum of the American Indian.

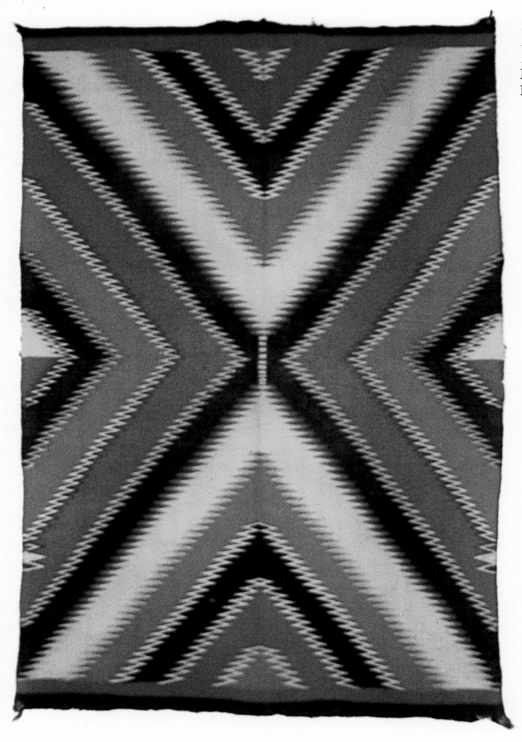

24 Wool blanket. Navajo, New Mexico. ca. *1900-1910. 36×48 inches.* Museum of the American Indian.

Opposite

25 Woolen "eye dazzler" Germantown blanket. Navajo, New Mexico. ca. *1880-1890.* Museum of the American Indian.

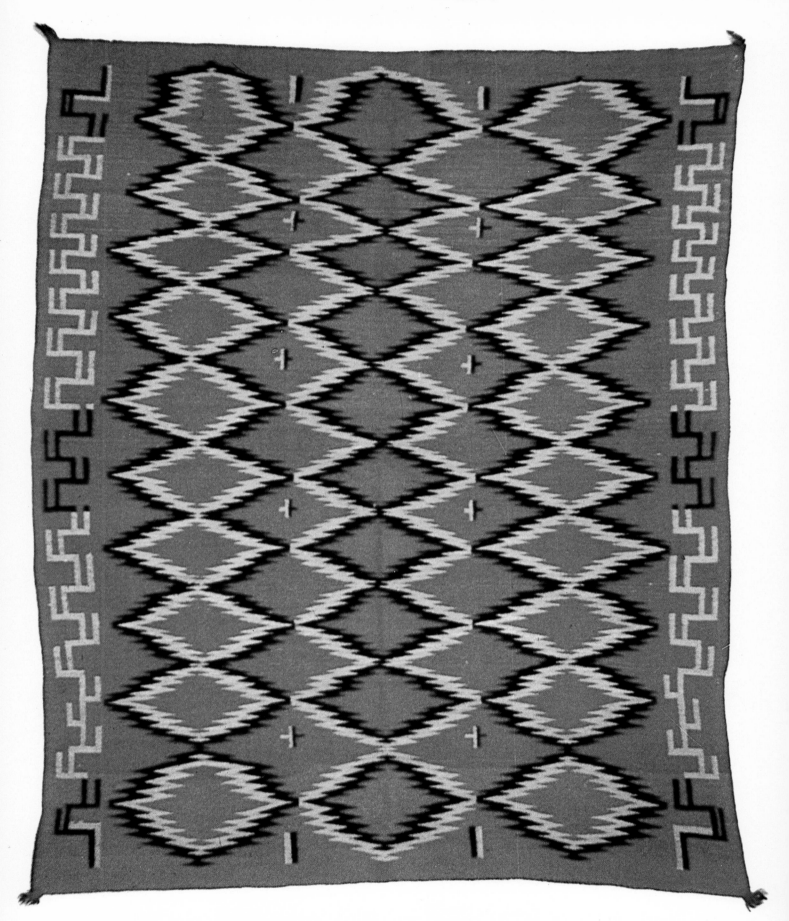

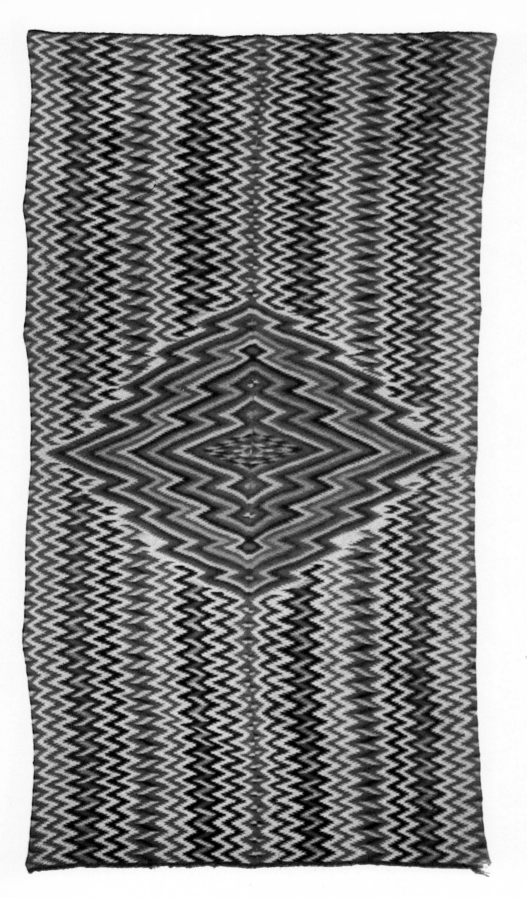

26 Two-piece wool serape. Saltillo, Coahuila, New Mexico. Collected in 1836 from Gen. Santa Ana, by Col. Sam Houston. L: 49 inches. Museum of the American Indian.

Opposite

27 Two Gray Hills style weave. Navajo, New Mexico. ca. 1965. 60×85 inches. Alice W. Dockstader photo.

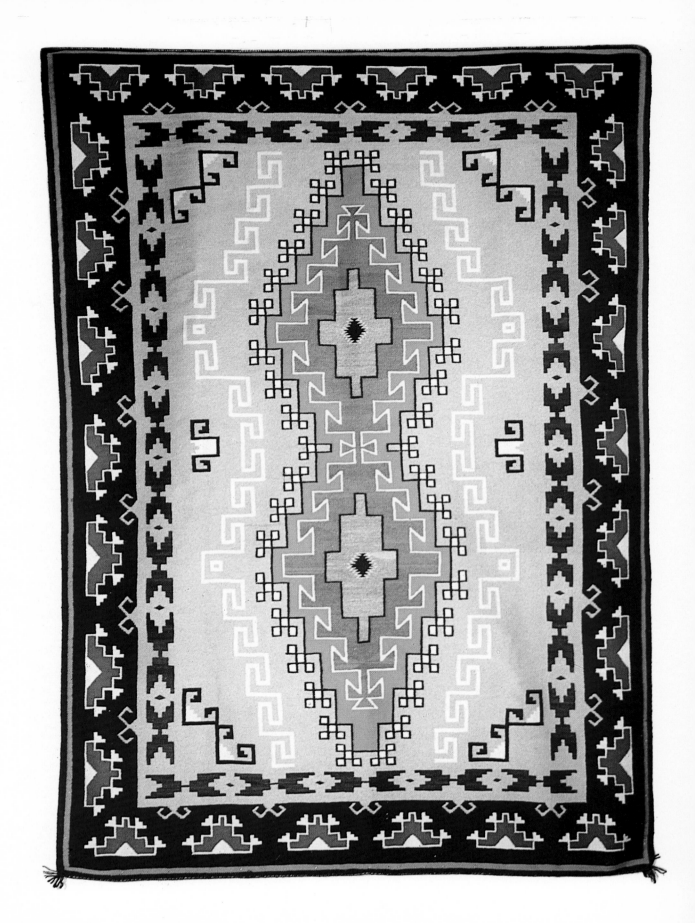

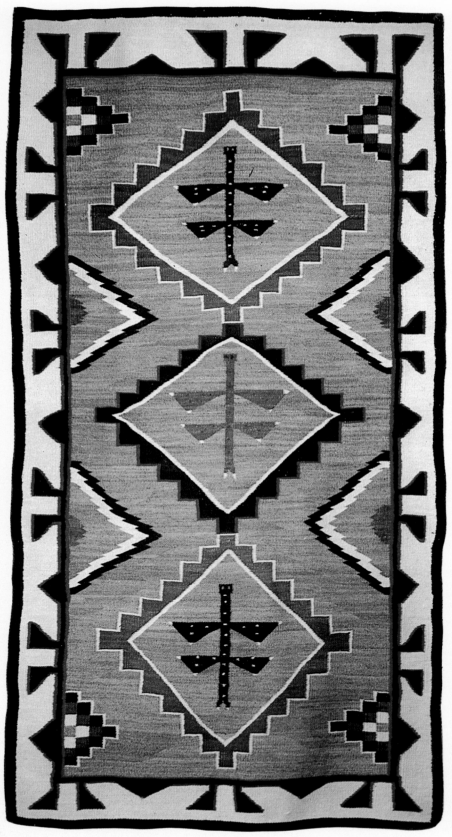

28 Regular tourist style weave; dragonfly design. Navajo, Arizona. ca. 1920–1935. 43×84 inches. Alice W. Dockstader photo.

Opposite

29 Pulled-weft wool blanket. Often called wedge-weave blanket. Navajo, Arizona. ca. 1880–1900. 54×80 inches. Alice W. Dockstader photo.

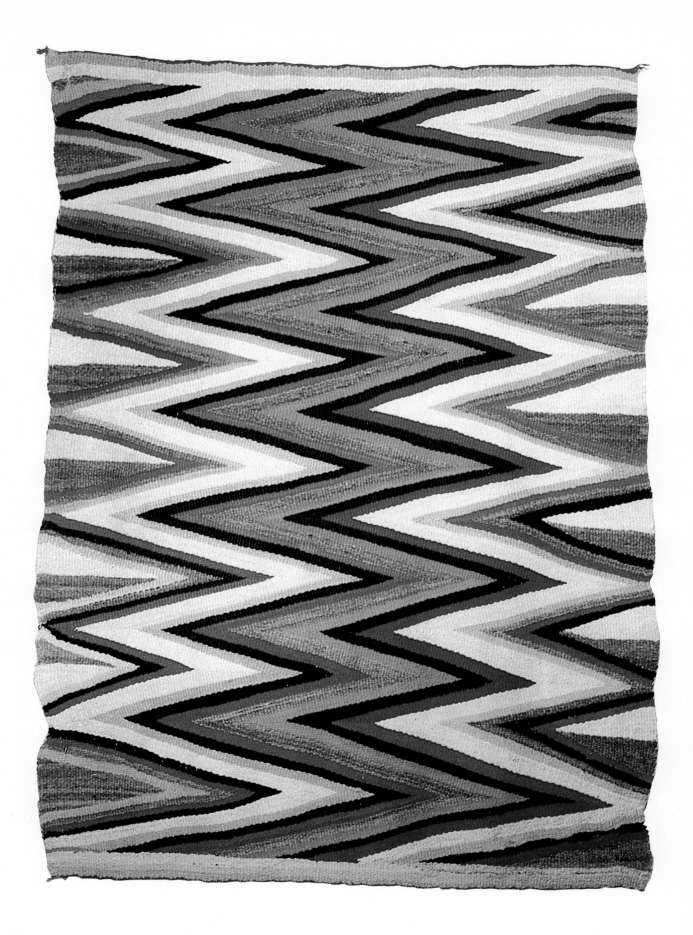

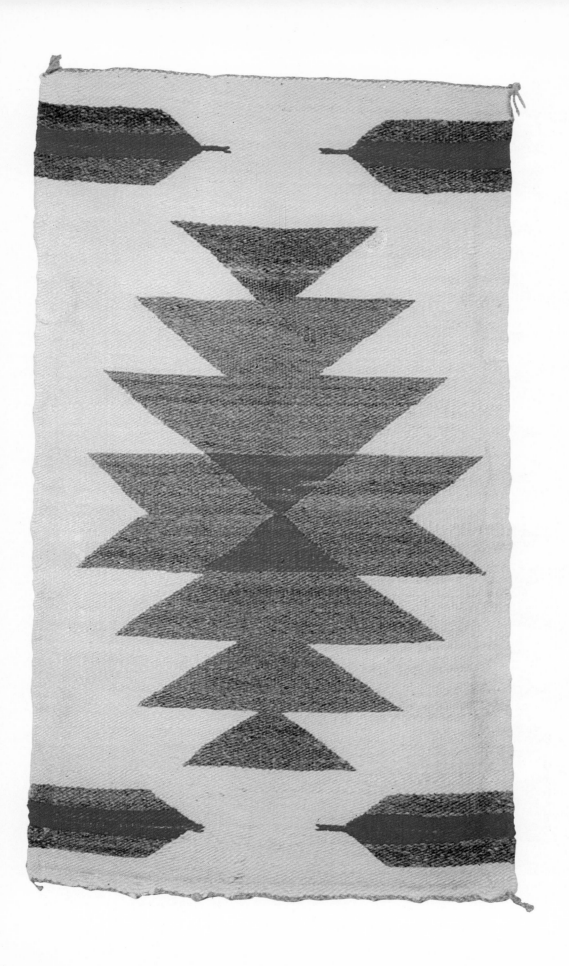

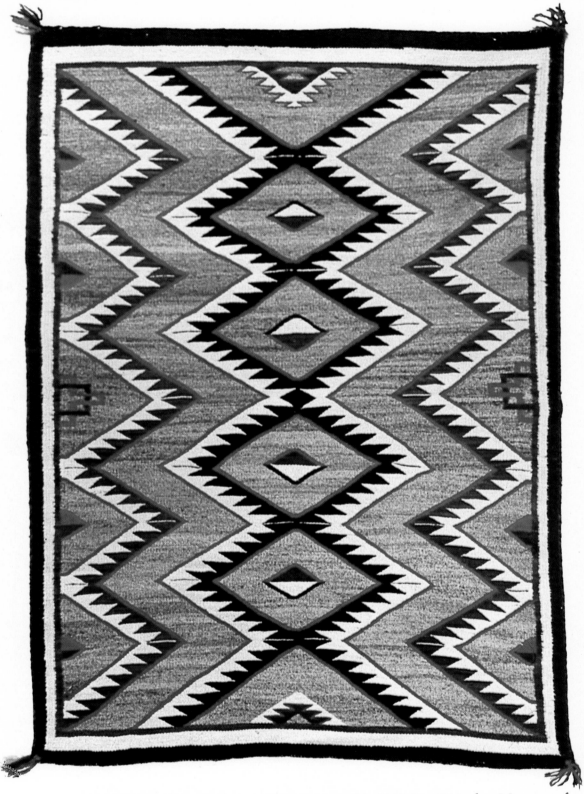

31 Serrated-design rug. Navajo, Arizona. ca. 1930-1940. 52×84 inches. Museum of the American Indian.

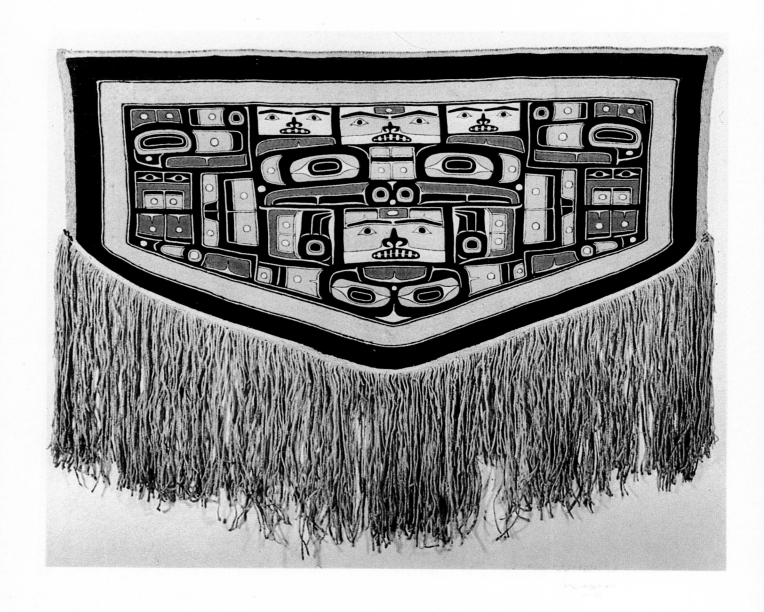

*32 Classic "Chilkat blanket" with design of a Brown Bear. Tlingit, Alaska. ca. 1880.
W: 64 inches.* Museum of the American Indian.

4·The Economic Brocade:
trade and commerce

The elements of technology and social custom intertwined to form the basic fabric of society, but the demands of economics also had to be interwoven to provide a strong tribe. Initially, the needs of the immediate family were paramount — it had to be clothed, kept warm, and provision for sleeping and group coverings were naturally given first attention.

Once these critical needs were provided for, however, the needs of the tribe itself came into consideration, and this was perhaps the first step in the long road towards economic interchange. This particular brocade took many forms: barter for produce or the manufacture for one's own neighbors took care of any immediate surplus. But with the introduction of the true loom, a larger amount of weaving became a reality, and often the industrious worker produced far more than was needed by the tribe. Coupled with increased skill and resources, this overproduction of textiles introduced the problem of disposal of the surplus, and the initial solution was distribution in economic terms.

Trade *per se* was not a new element in the life of the Indian weaver; even today we little realize the remarkable complexity of these ancient trading systems. That they existed is well documented, but the degree to which they served as avenues of the distribution of materials, spread of knowledge, ideas and concepts, is less clearly understood.

Weaving must have been a major commodity in this trade, and the introduction of new weaves, styles, designs, and — most important of all — raw materials, made a tremendous impact upon home products. First, as cotton increased in demand, the early finger weaver or suspension-rod craftsman could no longer depend completely upon wild cotton as a source. In time, agricultural crops came to include domesticated cotton harvested solely for the needs of the weaver. When this became increasingly successful and resulted in a surplus, much of this entered the native market for distribution outside the immediate area.

And these pressures for raw materials made themselves felt by the regular forays into distant areas for natural substances which could be beaten, shredded, or stripped, and spun into weaving threads. Some markets seem to have been far more important for the rawstuffs they could supply than for their purchasing power. This inter-tribal trade often required considerable travel to distant regions — on occasion, well over 500 miles, — indicating a familiarity with other Indian tribes over a wide

region which the early people enjoyed. There was a sense of exploration involved in this search for new and unknown fibers, as in turn was a sense of experimentation which affected not only the weave but the nature of the weavers. Traditionalists are also very often adventurers, particularly as regards their art and their technical world. Indeed, this degree of willingness to experiment, coupled with a sense of personal individuality, makes the artist and the craftsman usually a freer spirit in any culture as compared with the more conventional, economically oriented person, in spite of the need the latter has to expand his market and be eternally on the search for novelty, be it in product, raw material, or customer.

Another factor of importance was the Indian attitude which regarded technical knowledge, design motifs, and art forms as personal possessions, just as religious or "secret" power was considered as personally owned. This could be taught to others, but such a transferral was expected to be paid for in some way; this custom, therefore, assured the weaver of an additional source of personal income from his craft. Not only were members of the family instructed in the arts, but outsiders were also taught, upon application — or allowed to use art motifs and designs — in exchange for equal value.

The currency of the early period was often measured in weaving terms in many areas: blankets became units of value, widely recognized and accepted as such. In Colonial times in the Southwest, for example, the *manta* (the common cotton shoulder cape, or mantle) enjoyed such a position of regularly accepted value, and fines imposed upon the Indians by the Spanish authorities were often levied in terms of so many *mantas;* taxes were also payable in this manner. Many of these fines or levies involved the payment of as many as 2,500 *mantas* in a single incident — a commentary upon the prolific activity of the weavers of the time.

This practice was equally important in the Northwest Coast, where the importance of textiles was clearly acknowledged not only by and among the several tribes themselves, but were of equal commercial acceptance by the Hudson's Bay Company, whose own woven products became currency in the area. Among both groups, one blanket, *i.e.,* the standard weave, or basic textile, became an accepted unit of value. These values of course changed from time to time, as size, quality, type, and scarcity dictated, and the value tended to vary directly with the distance of the source of supply. Among native tribes, blanket values were measurable in terms of the time and difficulty involved in gathering the raw materials, processing and weaving them, and their status in the local culture. Esthetic qualities enjoyed an appraisable value, just as did the need or function of these objects; it should be recalled that until the late nineteenth century textiles obtained by Whites were normally used for much the same purposes as by Indian consumers.

This interchange was important, and makes the point that the weaver did not exist in a vacuum, turning out yards and yards of textiles without respite. There was a very keen awareness of the "customer," be this a member of the family or a distant consumer. Weaving became a major

part of the established trade of the period. Textiles were easily transported, had a proportionately high value, and their widely recognized utility gave them great popularity in the market. To the merchant they were an attractive commodity, since they were lighter in weight and far less fragile than pottery. In many instances these mobile traders were the craftspeople themselves taking their own products to the market; in other situations, middlemen bought the object from the maker and then exchanged it for some other product, making a profit between the transactions.

Even though the effect upon the Indian of the arrival of the White man has already been mentioned, its impact upon the Indian's economy will bear a slight repetition. The fascinating objects which were introduced into the native market — shiny beads, iron knives, steel axes, and new raw materials — all provided a magnet for commerce which created a totally different market.

Although it is quite true that the European was primarily interested in obtaining gold, furs, and land, more-or-less in that order, there was also a very early need for weaving. The demand for blankets, particularly, increased the pressures upon the weavers, who responded willingly; early invoice lists not only show blankets taken *to* the New World, but also large numbers of weavings *by* native weavers which figured prominently in the market. Such increasing demand existed throughout the North American continent, varying in direct proportion to the type, style, quantity, and quality of weave produced. It seems to have been of modest importance in the Eastern Woodlands area, and came into its maximum fulfillment in the Southwest, where the early Spaniards had already demonstrated their interest in wool growing and weaving through various enterprises, including the introduction of weavers and their equipment, the support of weavers by Royal decrees, and the purchase, confiscation, or legal expropriation of woven textiles.

But with the success of the Pueblo Revolt of 1680, when the Indian warriors drove the Spanish out of the Southwest for over twelve years, weaving took a new turn. Both Pueblo and Spanish weavers tended to continue the standard striped or diamond patterns of the day, with apparently little increase in quality or design. The Navajo, on the other hand, provided a dynamic force which moved into this vacuum, and succeeded so well that by 1800 the product of the Navajo loom was the single most valuable commodity produced in the Southwest.

This was looked upon as an affront by the Spaniards who, bitter at the loss of this rich market, in 1807 dispatched the Bazan brothers from Mexico City to set up a more effective weaving industry in Santa Fe. Although these expert craftsmen worked there for a period of something over two years, the Santa Fe weavers were unable to produce the fine weaving and dyeing equal to the standards of the Saltillo weavers, and their textiles, which were coarser and less well-woven, never replaced the superior product of the Indian loom.

The Navajo continued to experiment and improve their weaving until

Wool "slave blanket" in zoned design (i.e., the use of separate horizontal banded repeat patterns). Recovered from Ft. Kearney Battlefield, Nebraska, in 1861. Navajo. Marc Gaede photo, Museum of Northern Arizona.

by 1850 they were recorded as owning upwards of half a million sheep, although their own population did not exceed 10,000 persons. They developed a mixed economy based upon production for food, weaving, and wool raised for shipment to eastern markets. A sense of the proportionate development can be understood from the sales listed for one year (1890), when 1,370,000 pounds of raw wool, 2,900 sheep pelts, 12,000 sheep, and approximately 2,500 woven wool blankets were recorded.

Slowly, however, this superiority declined, particularly as the pressure to produce to satisfy an ever-expanding market demand made itself felt. Hasty work, less care given to designs, dyestuffs, and finishing of the wool combined to result in poor textiles. While some traders refused to buy

these inferior, coarsely-woven rugs, many did not, and the market became saturated with them. Pay to the weaver was strictly by the pound, ranging from 30 ¢ to a little over $1.00 per pound, regardless of design or quality of weave; only the very finest work could command any premium.

Inevitably, some substitution of raw materials entered the craft — most particularly in the use of commercially spun cord. Traditional Navajo and Pueblo weaving was done with a hand-spun wool warp; some weavers used commercial cotton cordage to speed up the weaving process, covering this with wool weft. Such a warp does not wear as well, and results in a poor product. Another unfortunate tendency was the use of cheap aniline dyes or other coloring substitutes which were available to the Indian weavers for a brief period.

By the first quarter of the twentieth century, Navajo weaving had reached its lowest level of quality. Where at one time textiles averaging a thread count of sixty to eighty weft threads per-inch were commonplace, those counts in 1920 were as low as twelve, eight, or even six. These were usually loosely spun yarns woven in a coarse-weave covering as much space as possible on the loom. Designs were gross, with ragged edges, often almost translucent when held up to the light. Colors were irregular, lacking the solid over-all effect found in the more carefully dyed threads.

Early wool "slave blanket" in orange, yellow, red and pink. The name derives from weavings by Navajo slaves taken to Mexico. ca. 1850. 58½ ×45 inches.
Fred Harvey
Collection photo.

It should be noted that very rarely were these products sold to, or used by, the native.

Indeed, where the woven product of the native loom had earlier been used for a wide variety of Indian purposes, from bed coverings to clothing, body shawls, saddle pads, and even for doorway closures, the function now became directed towards providing floor coverings, wall decorations and saddle or seat padding. This change of function was in part responsible for the change from the thinner more closely woven blanket to the heavier and thicker *diyugi* textile (commonly called "doughies"), which was more suitable for these purposes.

Furthermore, the sizes and types of various weaves also changed. Whereas earlier the blanket was proportionately shaped for the human body, the European demand for floor and wall covering changed this — as did the loom which was capable of producing larger weaving. The "standard" size became a rectangular textile, usually about 5×6 feet, while larger floor rugs of 6×9 feet were common, and 9×12 or 10×14 feet were not unknown. The famous "largest rug in the world," woven in response to a request by Román Hubbell in the 1930s, measures 22×36 feet and is a *tour de force* of the weaver's art. While it demonstrates the ability of the Navajo woman — in this instance, three people working on the one textile — such extreme sizes are extremely rarely woven.

The interest and increase in quality of these textiles has already been noted, and it is heartening to realize that the weaving arts have continued on an upward climb ever since. Even more propitiously, this interest has been reflected in an improved financial income for the weaver. Some of the better-known artists have achieved unheard-of personal incomes as a direct outgrowth of their talent; all of the good weavers have shared in the benefits, and even poorer craftsmen have been given an incentive to improve.

Today, fine weaving has reached an economic pinnacle; well-woven "prize" rugs sell readily for $6,000 to $8,000, and many reach the $10,000 mark. Some of the older blankets of the pre-1880 period have sold for upwards of $25,000; the whole price structure in this field is one which depends upon the desire of the collector to obtain a particular weave.

However, the quantity of production has not kept pace. In spite of the high prices paid, the total number of weavers has declined. Part of the problem is that only the very top artists enjoy this economic windfall; the average weaver still is forced to sell her work at a rate of income only slightly above that obtained in the 1925-1950 period. Considering the time spent in gathering raw materials, preparing them (or purchasing these commercially), and the time required to weave the rug, her income in terms of dollars is not an enviable sum. She may indeed be fortunate to receive the equivalent of $1.00 an hour. As a result, many weavers are simply unwilling to work at such demanding, high-concentration labor for such a low income. And this point of view is not limited alone to textile artists; it is a common problem with all hand-craft workers in today's industrial world.

We have no accurate knowledge of how long it took to weave a given fabric in earlier years, but it could not have been markedly different from today. A belt will take about two day's labor, and a blanket or rug can take a month or more; one of the finely-woven Two Gray Hills textiles can easily require a year or more to complete. Such investments of time

Tapestry weave mat; goat hair and sheep wool. Used as a cushion or saddle pad. Navajo; Arizona. ca. 1950. 28½ × 26 inches. Paul Schmolke photo, Maxwell Museum of Anthropology.

make it very clear why weaving is not more popular; even the amount of income received by the best weavers today do not make the craft an attractive full-time occupation, in economic terms. There must be added values, either in terms of spare-time fill-in activity, individual aspiration, or a prestige factor, to attract the contemporary weaver.

And these do exist. The fact that this is, by and large, a spare-time craft accounts for much of the interest, since a weaver can use her skills in an income-producing activity during those hours she might otherwise have

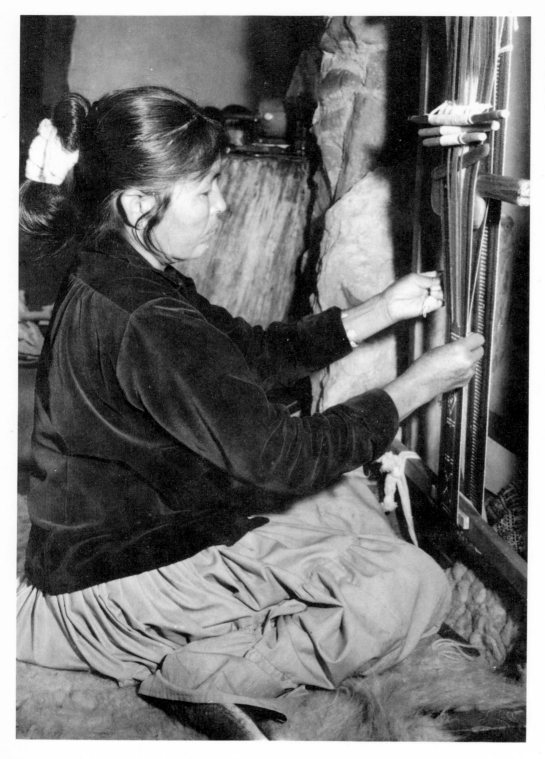

little to do. She also has a relatively high degree of freedom to leave the loom when she wishes, for whatever other demands or concerns as may arise. And lastly, public recognition has been awarded some of the most talented artists, including Daisy Taugelchee, perhaps the most publicized Navajo weaver, Sadie Curtis, Mary Long, and Maggie Price, to name only

a few of those whose names have become most familiar to collectors today. This recognition and the perquisites which accompany it has had a measurable effect upon all weavers, attracting younger women and certainly giving dignity to the individual artist.

In the eastern part of the United States weaving seems never to have reached the economic importance it has had in the Southwest, in part perhaps because it never enjoyed as great a role in White trade. Sheep were never commonly herded by Indian people east of the Mississippi River; most of the wool industry was a completely White-dominated business, largely as the result of influences brought over from Europe. Such woolen weaving as is known was a marginal activity, produced almost entirely for local consumption.

The Cherokee people were perhaps the most active weavers, and there is some evidence that they had developed a loom in prehistoric times, although the record is not clear as to the type. However, very shortly after the arrival of the first White settlers in the Southeast, the English loom was brought in, and a quasi-European craft developed among the Indians. It is true that Cherokee designs were maintained as much as was possible, but they were never entirely free from outside influences.

The development of the Qualla Arts and Crafts Coöperative Guild, originally sponsored by the Indian Arts and Crafts Board, had a strong influence upon the expansion of weaving in the North Carolina region. Primarily a Cherokee activity, it has provided an outlet for many Indian artists in the Southeast, and is a major market for weavers.

In the Northeast, the Huron and Iroquois weavers were subjected to strong influences by the French colonists, who brought the young Indian girls into the convents, where they were exposed to European designs and motifs. This influence is still to be seen today in the craftwork of the region; not only was this true of these two large tribal groups, but it also holds for the Abnaki Confederacy in Maine, which includes the Penobscot, Pennacook, Passamaquoddy, Malecite, and Micmac.

However, none of these textiles seems to have had any major impact upon the economy of the people. It must be said that part of this problem may simply be that we do not know the extent of the trade in these objects, other than the celebrated *ceinture flèche,* which was widely traded throughout the northern Great Lakes-St. Lawrence River region. Probably the lack of any measurable output of blankets, shawls, and other large-size textiles made their importance negligible, since European imports supplied most of this need.

The economy of the Midwest and Great Lakes Indians was likewise relatively unaffected by loom work. Those objects which were turned out by the weaver tended to be primarily used by Indians rather than Europeans, and the demand was therefore more limited. Matting, belts, bandoliers, and sashes were all directed toward native consumers, and the types of textiles which might have attracted White settlers were not produced by these artists. With the exception of small quantities of yarn obtained from traders on occasion, little wool was used by them. Here

again, sheep were unknown; buffalo hair was probably the closest weaving fiber to wool, and cotton was not part of the flora of the region.

In fact, the major region outside of the Southwest where weaving provided an important economic impact was along the Northwest Coast, where the so-called Chilkat blanket held a key position. Widely known and a prized possession of anyone wealthy enough to obtain one, this colorful garment was created in a variety of designs, and had an extremely high value even in the days of its maximum production. Other objects made in the same technique, such as shirts, aprons, leggings, and caps were also in great demand and enjoyed an active market.

In fact, the Chilkat blanket was one of the primary objects of value in the Tlingit native economy. It had a widely recognized value basis, was sought after by all of the Indians in the area, and was easily transported on the long trading journeys common in the early days. It was rivalled only by caribou hides or copper until the White trader changed these priorities with the introduction of guns and their interest in furs. The number of blankets was never large, apparently, since they took up to half a year to weave; one reference gives their value as equivalent to about $30 in purchasing power in the mid-nineteenth century. This was a large sum at that time, and reflects the great respect the Indians had for fine weaving. Rarely, if ever, did a trading party depart from the village without taking a quantity of these blankets with them as "sure fire" trading objects.

The activity of the Salish tribes in the Northwest Coast trade is clearly demonstrated by the important place held by the so-called "Chinook jargon," that indispensable *lingua franca* of the nineteenth century. These people held a monopoly on the interchange of goods in the greater Columbia River region and adjoining coastal area. What is less clear is the specific situation of weaving in that trade. Their mountain goat and dog hair blankets were well-woven, warm, and popular; the colorful "nobility blankets" were treasured — in Salish culture they had the same high value as did the Chilkat weaves to the Tlingit.

The quantity produced may have been smaller, they may have been less familiar to outside traders — or their all-white, coarsely woven quality may have made them desirable in the eyes of people accustomed to the more elaborated Chilkat blankets, but whatever the reason, Salish weaving seems not to have held as prominent a place in trade relations as with the more northerly Tlingit.

Farther south, in California, although there were large groups of civilized natives whose linguistic diversity is remarkable even today, there is left little evidence as to their inter-tribal trade practices. Certainly there is little indication of the role, if any, of textiles in the economy of the people. It would appear that many, if not most, of the more elaborate textiles produced by these people were reserved for ceremonial or religious usage, and were not a part of the tribal trade goods.

5·The Web of the Fabric:
a survey of textile production by region

Any survey of the distribution of Native American textile arts provides, among other things, an interesting review of the migration of the North American Indian. For this reason, perhaps the most useful approach is to examine the sum of all of the foregoing parts of this book *via* the most likely migratory routes from the prehistoric to the more recent past. This process, in effect, brings all the pieces together.

At the outset it must be acknowledged that anthropological theory does not always coincide with the views of the American Indian people as to their own tribal origins. Many of these oral histories sketch a very different pattern of migration and expansion. We do not wish to ignore these, for such accounts are not to be set aside as inaccurate; they may in time prove to be of far greater significance than is now realized.

But the only direct evidence currently at hand is that of the archeological remains which have been recovered, and one feels more secure in relying upon these for support. Therefore, starting with the Northwest Coast as the bridge from Asia, and following currently accepted academic hypothesis of the early movement of man into the New World, one would proceed in a southerly direction as these people worked their way slowly throughout the continent, settling in scattered areas. There were undoubtedly parallel movements of people going on in many regions, accompanied by greater or lesser developments of technological skills. Some of these may or may not have included the weaving arts.

The migration of people was not limited by these technological developments, although they may have influenced the ease of their movement. Many groups flowed out to occupy given areas of attractive land; others left their earlier settled sections as crops failed, and still others fled the approach of incoming tribes. Some moved south, and others, east; a few even reversed the major trend, turning back north after having settled for a while in the south. In fact, there seems to have been major movements of people going on in many directions throughout the entire prehistoric era. Our interest in weaving development as it accompanied this migration has no direct bearing upon the cultural or chronological level of these migrants; it was one of but many skills which developed, and is considered purely for the convenience of this volume.

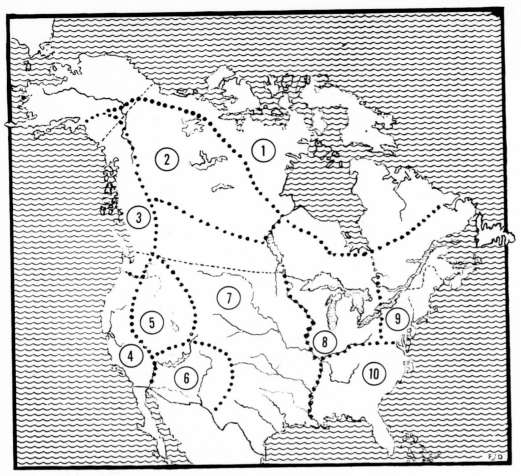

Map of tribal locations (As mentioned in the text)

(1) Arctic Eskimo. *Not considered.* (2) Sub-Arctic Indian. *Chipewyan, Cree, Kutchin, Naskapi.* (3) Northwest Coast. *Haida, Kwakiutl, Tlingit, Tsimshian;* Salish: *Cowichan, Lillooet, Stalo.* (4) California. *Chumash, Diegueno, Hupa, Karok, Kawia, Maidu, Mohave, Pomo, Washo, Yuma, Yurok.* (5) Basin-Plateau. *Nez Percé, Paiute, Ute.* (6) Southwest. *Apache, Cócopa, Maricopa, Navajo, Pápago, Pima.* Pueblo: *Ácoma, Hopi, Jémez, Laguna, Zuni.* (7) Great Plains. Northern: *Blackfoot, Cheyenne, Sioux;* Central: *Osage, Oto.* Southern: *Caddo, Comanche, Kiowa, Wichita.* (8) Midwest-Great Lakes. *Chippewa, Fox, Iowa, Kickapoo, Menomini, Potawatomi, Sauk, Winnebago, Mahican/Stockbridge.* (9) Northeast-Eastern Woodlands. *Delaware, Huron, Iroquois, Malecite, Micmac, Naskapi.* (10) Southeast. *Alibamu, Cherokee, Choctaw, Creek, Houma, Koasati, Pamunkey, Seminole.*

The Northwest Coast

We know almost nothing of the prehistoric weaving of this region; a natural environment hostile to the preservation of fragile fibers has erased almost all such evidence long ago. But the best known and most advanced textile to be found in the Alaska-British Columbia region in the more recent past is without doubt the famous "Chilkat blanket." Named for a subdivision of the Athapascan-speaking Tlingit tribe which first

*Early blanket with
Raven design, and two
copper tinneh
representations.
Collected before 1832 by
Capt. R. B. Forbes.
Probably Tlingit,
Alaska. L: 67 inches.*
Peabody Museum,
Salem, Mass.

introduced it to the White recorder, this is indeed a remarkable weave. In point of fact, this seems to have been developed first by the Tsimshian people, unrelated to the Tlingit, who occupied the interior area of Alaska, in upland Skeena River country. In time, they became strong enough to push the Tlingit out of the Skeena delta area along the Pacific Coast, established themselves there, and became important traders. Probably the art spread to the neighboring Tlingit *via* trade and intermarriage. These latter people, exhibiting the aggressive adaptation for which all Athapascan people are noted, soon excelled in the art.

These blankets were woven on a suspension or bar loom resembling the letter H: two solid vertical posts which were connected by a horizontal wooden bar set at a desired level comfortable to the weaver. The warp is suspended from this bar in lengths following the convex, fringed form of the blanket. From this arrangement comes the term "warp-weighted loom" by which this technique is commonly known. Since it required six

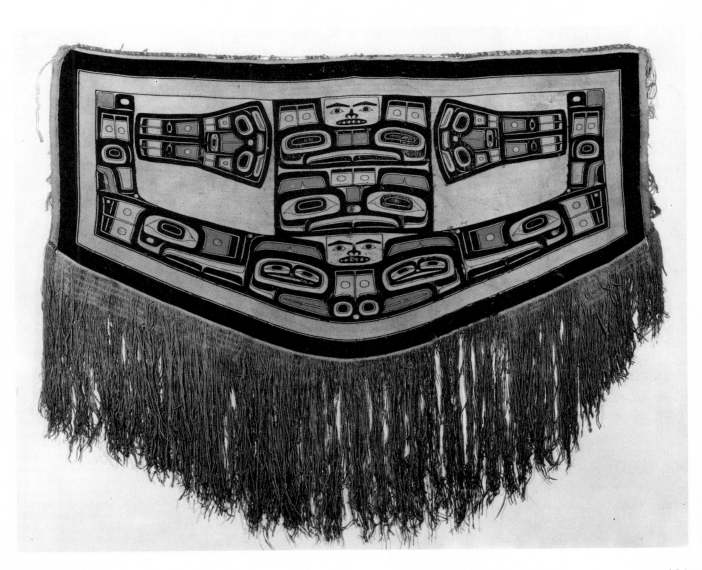

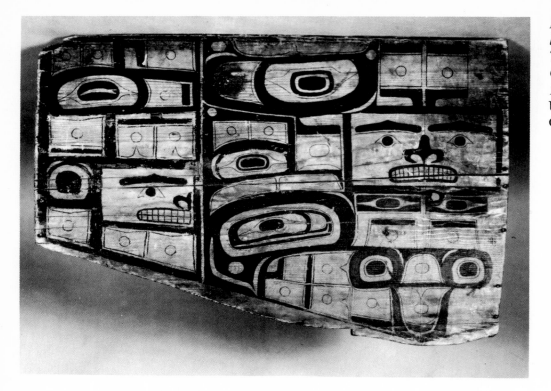

Painted wooden pattern board for a weaver. Tsimshian; British Columbia. ca. *1880-1890. L: 34 inches.* University of British Columbia Museum.

months to a year to complete such a blanket, it is necessary to protect the unwoven warp threads; these are contained in small bags to keep them clean and usable.

The warp threads are two-strand cedar bark, shredded and spun into lengths and wrapped with mountain-goat wool in Z twist. The weaving proceeds in a tapestry-twined technique in which the various section elements are connected in a raised outline which emphasizes the parts of the textile; these outlines are accomplished by rows of three-strand twining. When the design is complete, the long fringe sections which remain are filled out with extra lengths of mountain goat wool yarn; braided borders are added, and various ornamental devices are included at the pleasure of the weaver. This technique allows the elements to be united in a circular form, rather than limited to the more rigid rectangular appearance typical of usual loom weaving.

The designs themselves are derived from traditional forms painted in black on flat wooden pattern boards which were invariably made by the men; they are usually only one-half to one-third of the design, since the blankets are normally bilateral. They became conventionalized into geometric representation of totemic animals and natural forms, of which the bear is perhaps the most common, followed closely by the killer whale. The placement of the various elements in the design includes not only the head, face, and other obvious features, but the vital organs which are arranged in an abstract pattern not unlike a sketch of the animal seen in a flattened out pose. The small oval roundlets are usually

110

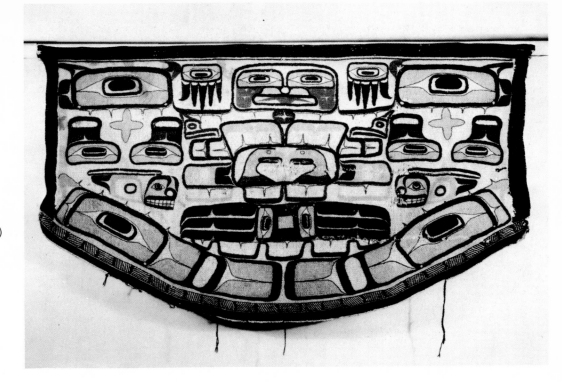

Mountain-goat wool blanket, with designs of a Hawk (or Raven) woven in rounded form. Collected from the Hunt family at Fort Rupert, but Tlingit; Tongass, Alaska. ca. 1900. University of British Columbia Museum.

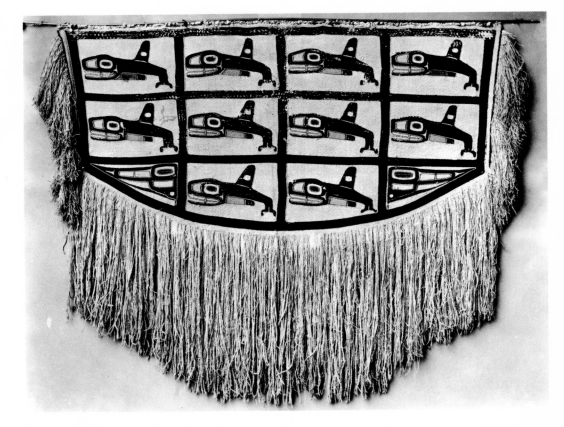

Mountain-goat wool blanket; repeat pattern representing the Killer Whale. Tlingit; Alaska. ca. 1860-1880. 64×54 inches. Field Museum of Natural History, Chicago.

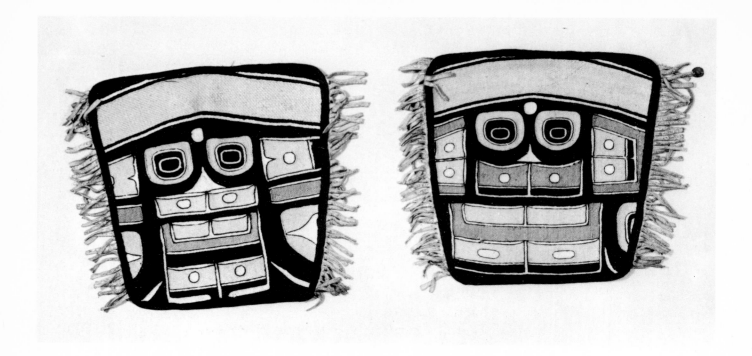

conventionalized representations of the ball-and-socket joints of the knees, wrists, ankles and similar parts. The other designs can be interpreted in many ways, depending entirely upon the intentions of the designer; thus the same textile can, and often is, interpreted quite differently by two equally knowledgeable Indian people.

Colors are traditionally black, yellow, and blue-green on a natural white base. Black, or black-brown, was obtained from hemlock bark; yellow came from a lichen or moss, while blue-green was derived from copper oxide. These were set with urine as a mordant. Later, with the introduction of commercial dyes, a stronger turquoise became available, as did a vibrant yellow or yellow-orange. Occasionally other colors were used by individual weavers, but they never replaced the traditional four basic colors. Sheep's wool was also used for a very short time, but seems not to have enjoyed wide acceptance.

Sizes of these blankets varied with the wealth of the individual, or the purpose for which the textile was produced. Some as large as 72 × 38 inches are known; others, smaller, were more usual, and dance aprons measuring 18 × 38 inches were made to be worn around the waists of the performers; they faithfully duplicate the design styles of the larger blankets, and some scholars feel they were the original forms, with the shoulder cape representing a later elaboration. Woven objects were always valuable property, and when not worn, were carefully rolled up and stored in special containers made from the entrails of a bear, and then placed in carved wooden "treasure boxes." Damaged blankets would be salvaged and small portions made into cuffs, leggings, or other accessories.

Pair of mountain-goat wool dance leggings. Collected from the Haida at Queen Charlotte Islands, but probably made by a Tlingit weaver. ca. *1900-1910. 13×13 inches.* University of British Columbia Museum.

112

One of their more highly regarded features was the long fringes fashioned from intertwined cedar bark and goat wool. Swaying as the dancer performed, it had a somewhat similar effect to that of a Hawaiian dancer's grass skirt; indeed, the native name *naxin*, "body fringe," demonstrates their awareness of this visual quality.

The unique weave of these garments and their ornamentation offers some puzzling questions as to their origin; where these came from is not known, but they do suggest a similarity in design form and arrangement to the appliqué garments of the Ainu of northern Japan. This may simply be a fortuitous coincidence, or there may be a relationship of sorts whose origins lie in the distant past. Some designs were less formalized than others; in the older examples, repeat patterns and geometric designs were common — and one example from an early collection shows two large "coppers" represented, indicating the great value of such garments.

Closely related to the Chilkat weave is the standard blanket of the Salish and Kwakiutl peoples of British Columbia and northern Washington. Woven from mountain sheep or dog hair wool and shredded, twisted cedar bark, these people have developed several types of textiles. They are woven on a unique two-post loom in several different weaves. The most simple arrangement makes use of two upright posts which are connected at the upper end by a single round pole. The warp threads are looped over the pole in much the same fashion as in Chilkat weaving, and the weaver

Standard two-bar loom. Cowichan; Vancouver Is., British Columbia. ca. 1875. L: 13 feet (horizontal bars). Museum of the American Indian.

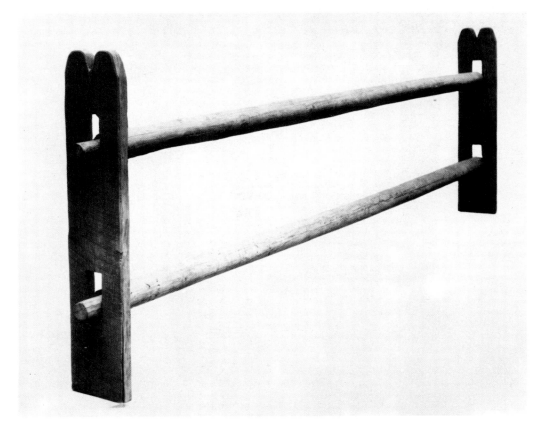

113

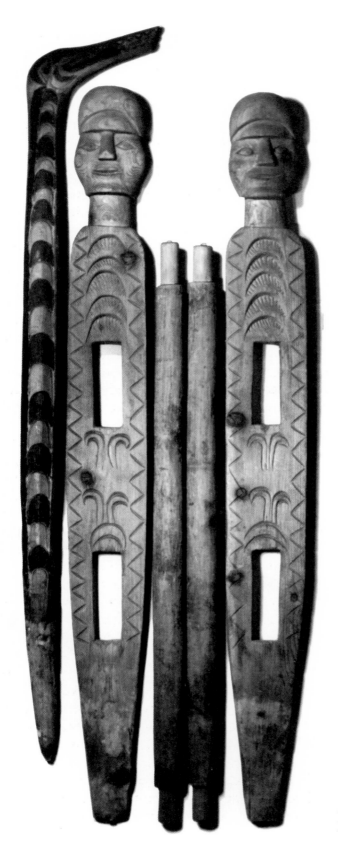

Elaborately carved two-bar loom, with uprights and tension bar. Probably Cowichan, Vancouver Is., British Columbia. ca. 1875. H: 68½ inches (uprights). Museum of the American Indian.

progresses from the top to the bottom in a finger-weaving technique. Mats, rugs, sashes, and tumplines were produced by this method.

A second technique involves two round horizontal poles which are inserted into long slots cut into the vertical posts for the purpose; wedges placed in these slots hold the poles in place, and provide the needed tension. The warp thread is a continuous fiber; wound round and round the two poles, it results in a ring warp. Twilled textiles and the so-called "nobility blankets" were woven on this arrangement.

A third technique includes the placing of a temporary rod or cord between the horizontal poles; the warp is then strung between the two rods and around the central piece in a manner slightly representing the letters M W, in a continuing fiber. When the weaving is completed, the operator can easily remove the textile from the loom by pulling away this center rod, at which point the looped-around fabric is free to fall away from the loom poles. Tension is achieved by rotating the vertical poles.

The textiles produced on Salish looms present a typical appearance by which they can readily be identified. The wool, obtained from the elusive wild goat and mountain sheep (actually a member of the antelope family, *Oreamus americanus*), was cleansed and the coarse outer guard hairs were removed as much as possible. The finer undercoat hairs were beaten to align them, and S spun into long threads. Other fibers were often added to increase the bulk, particularly those of the bear, raccoon, squirrel, or other small animals, down from various birds, and occasionally rush fibers. These were worked onto spindles which were extremely long round wooden rods, often three to four feet in length, balanced with large, carved circular whorls. Depending upon the fineness of the spun threads, the weave — and the finished textile — was more-or-less loosely woven.

The use of dog hair has often been mentioned in connection with Salish weaving, and although we do not know the precise breed of animal involved, there is no doubt that these people domesticated and bred a small white-haired dog especially for its wool. Some authorities have suggested that the breed was related to the pomeranian, or spitz, family. Early European explorers frequently attested to the herds of small dogs which were kept by the Indians, and examination of early textiles reveals canine hairs in the fibers.

Early designs of these blankets were colorful and complex; unfortunately, none have survived from the pre-European period to our knowledge, so that the actual color palette used by prehistoric weavers is not clear. But by inference, plus the few sketches and earliest dated samples, there were three primary types of blankets: the plain diagonal-weave textile, usually intended for everyday use, the twined-weave textile which provided the "nobility blankets," and the twilled-weave which yielded a decorative design. These were plain white with a few bands of contrasting color or complex patterns of the nobility blankets in which geometric combinations in panels were woven.

All of these were woven on the horizontal bar-loom in varying prearranged techniques — and it should be emphasized that this was all

115

*White mountain-goat
wool blanket. Salish;
British Columbia.* ca.
1890. University of
British Columbia
Museum.

finger work. The Salish people did not use a heddle or batten.

After the textile was completed, the white blankets were whitened with clay and beaten to clean them, and also to give them a stiffened, fresh appearance. This beating was accomplished by a carved wooden instrument resembling a saber. With the introduction of European materials, sheep wool was used by a few weavers, but apparently not widely, and commercial dyestuffs were also introduced, with only limited success. English trade cloth was raveled and re-spun, or on occasion torn into small strips which were woven into the fabric. Tumplines (or forehead bands to assist carrying backpacks, as a baby carrier) and belts were frequently produced for women's use, often with the use of commercial cording for the warp threads.

Since many of the blankets were used as a shroud, or funerary gift, and buried with the body, few of these textiles have survived, and with the passage of time, the weavers themselves declined in numbers to a point

where the continuum of the art was threatened. In the early 1960s, Oliver N. Wells, a resident of Sardis, British Columbia, encouraged some of the local Salish women to produce textiles which could be sold, and thereby earn for themselves cash income. The project has proven successful, and today there are several skilled weavers who regularly supply various blankets and garments for the market. Exerting his influence only in the direction of quality and craft survival, he made no effort to direct design, and as a result, the revival has been healthy as well as profitable for the weavers.

The range of weaving includes blankets, robes and mats, colorful bed covers, wall hangings, and similar large-sized textiles, as well as chair covers, small pillow tops, saddle pads, and other useful products. These are decorated in the colors typical of the regular weaves — black, brown, orange, and yellow — with some recent additions, including red, green, and pink. All of these are obtained from vegetal coloring, using mineral mordants. The Canadian Government has recognized this project, and working through the Chilliwack Arts Council, has provided support and exhibitions to promote the success of the revival effort.

In addition to the various animal-hair textiles referred to previously, there was a modest but important area of painted textile art produced by these people. Originating perhaps from an earlier technique of painting designs upon caribou, walrus, deer, or elk hides, the custom spread to the decoration of woven cedar bark or cloth. Shoulder cloaks were painted with totemic designs by most of the people of the region; usually in black

Detail of dog hair weaving; nobility blanket. Salish; British Columbia. ca. 1875. Area: 18 inches. Museum of the American Indian.

and red, commercial colors were later obtained, and today one finds the use of orange, black, green, and red dominant. Another common garment was the conical cape also painted with totemic designs.

A more impressive painted textile was the large ceremonial screen found in many Kwakiutl dance houses. These were used to separate the audience from the performers in the religious pageants for which these people were noted. A dancer, masked and in costume, would dramatically appear from behind the screen, perform, and just as magically vanish again behind it. The large size, graphic black-and-white design, and symbolic significance combined to produce a powerful effect upon the spectators.

Bearing in mind the large cedar-bark mat sails woven by these people for their sea-going vessels, it seems probable that the earlier ceremonial screens were woven of this material, painted, and installed in the houses. But with the coming of European whaling vessels, sail canvas was quickly put to good use, and eventually other woven fabrics. Whatever the basic material, the ingenuity of the Indian was readily equal to the task of making the best use of whatever resource was provided by nature or fortuitous circumstance.

Opposite

Painted cotton dance screen, or ceremonial curtain; with design of the two-headed Sisiutl and a human figure. Kwakiutl; Kingscombe Inlet, British Columbia. ca. 1925-1950. W: 10 feet. University of British Columbia Museum.

Basketry baby carrier with woven wool carrying band (tumpline). Lillooet; British Columbia. ca. 1875-1900. 9½ ×26 inches (basket). Museum of the American Indian.

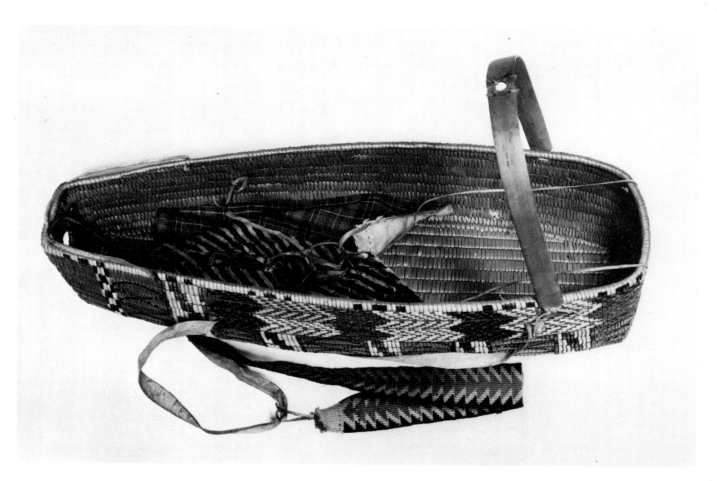

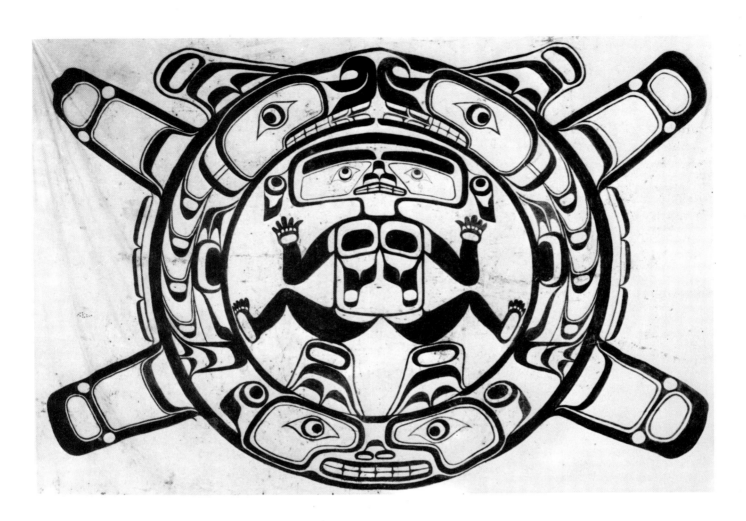

Western Canada

In the neighboring region of western Canada, the Athapascan people produced a variety of finger-woven textiles, primarily open-work netting and interlooped weaving, to manufacture fish bags, storage containers, food pouches, tumplines, and other weaves. The Loucheaux, Kutchin, Hare, Slave, and related tribes of the Northwest Territories region produced these in large quantities; today they have been supplanted by commercial metal or cloth containers. These early textiles were decorated by porcupine quilling, close-weave banding, and the occasional use of colorful trade beads, particularly the bright blue "Russian trade beads" which were so popular in the Northwest. Some amount of embroidery is also often added as a decorative element.

Belts, straps, and other forms of banded weaving are commonly seen in collections, although most of these have given way today to commercial belting. These were tightly woven bands, usually about three inches in width, with geometrical designs running lengthwise; occasionally they were decorated in checks or bands woven crosswise. Fringes were frequently warp selvedge allowed to swing free, or attached, separate

strands of native plant fibers or thin strips of hide. These, in turn, were often decorated with beading, quilling, or any combination of colored materials.

But the most remarkable examples of weaving from this region are produced on a bow loom. This simple device consists of a single curved branch or stick with several strands of warp thread stretched from one end to the other, the number depending upon the width desired. Birchbark or wooden spreaders at each end keep the warp taut and straight. The weaving is accomplished by interlacing the weft threads (in this instance small split bird quills, or occasionally porcupine quills) perpendicularly across the warp. When completed, the woven band is detached from the loom and is ready for attachment to the desired surface.

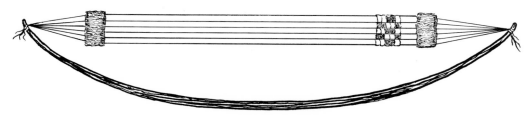

A bow loom; a mobile loom made from a stick, branch, or rod. Warp threads are strung from one end to the other to provide the proper tension, then the weft strands are interlaced as desired. Birchbark spreaders retain the necessary spacing. Northwestern Canada. L: 24 inches.

The finished bands are astonishing examples of a *tour de force* of fine detail and technical perfection. The minute quills, carefully dyed and split, and the tight weaving which gives the strong geometric pattern, provide a triumph of patience and skill.

The strips are usually executed in lengths of from six to twenty-four inches, and from one to eight inches in width. They are fastened in an appliqué technique to the hide or cloth surfaces of pouches, sleeves, leggings, armbands, or headbands as decoration. Although created by several tribes in the sub-Arctic area, the Nahane, Chipewyan, and related Athapascan tribes of the Great Slave Lake region produce the most sophisticated examples.

Out on the Canadian Plains, the tribes roaming this vast area were apparently never major practitioners of the weaving arts. The Siksika and Kainah (more commonly known as Blackfoot) may have used buffalo hair to some extent in earlier days, but with their adoption of the horse, and expansion out onto the Plains, hide containers soon supplanted any weaving that may have been practiced. Aside from an occasional old medicine bag or pouch — which may, or may not be Blackfoot made — almost nothing is known of the type of fabric once existing in the area.

The neighboring Cree made great use of cloth, decorating this with elaborately embroidered floral designs. Many of these were further

120

ornamented with beadwork, but almost all of the examples known date to a time after the entry of the European explorers; therefore, the evidence supports no feeling of certainty concerning the existence of native weaving by these Algonquian-speaking folk. An equally knotty problem lies in the designs themselves: there seems to be little doubt that these elaborate floral motifs have been heavily influenced, if not actually introduced, by the early European colonists. The missionaries instructed the young Indian girls in convent classes, where art motifs naturally reflected the floral designs so popular in Europe at the time.

But the bulk of Cree textile use was not native made; it developed from the very early entry of the Hudson's Bay Company traders into the western country, the introduction of trade cloth, and its immediate adoption by the Indians as a highly prized commodity. This trade cloth is the fabric upon which almost all of the garments, containers, and textile wrappings are made.

California

Apocynum fiber headband, decorated with red-headed woodpecker feathers interwoven into the textile, with shell ornaments. Pomo; California. ca. 1890. 8×20 inches. Museum of the American Indian.

Further to the south, a great area of body decoration was developed by the tribes of northern California. The benign climate made heavy clothing and coverings unnecessary, and most of the early fabrics were also relatively loosely woven. The basic technique was finger weaving, although some became remarkably complex. Color was no problem; there were plant resources available for dye, and more particularly, the inclusion of brilliant bird plumage into the weave. Most notable are the headbands, tumplines, and belting woven of hemp fibers and decorated with shell beads or feathers, introduced as the weavers proceed. These are

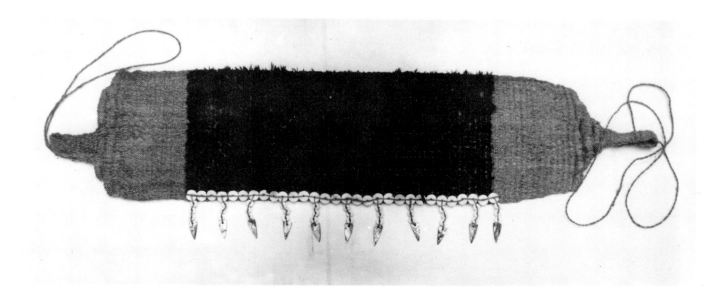

found among the Yurok, Karok, Hupa, and Pomo, who have created these objects and made them true works of art. The string-net woven hair ornaments of the Yokuts were painted in bright colors, or occasionally colored by secondary weaving and decorated with feathers. These were worn on the head and allowed to hang down over the back of the wearer. Heavy tightly woven headdresses, consisting of bands worn over the forehead and fastened in the back, were interwoven with flicker or woodpecker feathers, providing a brilliantly colored ornament.

But most colorful of all were the large woven hemp belts or body sashes, which were also decorated with thousands of feathers. They were similar in form to the headbands and were woven by the Pomo, Hupa, Yokuts, and Maidu men, who used them in ceremonies intended to ward off evil. The Pomo particularly believed these belts to be possessed of great magic power. Much of this artistry is closely connected in technique to the feather decorated basketry of the same tribes. There are some bead-and-shell-decorated dresses which suggest a possible relationship to weaving, but those known today are all of deer or elk hide, and lack any indication of actual weaving.

In the southern part of the state, the Kawia and Diegueño made extensive use of knotting, preparing elaborately feathered skirts of twisted cedar, finger woven with an open loose-weave design. There was also a widespread use of twisted rabbit fur to provide warm sleeping blankets similar to, and perhaps influenced by, the rabbitskin robes of the Paiute and the Hopi people.

Feather cape woven of hemp and duck feathers. Maidu; California. ca. *1800-1830. 50×52 inches.* American Museum of Natural History.

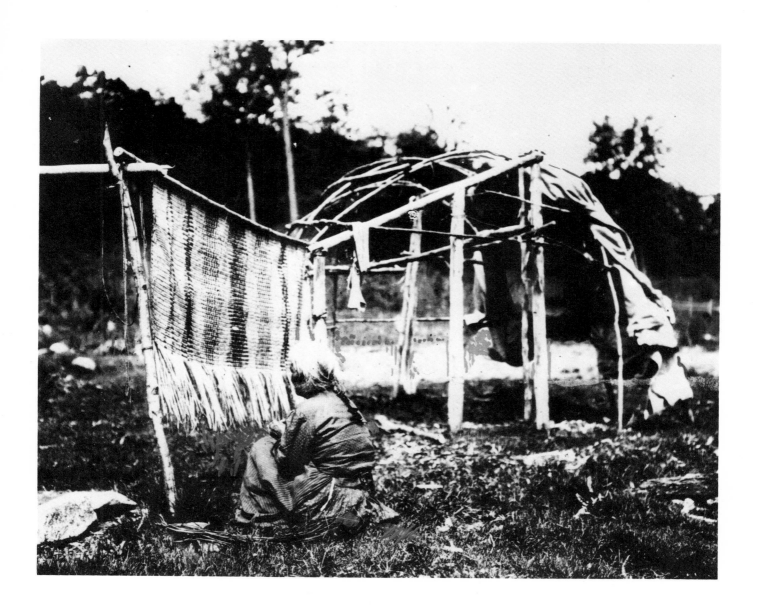

Mat weaver using suspension, or drop loom. Menomini, 1909. James Bay, Ontario. American Museum of Natural History.

Little else remains today of the weaving which one assumes once existed in California; tantalizing hints in the fragments found in caves and archeological sites of the state, as well as the colorful pictographs showing costumed people, make the viewer believe that here was once a vibrant art no longer practised today. The savage annihilation of the large population of Indian people which once inhabited the state was accompanied by an equally ruthless destruction of their material culture, as villages were destroyed and their contents burned, leaving almost nothing preserved — even by curio collectors of the Gold Rush era.

And it must be recognized that no small amount of this loss is due to the Indian people themselves, in observing their own funerary customs. Uncounted numbers of beautifully woven and decorated "gift baskets," costumes, and ornaments were burned in cremation ceremonies. This practice was widespread throughout the entire California area.

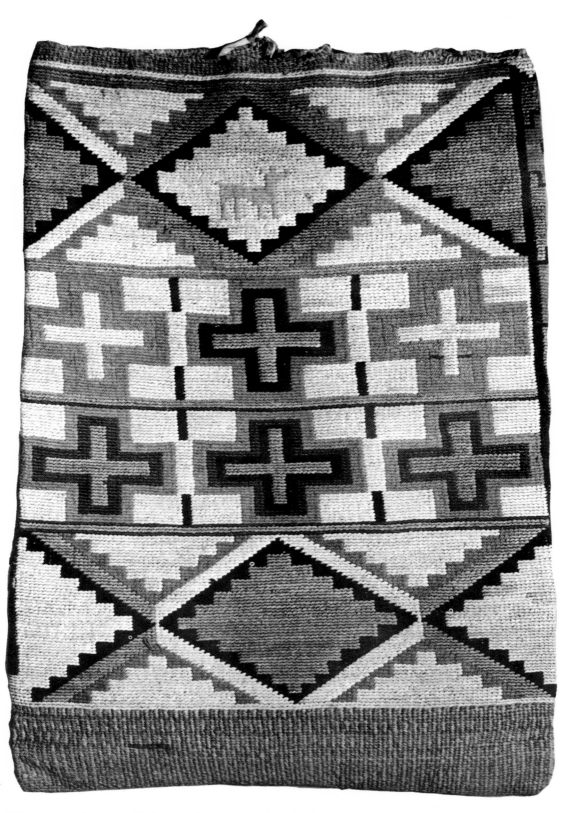

Woven cornhusk "sally bag", showing variety in design of the two sides of the same container. Nez Percé; Idaho. ca. 1890-1910. 16×23½ inches. Museum of the American Indian. (See opposite).

124

Basin-Plateau

In what is Idaho, Nevada, and eastern Washington today, prehistoric evidence reveals a long history of the use of Indian hemp, ryegrass, and squawgrass in the manufacture of the wallet-type "sally bags" so familar from the present-day Nez Percé, Yakima, Umatilla and related tribes who inhabit this region. However, although these demonstrate a textile-like appearance, and are indeed woven throughout, they do not employ a loom in their manufacture, but are entirely finger woven. They may therefore be regarded more as a form of basketry rather than textile weaving, even though the completed fabric has more of a pliable texture than does most basketry. They, like some of the cedar-bark and rush matting known to many of the native people, constitute one of the most difficult textures to catalogue; they can be called either weaving or basketry, depending in part upon the criteria one employs.

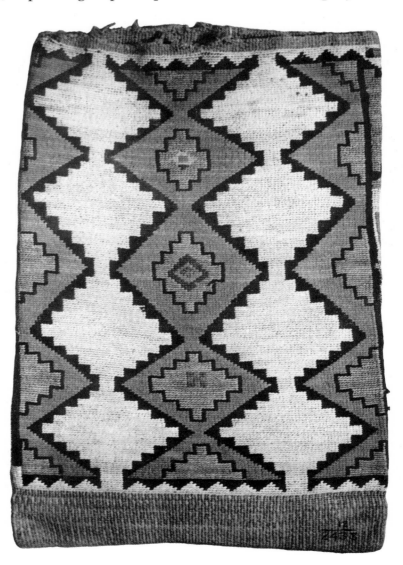

The earlier examples were all hemp, but with the entry of European settlers and the restriction of the once-nomadic Indian to sedentary reservation life, corn became a staple food crop, and cornhusks were worked into fibers which replaced hemp — particularly as the Whites forced the Indians away from the areas where it was once commonly available. Another change has been in the warp; today cotton cording has almost entirely replaced the older hemp or ryegrass.

These are strong containers used for the storage and transportation of almost everything the Indian used. They are woven in many sizes, from small hand-size pouches to quite large storage wallets. The designs are geometric, and in earlier days offered soft colorful contrasts, obtained from vegetal dyes; more recently, aniline dyes provide a more pronounced palette. One interesting feature of these bags is the differing design on each side: almost never are these designs the same on both sides of the wallets, in contrast to the usual bisymmetrical appearance of most Indian art.

These wallets are generally so constructed that they expand with use, many allowing the owner to contain a large amount of foodstuffs in such a bag. Others are simple envelopes without the expanding feature but of sufficient strength to hold a great variety of heavyweight objects safely. Many were cylindrical, occasionally with a rawhide bottom to give greater strength. The technique employed to manufacture these bags is a simple twining weave with separate warps and paired wefts twined horizontally across the fabric of the bag, front and back. Decoration is achieved by the use of colored strands (sometimes commercial yarn is used) added in a false embroidery technique; this is accomplished during the weaving process by wrapping a strand of the colored yarn around the outer weft as it crosses over the warp. Since the yarn does not pass behind the warp, only the ends are visible on the inside of the weave. The bottom is strengthened by the use of heavier cording interwoven on the lower two or three inches, and commonly a cloth or rawhide strip is included around the top of the bag; sometimes rawhide thongs or drawstrings are used to act as closing cords.

Sketches were never used in the designs of sally-bags; they were simply woven in regular fashion, with the elements of the design carried in the weaver's head, and executed as the weft proceeded. Other products of this technique by the Basin-Plateau tribes were conical hats, worn by the women (and some men), brightly colored with vegetal dyes, and often further embellished by the addition of beadwork.

To the south, in Nevada and eastern California, the Paiute people made use of twisted rabbit fur to weave soft, warm robes and sleeping blankets. They were made in the same technique as Hopi rabbit-fur robes, and were traded far and wide over the western region. These were not decorated in any way; their soft, furry appearance giving them a rich sheen in direct proportion to the color of the rabbit fur itself.

Man with a rabbit-fur blanket. Mohave; California. ca. *1910.* Southwest Museum.

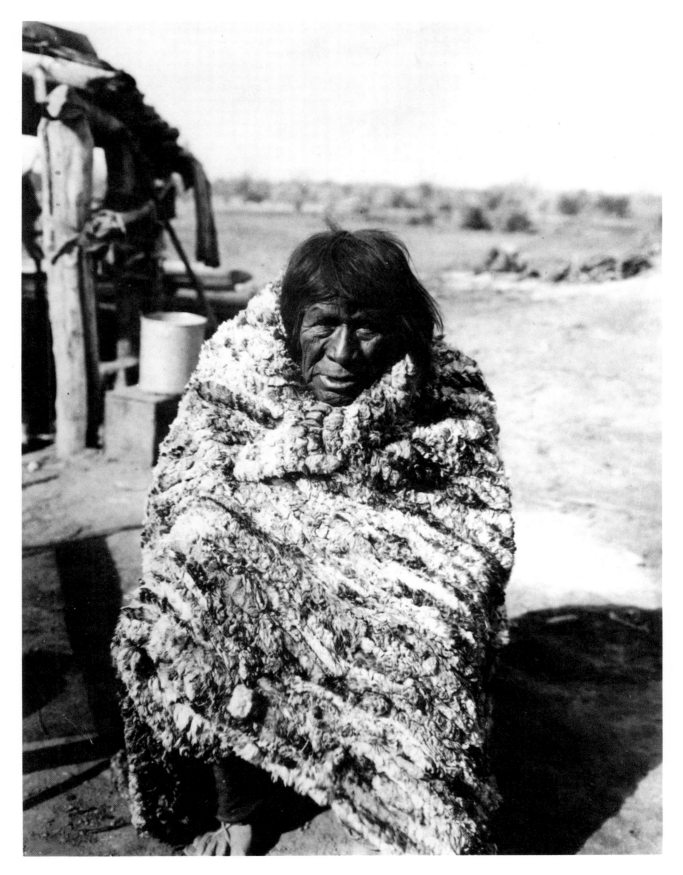

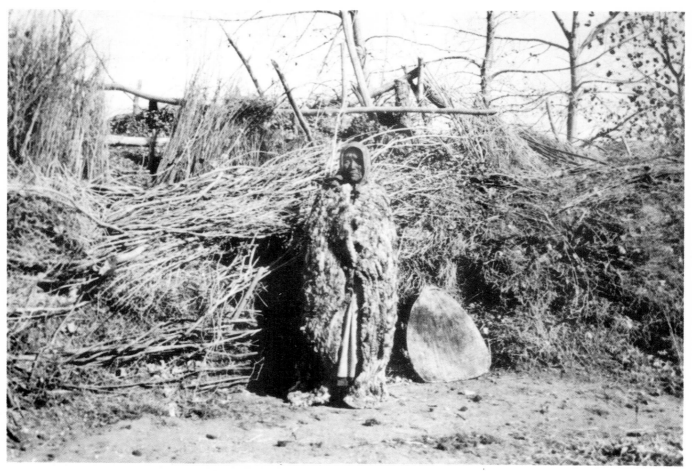

Woman wearing a rabbit-fur blanket, outside her brush dwelling. Paviotso Paiute; Stillwater, Nevada. ca. 1924. M. R. Harrington photo, Museum of the American Indian.

The Great Plains

From the Canadian border to Oklahoma, and Colorado to the Mississippi River, the Indian tribes roaming the Plains country rarely became active practitioners of the weaving arts. While there is little doubt that those tribes who migrated from the Great Lakes may have been familiar with many finger-weaving techniques, in common with their neighbors in that area today, they seem not to have taken these skills with them out onto the Plains country when they were driven west by their enemies.

And after their acquisition of the horse, their life style changed so radically that sedentary weaving activities were no longer practical. The great bison herds became a staple of life and provided the source for clothing, coverings for dwellings, and the raw materials for robes and containers — in short, essentially everything needed in their mobile life. It is true that buffalo hair was used, particularly in the manufacture of cordage and some containers; but this was apparently only in limited

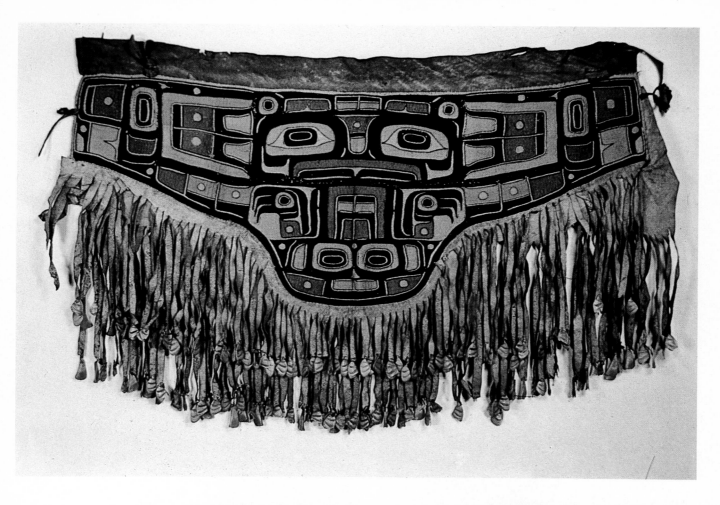

33 Mountain-goat wool dance apron with puffin-beak fringe. Tlingit, Alaska. ca. *1890.* Museum of the American Indian.

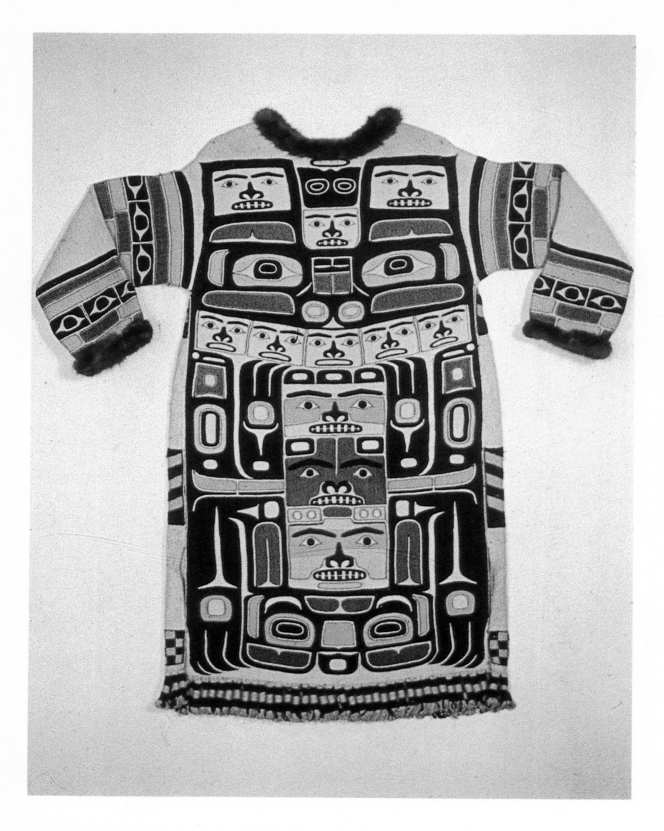

34 Mountain-goat wool shirt, with otter fur trim. Tlingit, Alaska. ca. 1850-1875.
Museum of the American Indian.

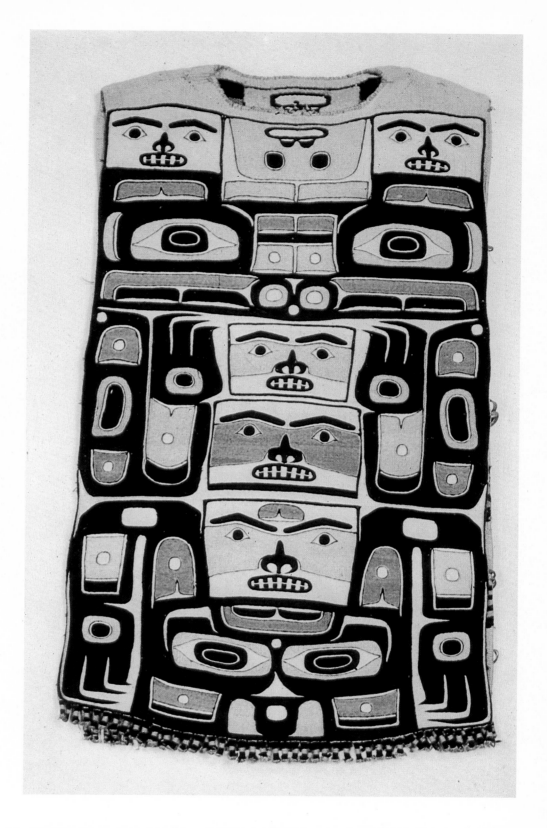

35 Mountain-goat wool shirt. Tlingit, Alaska. ca. *1850-1875.* Museum of the
American Indian.

36 Carrying basket with woven wool tumpline. Salish, British Columbia. ca. *1875.*
Museum of the American Indian.

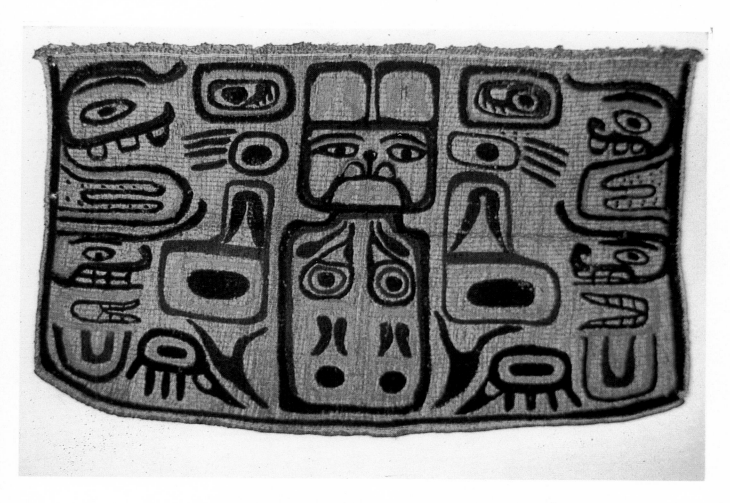

*37 Woven cedar-bark blanket, with a painted design of the Brown Bear. Kwakiutl;
British Columbia.* ca. *1900-1910.* Museum of the American Indian.

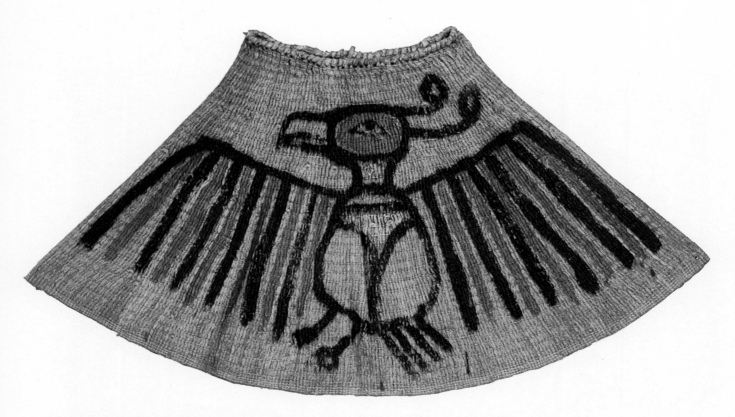

*38 Woven cedar-bark cape, with painted design of the Eagle. Kwakiutl; Kitimat,
British Columbia. ca. 1900-1910.* Museum of the American Indian.

Opposite

*39 Elkskin pouch, with woven quill appliqué decoration. Chipewyan; Lake Atha-
basca. Northwest Territories, Canada. ca. 1850-1875. L: 10 1½ inches.* Museum of
the American Indian.

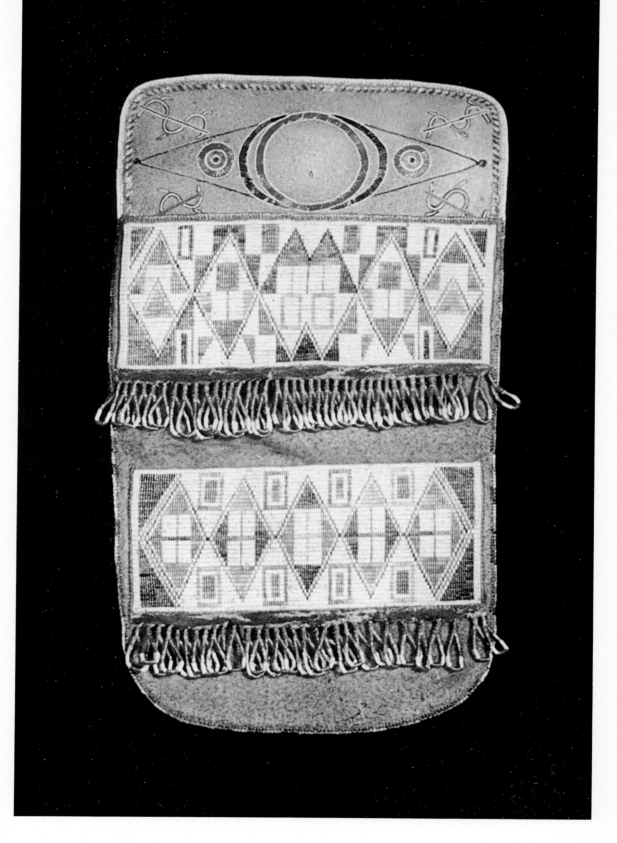

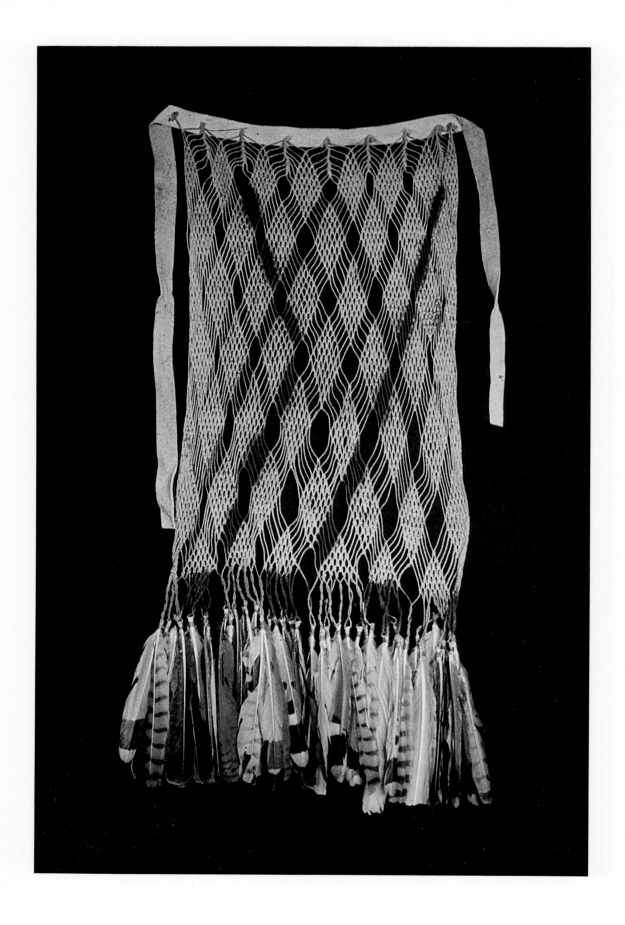

Opposite

40 *Knotted net headdress
on buckskin band; feather
fringe. Karok, California.
ca. 1900-1910. 10×32 in-
ches.* Museum of the Amer-
ican Indian.

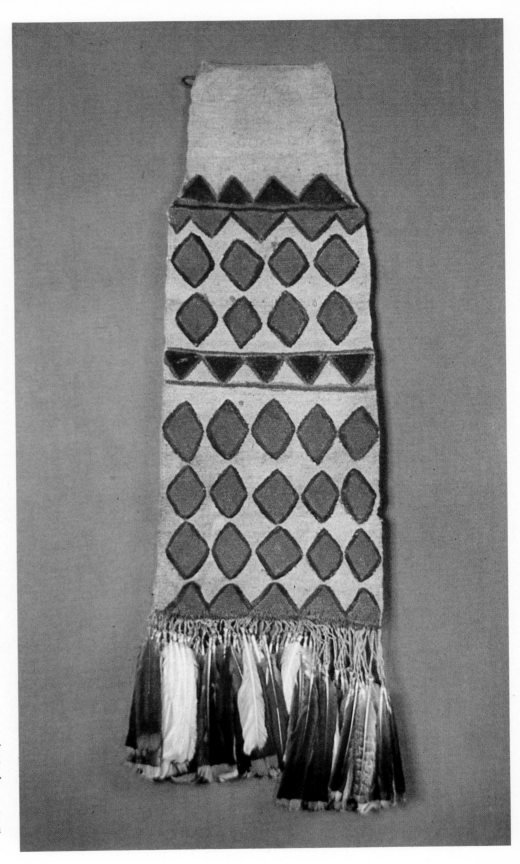

41 *Woven milkweed fiber
ceremonial headdress with
painted decoration. Feather
fringe. Karok, California.
ca. 1900. 10×36 inches.* Mu-
seum of the American
Indian.

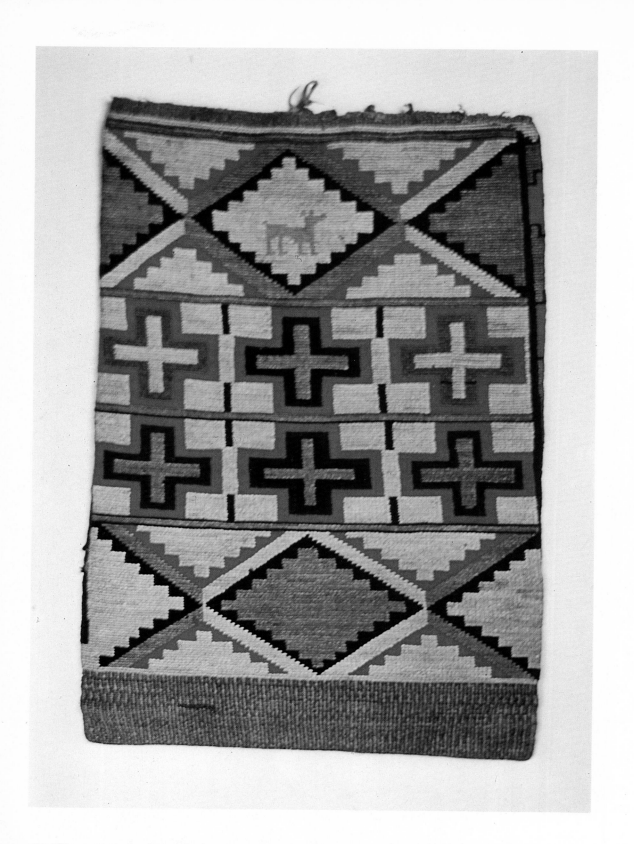

42 *Woven cornhusk "sally bag." Nez Percé, Idaho. ca. 1890-1910. 16×23½ inches.*
Museum of the American Indian.

43 Woven cornhusk "sally bag" or twined wallet. Nez Percé, Idaho. ca. 1900-1930. 14×22 Inches. Museum of the American Indian.

44 *Woman's twine-weave hat; vegetal-dyed cornhusk fibers. Nez Percé, Idaho.* ca. *1900. 7½ inches.* Museum of the American Indian.

Opposite

45 *Early pictorial design wool blanket. Navajo, New Mexico.* ca. *1900. 36×50 inches.* Museum of the American Indian.

46 *Modern Yei design rug. Navajo; Greasewood Springs, Arizona. ca. 1930-1940.*
140×68 inches. William D. Harmsen Collection.

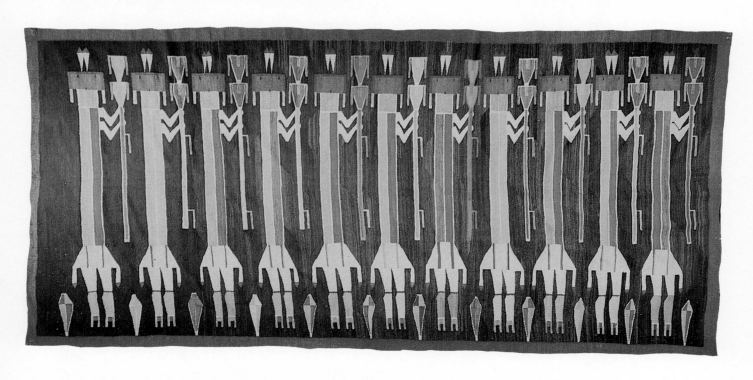

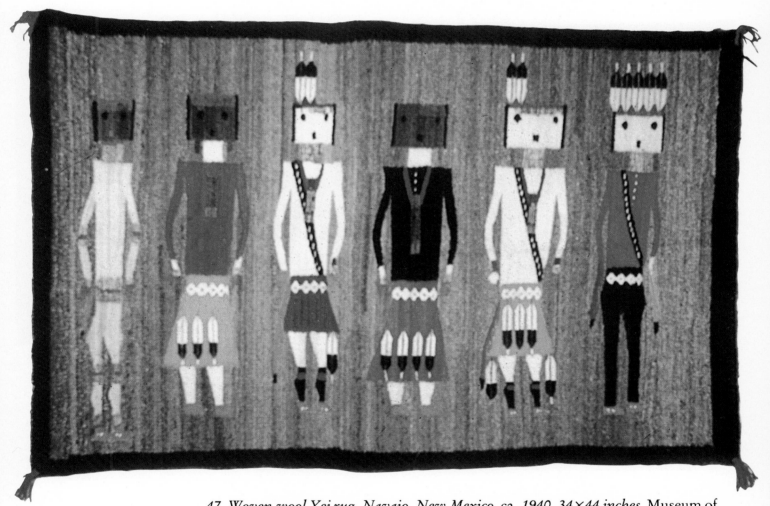

47 *Woven wool Yei rug. Navajo, New Mexico.* ca. *1940. 34×44 inches.* Museum of
the American Indian.

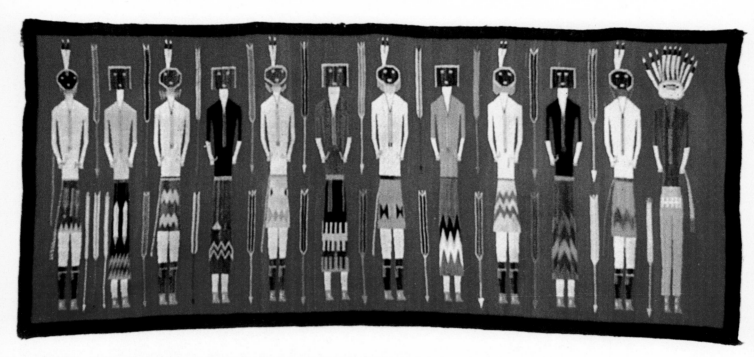

*48 Wool floor runner with twelve Yei figures. Navajo, New Mexico. ca. 1950.
38×78 inches.* Museum of the American Indian.

quantities. Certainly there seems no evidence of a major textile development in the Northern Plains area.

The Central and Southern Plains tribes seem to have retained more of the weaving arts than did their northern neighbors — or at least they made greater use of weaving. Yarn bags, which were substituted for the earlier buffalo-hair medicine pouches, were particularly common among the Oto, Pawnee, Osage, Kansa, and Omaha. During the tragic period of the removal of the Indian tribes from their homes in the East, many who lived in the Great Lakes area were resettled in the Central Plains, including the Winnebago, Potawatomi, Kickapoo, Sauk, Oto, and several other remnant groups. They brought the knowledge of sash weaving with them, even though not in the quantity of production so characteristic of their earlier life. Today, only a few women still weave yarn bags; more continue to weave sashes, and a few have become mildly interested in undertaking more extensive types of weaving. But while these people tend to follow the same old time technique, they employ modern cordage, particularly commercial cotton twine.

The Comanche, Kiowa, Caddo, Creek, Cherokee, and Wichita peoples, also removed from their earlier homes, have carried few weaving skills with them in their move to the Southern Plains. Those Indians, such as the Comanche and Kiowa, who wandered the area in earlier times, apparently preferred to utilize the bison resources in the same way as did their Northern Plains kindred; this is equally true of the Wichita and Caddo. No other weaving is traceable to the Plains area in historic times, and there seems to have been no carry-over from the remarkable prehistoric skills demonstrated in Oklahoma at the Spiro Mound site. If there ever was such a continuum, it was lost in the traumatic displacement of the Indian following the entry of the White man into the central-southern region.

One interesting aspect of Plains cultural relations is the important place of the Navajo blanket in the commerce of that region during the early nineteenth century. Indeed, some of the finest examples known of mid-century Navajo weaving were collected among the Ute, Blackfoot, Sioux, and Cheyenne tribes — a clear indication of the high regard which these people had for good textiles, as well as a commentary upon the wide range of inter-tribal trade. Most of these blankets were acquired in the trade for horses or hides during the regular visits of the Plains Indians to Taos and Santa Fe.

The Southwest

It must be realized that there were other fine weavers in the Southwest besides the Navajo and Pueblo people. At one time, according to reports of early explorers, the Pima (and, apparently less actively, the Pápago) produced tremendous numbers of finely woven cotton blankets. They

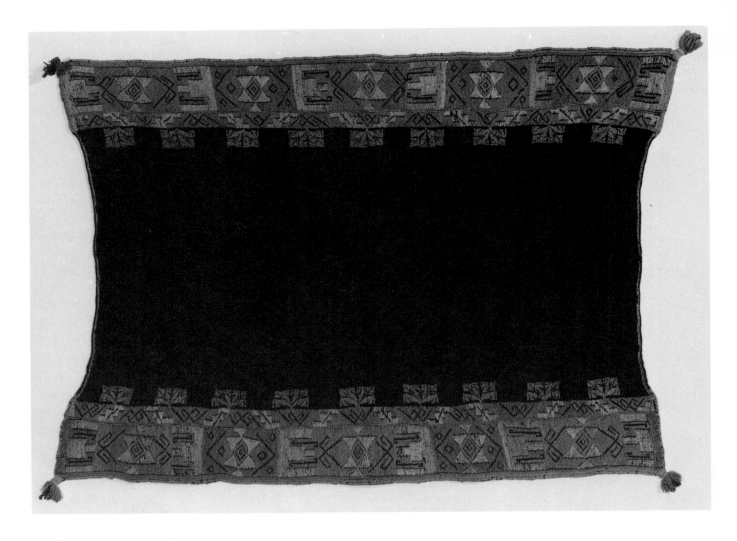

grew cotton for the purpose, and their completed textile products were in demand over a wide area. These were not small textiles; they measured up to 60×60 inches, and were so numerous that they were to be seen everywhere.

The Pima, a relatively large population at the time, wove these for personal use and for trade — the quality of their white cotton blankets was such that they enjoyed wide popularity in the marketplace. Yet it is astonishing to note that apparently only three complete examples have survived in museum collections today.

How does such a popular, widely known and sought after object disappear so completely? There must literally have been thousands of these fine weaves in the mid-1800s — a time, it should be remembered, when there were fairly large numbers of explorers, Army men, miners, and settlers traveling through the Southwest. To have vanished so thoroughly seems impossible, for they were no more nor less numerous than Navajo blankets of the same period, and of these latter there are several hundred or more extant in collections throughout the country. Probably, if one can hazard the guess, their very plainness led to their

Embroidered wool manta; red and black. Ácoma; New Mexico. ca. *1850-1875. 36×38 inches.* Denver Art Museum.

disappearance: many were used for packing or wrapping shipments of cargoes back to the Midwest and East and once they arrived were not recognized as being of special "Indian" interest. That they were relatively undecorated also meant that they were not highly regarded by the Eastern traveler occasionally going into the Pima area who were more concerned with Indian Art (a concept with heavy overtones of "symbolic design" content). Thus, they were casually treated and ultimately discarded.

The neighboring Pápago, Cócopa, and Maricopa people also wove; but here again, and perhaps for the same reasons, only a few of their examples have survived. Most of them are belting, straps, and similar banding materials often found on baby carriers and similar functional objects. These are simple finger weave or backstrap loom products, usually black and white or occasionally indigo and white, and so similar that it is difficult to distinguish between a Cócopa, Maricopa, or Pápago band.

The Pima also wove a variety of beautiful belts, usually indigo, red, and white, on a backstrap loom with a distinctive design. The latter is so similar to design elements of the Cora, Tarahumara, and Huichol belts that one would feel a definite relationships between the several textiles, and perhaps more distantly the Hopi.

Yuma and Mohave weaving is known only through belting and strap work produced by means of the backstrap loom. That it was a common technique is amply demonstrated by the examples which have survived, although these, too, are rare. They tend to be black and white, or indigo and white with a simple cross-weave pattern.

Right

Cotton belting; indigo and white-twined weave. $2\frac{1}{2} \times 70$ inches. Cócopa, Mohave (and right) Pima. American Museum of Natural History.

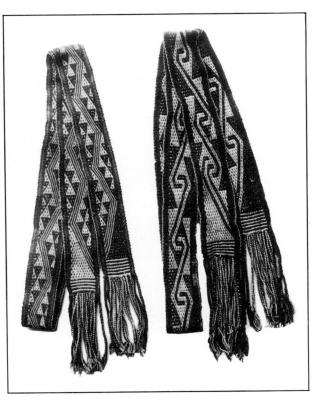

In the northern part of what is today Arizona, it is the Hopi among all of the Pueblo villagers who have achieved the greatest success in weaving — their products combine both functional textiles as well as a wide range of ceremonial weaves. Indeed, they have achieved such widespread recognition in this latter production that they have become the source of supply for most of the ceremonial costumes for the Río Grande Pueblo tribes today. And this is not a late phenomenon; even in early Spanish times, the Hopi (and to a lesser extent the Zuni) were regarded as among the leading textile producers; and when the Zuni tended to drift away from the loom in favor of silversmithing, the Hopi remained as the preëminent weavers of the Pueblos.

Among the Hopi, the men do the weaving; a few styles of textiles are produced by women, but largely in individual cases. Almost all Hopi weaving is done on large vertical looms (with the exception of belt and sash weaving) which are located in the *kiva*. This below-ground structure is, in essence, the men's sanctuary where they retire for privacy, rehearse

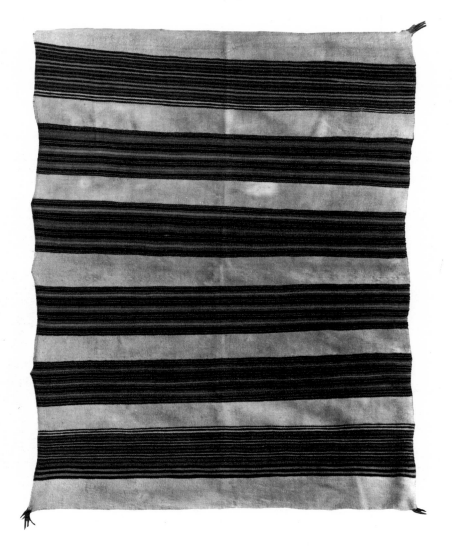

Ordinary old-style bed covering of wool. Hopi; Arizona. ca. *1900.* Marc Gaede photo; Museum of Northern Arizona.

Opposite

Weaving a brocaded ceremonial dance sash. Hopi; Second Mesa, Arizona. ca. *1950.* Marc Gaede photo; Museum of Northern Arizona.

religious ceremonies, and pursue craftwork such as weaving and carving the colorful small *kachina* figurines.

Hopi weaving includes several varieties and styles, for everyday and special occasion needs. The major productions are bed coverings, costumes, accessories, and ceremonial garments. The bridal costume has already been mentioned; other clothing worn by women include a black woolen dress worn over one shoulder and under the opposite arm, with a typical belt. A white shawl with parallel red stripes is also a part of her costume, usually worn on ceremonial occasions.

The man's costume is less elaborate for everyday wear, and has been considerably influenced by Spanish dress, most particularly the split-cuff

Maiden's cotton manta; *brocaded red borders on white. Hopi; Arizona.* ca. *1950.* $33\frac{1}{2} \times 36\frac{1}{2}$ *inches.* Paul Schmolke photo, Maxwell Museum of Anthropology.

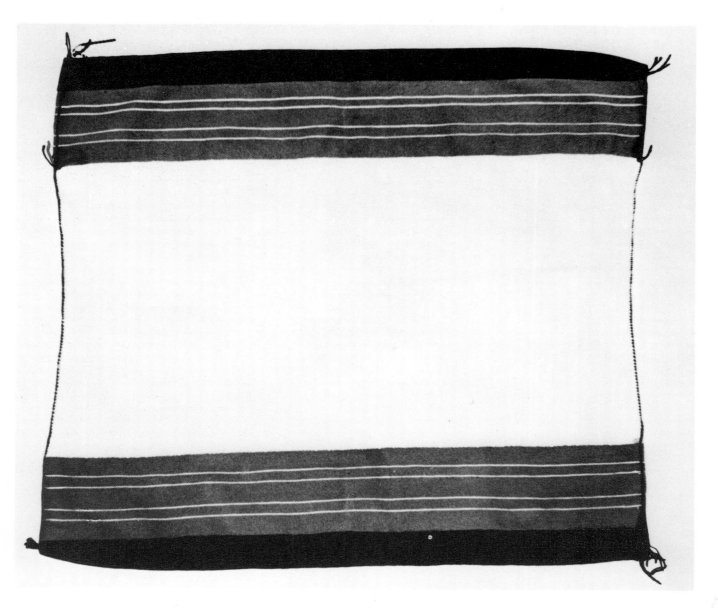

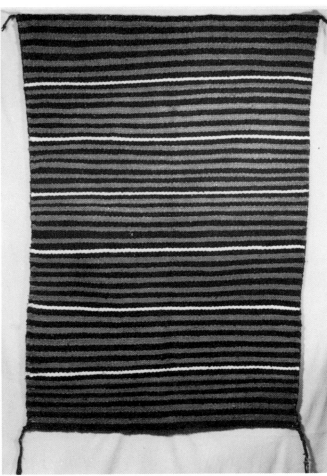

Left

*Detail of weave:
maiden's cotton* manta.
Hopi; Arizona. Marc
Gaede photo, Museum
of Northern Arizona.

Right

*Modern wool blanket.
Hopi; Second Mesa,
Arizona. 1960-1970.
30×46 inches.* Marc
Gaede photo, Museum
of Northern Arizona.

trousers, knit socks, and jacket. Prehistoric examples of shirts, belts, and sashes demonstrate the indigenous antiquity of these garments, together with the standard black breechcloth. Belts, leg garters, and hair ties also seem to have a prehistoric origin, all of which were woven on belt looms.

Some of the more dramatic costumes are the Hopi textiles woven for ritual occasions, most particularly the elaborate *kachina* ceremonies. The man's dance kilt, with brightly colored designs on a white cotton base, is used throughout the Pueblo world; the sash, invariably in black, green and red, is a popular trade item to other Pueblo villages, and tightly woven belts in the same color scheme are all longtime products of the loom. The sash and kilt are brocaded in traditional designs which have apparently been standard for many years.

The Hopi also weave two other standard ceremonial garments: the brocaded white wedding sash mentioned earlier and the white cotton woman's shawl which is frequently embroidered with brilliantly colored designs after being removed from the loom. It is one of the largest size

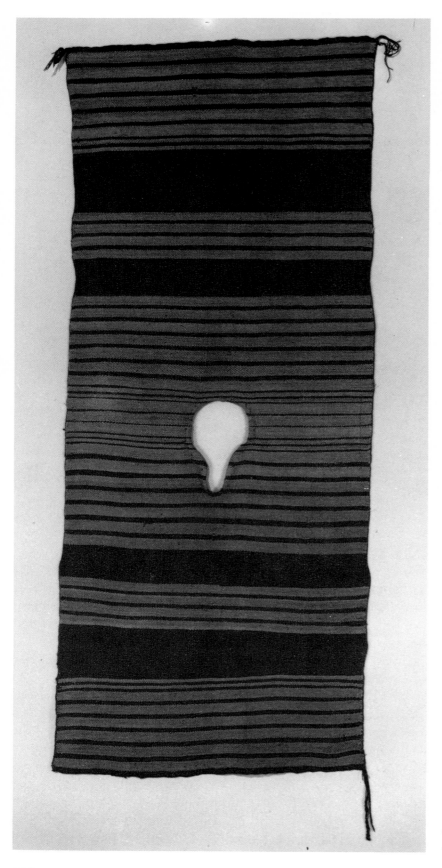

Old-style man's wool poncho. *Hopi;
Arizona.* ca. *1850. 28×38 inches.* Denver
Art Museum.

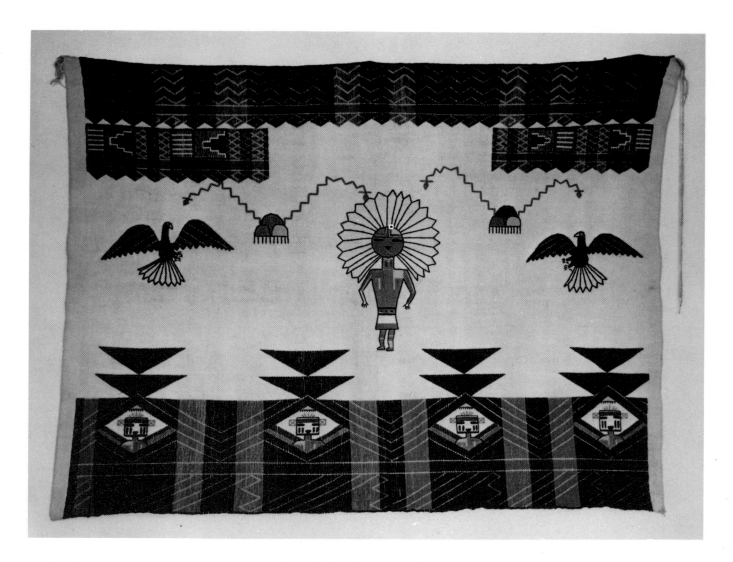

Embroidered cotton ceremonial shawl. The central design represents Tawa, *the Sun Being. Hopi; Oraibi, Arizona. ca. 1900-1910. 55×72 inches.* Museum of the American Indian.

weaves produced in the Southwest. Occasionally, the white cotton loose-sleeved shirt is produced, embroidered with small motifs, and the square black-and-white checkered blanket; the type intended for men has larger checks, and is of larger size, than that used by boys. Very little blanket weaving is done anymore, although on occasion a weaver will produce one for the market or as a gift to a friend.

The Zuni weavers produce almost nothing today; once they were master weavers working on the same vertical loom as did the other Pueblo craftsmen; they produced dresses, shawls, kilts, sashes, and jackets. A few people still produce an occasional belt or ceremonial garment, but most of these are now obtained from the Hopi by trade. Most Zuni artistry is now devoted to silversmithing and jewelry production.

This same situation obtains at the other Río Grande Pueblo villages; the only places where weaving is practiced in any degree is at Laguna and Jémez; most of the rest have given up the craft with the exception of the inevitable rugged individualist who continues the craft for personal reasons. The magnificent Ácoma shawl, once the glory of that village, is

153

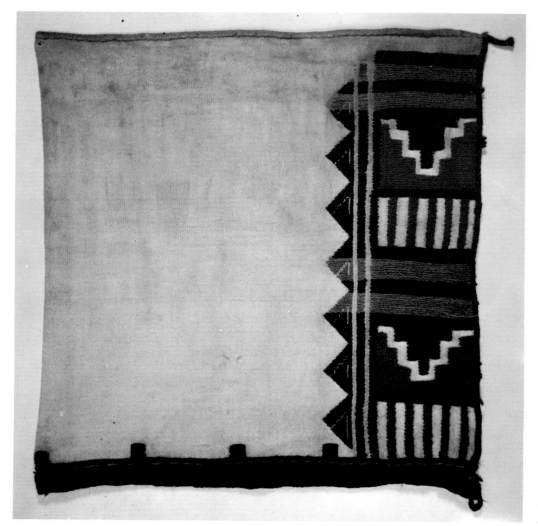

almost totally gone; formerly the prized textile among the Río Grande Pueblos, they combined fine weaving with delicate, colorful decoration. Only occasionally is one woven for special needs today.

It is the Navajo, the largest tribe in North America today, who have not only continued the weaving traditions in full flower but have far surpassed their earlier successes — they now produce nine-tenths of all native weaving in North America today. Although these people may have brought a textile tradition with them when they entered the Southwest approximately 500 years ago, it was probably a relatively simple suspension or belt loom. Shortly after their settlement among the Pueblo people, they adopted many of the customs of the latter, including sand painting, masked ceremonies, and weaving. Being a nomadic people, they apparently reversed the division of labor with the women taking on the weaving duties. To this they devoted a great amount of attention, eventually emerging as the finest weavers among all Native American people.

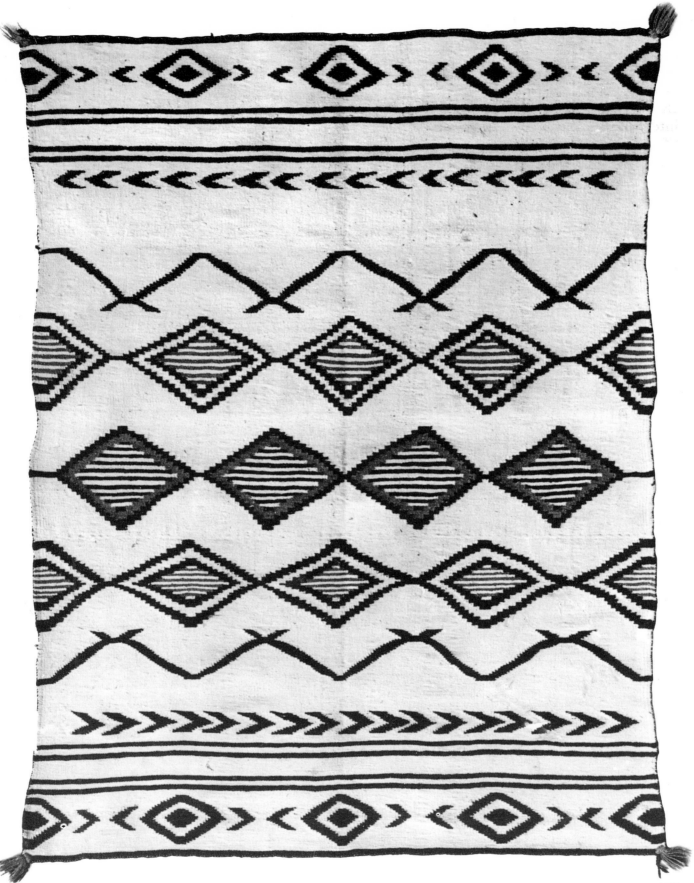

155

Early Navajo weaving examples have disappeared into the past; the earliest datable example is the fragment found in Massacre Cave, Arizona, dating to 1822. The next to which a date can be applied was collected in 1851; these demonstrate the difficulty of definitely establishing specific chronologies of weaving. The type of design has been gradually worked into a series of categories centering around the motif known as the "Chief's Blanket." Dealers and collectors have been primarily responsible for developing a time chart for this textile to which "phase" labels have been religiously applied, implying a common application of this design throughout the tribe, as though everyone proceeded at a common esthetic pace.

Yet it must be admitted that the term has a limited use in isolating one type of textile and thereby tracing a certain design development. Phase I is simply a banded white shoulder blanket, with horizontal stripes of black (or indigo) and red. It is strongly influenced by Hopi textile design. Phase II introduces the period when this horizontal banded design was initially broken by corner panels of red and black. In Phase III, these panels had become terraced areas, often breaking into a large portion of the design. The ultimate in this design — perhaps Phase IV — was a well-balanced arrangement in which each segment is a design in itself, producing a textile which can be folded in quarters and still present the same relative balance. But the maximum esthetic and technical quality of the Chief's Blanket was probably that inspired by Lorenzo Hubbell in the 1890s.

Opposite:

Wool serape, *often confused with Navajo weaving.* Chimayó; *Rio Grande Valley, New Mexico.* ca. 1890-1910. 56×88 inches. Museum of the American Indian.

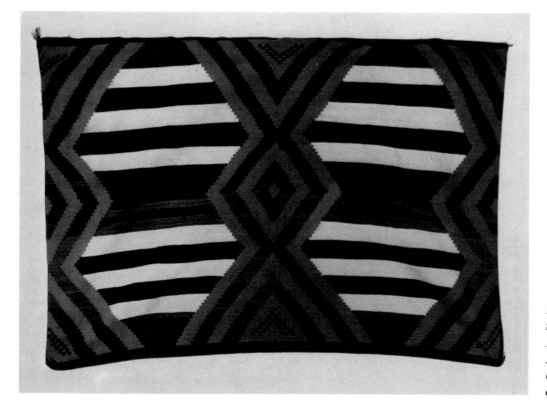

Balanced arrangement of the Phase III "Chief's Blanket." Navajo, *Arizona.* ca. 1880-1900. 62×48 inches. Museum of the American Indian.

156

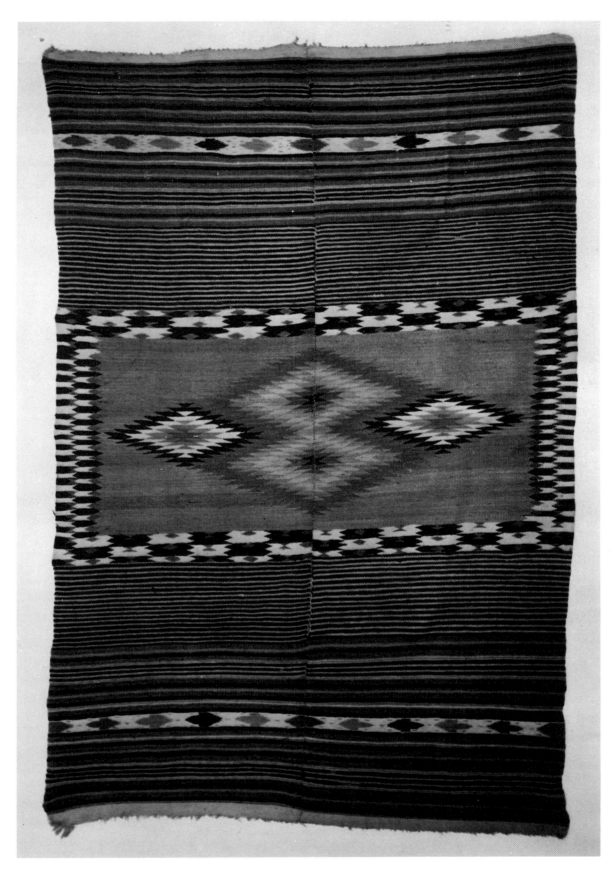

157

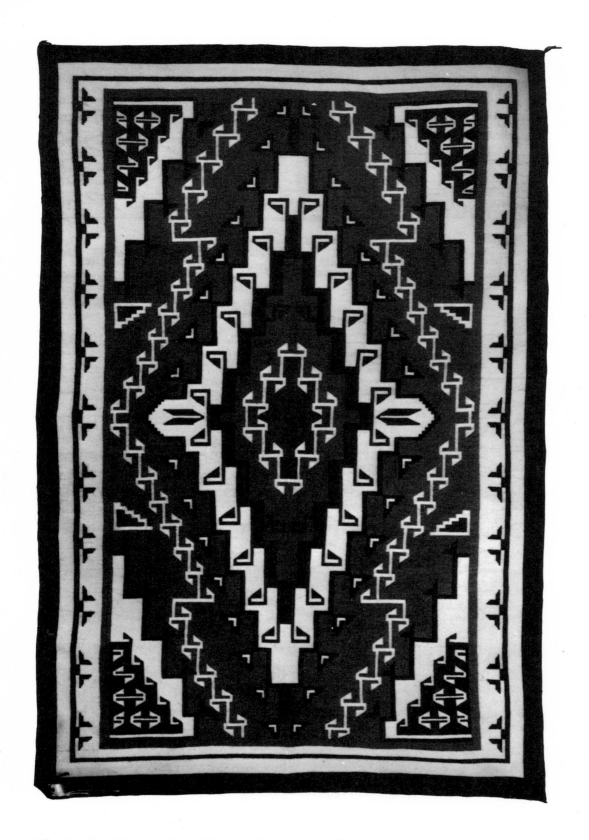

Black-and-white wool rug. Navajo; Two Gray Hills, New Mexico. ca. *1960.*
Marc Gaede photo; Museum of Northern Arizona.

The term "Chief's Blanket" is, of course, a misnomer; it was never intended for such restricted use but was simply an expensive textile — therefore available only to relatively wealthy individuals. In point of fact, there was also a woman's wearing blanket of this general design. All of these early textiles were light-weight shoulder blankets, shawls, and robes, greatly influenced by the Spanish-Mexican *poncho*. These were woven in two strips equal to the width of the loom, then the two panels were sewn together. A slit was left in the center to allow the garment to fit over the head.

In addition to this *poncho* use, there were two other major influences from Mexico in the last half of the nineteenth century. One was the Saltillo-weave *serape*, which had been in fairly common use all through the century, and the importation in 1865 of 4,000 Río Grande-style *serapes*; these were purchased by the U.S. Government to be given to the Navajo prisoners at Bosque Redondo. The coincidence with this purchase, the return of the Navajo to their homeland in 1868, accompanied by a resumption of weaving, was immediately seen in textile designs of the next twenty years.

A second, and lesser known influence during the early nineteenth century was the existence of numbers of Navajo women slaves, living on Mexican *haciendas*; these people were captured by Mexican troops, or sold by slave traders. Once they arrived at the large estates in northern Mexico, they were often put to work as weavers to provide large numbers of *serapes* and blankets. Many of these textiles were more-or-less copies of Mexican weaving designs of the time, combined in various ways with Navajo design. Out of this cultural interfusion came a class of textiles, commonly called "slave blankets," whose ancestry is impossible to clearly establish, yet whose design mix seems obvious.

When some of these slaves were ultimately able to get back to their homes, as many did, they brought some of these ideas with them and may have exerted some effect upon Navajo design — but not as much as those weavers who returned from Bosque Redondo, of course.

It has been mentioned that almost all of the weaving done at this time was for the purposes of the individual — wearing blankets, shoulder garments, dresses, "doors" for the home, sleeping covers, and the like. It was only in the latter part of the century that these were no longer used by the native but were purchased for a quite different use by the tourist. This change also affected the type, size, and weight of the textile; saddle pads became more heavily woven, wall hangings were of a different type and size, and floor rugs particularly increased in weight and thickness.

The introduction of aniline dyes into the Southwest gave birth to the standard "Germantown" weaves, exemplified by the brilliant hues available from these new dyes, the tight weave possible from pre-dyed machine-spun thread (or re-spun by the weaver), and the fine-line zigzag or "lightning" designs taken from the Saltillo weaves of Mexico.

It is interesting to note that with all of the outside influence which has been pressed upon the Navajo (and Pueblo) weaver, and the relative

willingness of the former to respond by design flexibility, the technical aspects of Southwestern weaving have been changed very, very little. The loom is still the same physical construction as it has been for many centuries; weaving tools continue to be the hand-made wooden implements known to many generations of weavers; and the sequence of the various weaving processes is almost identical. Indeed, were it possible for a weaver of 1500 A.D. to come back to the Southwest, the artist could settle down to today's loom and complete a textile without any uncertainty whatsoever.

The greatest change of the past half century, of course, has been towards a greater technical virtuosity and complication. Designs have become far more elaborated, some even to the point of bad taste. Color combinations are overdone, and in the instance of pictorial weavings, an almost photographic effort is sought. In fact, some of the Navajo weaves have almost become European tapestries in their realistic effects.

The impetus of this outside interest, however, has not made itself felt among other Indian groups in the Southwest. It has had only modest effect upon the Hopi, little on the Zuni, and apparently none at all upon other Pueblo or Desert tribes. It may be that the weaving tradition had gone too far out of their culture to be revived; only a handful of individual weavers responded to the opportunities offered by state fairs, museum exhibits, and special events designed to provide an outlet for crafts. These few people tend to regularly produce a modest quantity of textiles primarily for tribal religious needs, for special outside consumption and personal needs, but weaving as a major factor in those tribal economies is no longer important. This is a tragedy, for Pueblo weaving has a long and remarkable history with many unique qualities which should not be lost.

Midwest

In the central part of the United States, from the Great Lakes to Tennessee and from Iowa to Ohio, a large number of Indian tribes had settled, establishing a Woodlands culture marked by sedentary village life, a hunting-gathering economy, and an extensive reliance upon wood, stone, hides, and bone. The use of clay for pottery was known to these people but seems to have been of secondary importance, and of only average quality. The climate and the absence of richly endowed burial practices has left little evidence upon which a judgment of prehistoric weaving from this region can be based. Some fragments are known which support the conclusion that weaving was a well-known art, but evaluation of the processes is forced to depend largely upon historic examples.

Fortunately, fiber remnants have been found, preserved in contact with copper implements, together with textile impressions on pottery which have been recovered from archeological excavations which demonstrate the antiquity, if not the complete range, of weaving in the Woodlands

Modern pictorial tapestry; U. S. Eagle. Navajo; Arizona. ca. *1950-1960. 49×45 inches.* William D. Harmsen Collection.

region. These have been found in sites which contained organic matter suitable for C_{14} dating, showing that complex weaves existed as early as *ca.* 250 B.C. in Ohio and Illinois, although we cannot state what substances would have been employed at the time. Certainly the quantities of Indian hemp, cattail, and rush which have been excavated in these sites give the confidence that these plant fibers were in use then, as now, in weaving.

The technique was universally twining in almost all areas; fibers spun in an S twist were combined in pairs and reversed in a Z twist to provide weft cordage. A tremendous variety of weaves were known to these people, as well as the ability to combine remarkably disparate fibers, such as human hair, bison hair, and nettle, cedar, elm, and basswood bark, making one feel that they were capable of producing just about anything they might want in the field of weaving.

The loom used seems to have been the suspension or drop loom so widely used throughout North America; no evidence of heddles has been found from prehistoric sites. It seems also unlikely that the backstrap or belt loom was used, in view of the nature of the textile remnants known and the absence of such an important example of weaving equipment in early historic times. Although no examples have survived, it would seem certain that people who could produce such a variety of weaves and use

such a wide range of materials were eminently capable of weaving clothing and other large-size products. Early explorers in the Midwest speak of seeing large quantities of native cloth in the sixteenth and seventeenth centuries, and while there is no certainty that these were woven on indigenous looms, the tenor of their comments makes one feel that the European loom had not made serious inroads upon native manufacture until later.

It is true that with the introduction of European textiles and tailoring, Indian clothing underwent a dramatic and almost immediate change. Native styles and fabrics were abandoned in favor of the foreign woolens and linen yardage, and by the beginning of the eighteenth century only

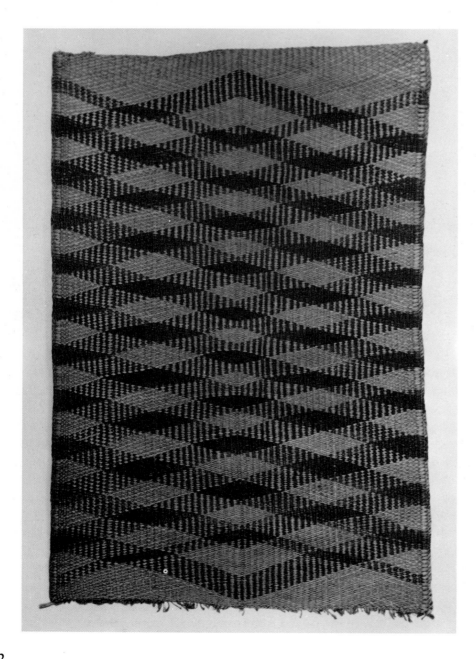

Woven rush mat. Potawatomi; Holton, Kansas. ca. *1900. 45 × 70 inches.* Museum of the American Indian.

162

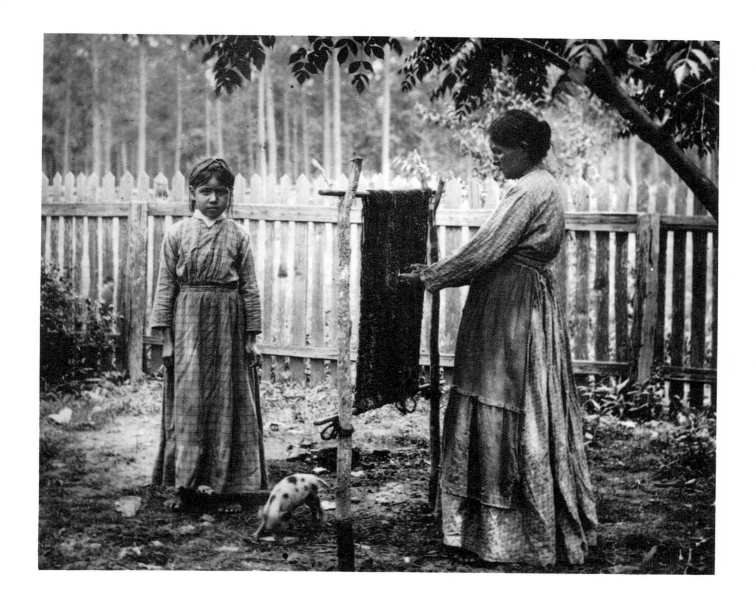

Mrs. Williams weaving a moss fiber blanket on a two-bar loom. Koasati (or Houma?); Houma, Louisiana. ca. 1908. M. R. Harrington photo, Museum of the American Indian.

a little native weaving was continued, with the exception of narrow-gauge belting and the manufacture of containers.

The use of tule and rush fibers, woven on a suspension or drop loom to produce rush matting and covering, was widespread in the Midwest, notably among the Chippewa, Menomini, Sauk, Fox, Potawatomi, and Winnebago peoples. These were often decorated by geometric or naturalistic designs interwoven into the mats in soft vegetal colors. Some of these forms are difficult to visualize due to their extreme linear form. With the accessibility of aniline dyes, these colors have become more pronounced, and today one sees rush mats woven in strong blue, green, purple, or maroon colors, and more readily-recognizable designs.

These mats vary in technique and fineness of weave; the coarser examples were used as coverings for the dome-shaped dwellings of the people, for bed and floor coverings, interior house linings, and similar

Moss blanket. Alibamu; Livingston, Texas. ca. *1875–1900. 14×20 inches.* Museum of the American Indian.

needs. The more finely woven mats were also used as *wigwam* decorative hangings, wrappings, and at give-away ceremonies.

Another important woven product of the Midwest weaver was the almost endless variety of fiber bags. These were usually made of bast from the beaten inner bark of the basswood, cedar, or slippery elm. The fibers were boiled in a solution of lye made from wood ash which separated the fibers, then were dried and twisted or spun into cordage for weaving. They were either left unspun and uncolored for use as parallel strands, or were dyed with vegetal pigments in contrasting colors. The bags woven from this technique were used for storage of foods, personal possessions, sacred medicine objects, or anything else the owner wished to preserve or store.

The bast fiber bags were usually coarser in appearance, the weave was looser, and the container was strictly a utilitarian product: perhaps not esthetically remarkable but exceptionally strong and serviceable. The more finely woven bags were usually softer and made from nettle, bison hair, or Indian hemp; after the introduction of commercial cotton twine, it became widely used for the purpose. Some were colored with vegetal pigments, but many were either purchased already colored or were dyed with commercial dyes, often giving a strong color contrast. These soft-weave bags were more closely woven, and more care was taken to finish the top opening, edges, and the ends of the weave. The utilitarian

164

Two yarn fiber medicine pouches (top) Thunderbird design. Iowa; Oklahoma.

(below) Underwater Panther design. Menomini; Wisconsin. ca. *1875-1900. 18×26 inches.* Museum of the American Indian.

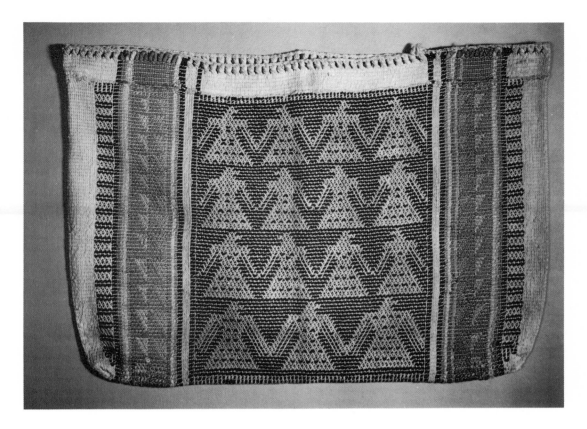

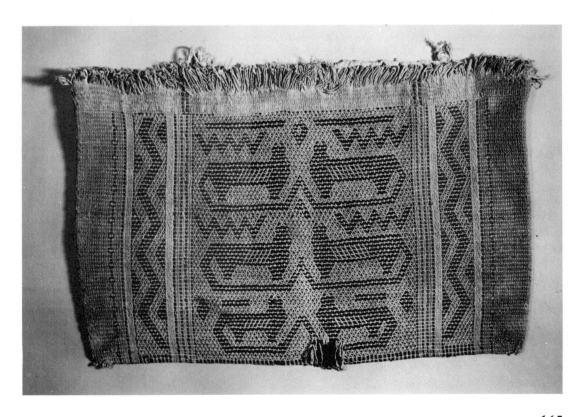

bags were frequently left plain, but most of the other containers had geometric designs of animals, birds, and related motifs interwoven into them; on occasion a human might be depicted, but this was not common.

A favorite theme included mythological beings, most particularly the Thunderbird, either singly or in duplication; and the Great Underwater Panther, so important to these lake people. One regular pattern is to be seen in the decoration of these bags: just as in the case of the Nez Percé twined wallets, the Great Lakes fiber bags were also decorated with different designs on each side. Almost never does one find a bag with bilateral symmetry in design; normally, one side will have a zoömorphic or mythological design, and the opposite side will be woven in a geometric or linear pattern completely unlike it. Even when geometric designs are woven on both sides, the two will be different. These are usually executed on a central panel in brown on the natural buff color base; occasionally, but rarely, this will be reversed. Colored lines, normally in red, were inserted at each end of the panels.

With the coming of the White man and the introduction of wool and commercial cording, these bags underwent a considerable change. Not only were they made from a different material — often re-spun fibers from commercial cloth, as with the Navajo in the Southwest — but, surprisingly, in a different technique. While the difference is not great, it nevertheless produces a new range of designs, as well as creating a variation in form. The older fiber bags were woven on a suspension loom, with the weft threads twined around loose-hanging warps. This resulted in a seamless "pocket" when the loose ends were braided together to form the rim of the pouch. With the new wool-fiber bags, the weaver hung the warp threads over a cord stretched between two vertical poles. As the wefts were twined around these warp threads, a flat cylinder was formed. When the weaver was finished, the fabric was slipped off of the poles, the starting end was sewn closed forming the bottom of the now rectangular container. As a result, these "yarn bags" or wool pouches have a bottom seam, while the older fiber bags are normally seamless.

This difference also is seen in the decoration of the two types of bags. The fiber bags normally have a central panel and two smaller end panels; the major design element is in the larger of these, with geometric bands or lines at each end of the bag. Usually the wool bags have simpler decorations, consisting of horizontal bands of colored cording in varying widths.

A further interesting departure is to be seen in the manufacture of the wool pouches. Whereas the design elements of spaced twill-twining were customary in weaving the fiber bags, this was abandoned with the introduction of wool, for some unknown reason, and a new full-turn (or full-twist) twining technique was employed. This simply means that the weft threads were given a full twist between each warp strand, yielding a fabric whose inner surface shows only short vertical twists, while the horizontal wefts are not visible.

This is an unusual technique, not widely used outside of this region in

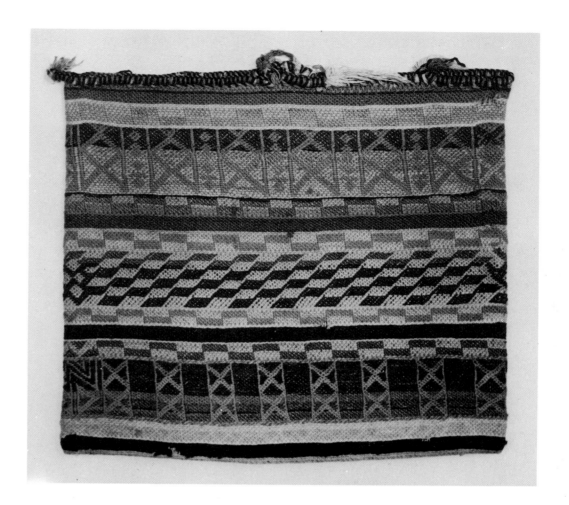

String yarn medicine pouch with geometric design. Chippewa; Wisconsin. ca. 1875. $18\frac{3}{4} \times 20\frac{1}{2}$ inches. Museum of the American Indian.

historic times and only occasionally in prehistoric weaving. It allowed the weaver to produce a wide variety of designs with relative ease, and it is surprising that it remained so little known elsewhere.

Other weaves from the Great Lakes region include sashes, belts, and garters, both in bast fibers and wool, decorated by geometric designs. With the introduction of trade beads, these replaced the older porcupine-quill work, and a bow loom or beadwork loom became commonly used. Some sashes or belts were made with the beads interwoven; others were strictly the product of the weaving process on the bead loom itself.

In the field of costuming and accessories the Midwest tribes adopted European cloth almost overnight. The traders brought in bolts of cloth in varying colors, which quickly replaced the hand-woven textile, and in time became "traditional" Indian clothing. In the accessories, such as armbands, sashes, belts, and garters, one finds a carry-over of older design elements and styling. But today, there is little indigenous weaving still active in the Great Lakes area. Those tribes who still live there rely completely upon commercial cloth for their clothing needs, and only a few women still weave the fiber or wool storage bags. There is a small trade in

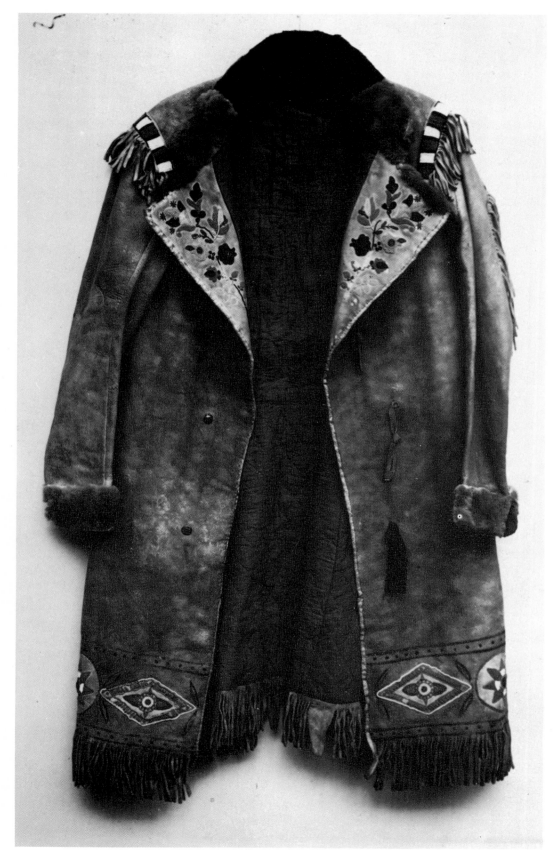

Tailored buckskin coat with embroidered decoration, belonging to John W. Quinney. Mahican/Stockbridge; Wisconsin. ca. 1797–1855. L: 60 inches. Museum of the American Indian.

mats, which is probably the single most active woven craft still practiced.

The contemporary costume of the people living in this area has become relatively standardized, with elements of old and new intermixed. While the general effect is certainly "Indian," the critical eye can readily distinguish the blend of the two.

Eastern Woodlands

Related to the foregoing people but removed by distance and time, the Atlantic Coastal folk have also lost much of their original cultural patterns in the flood of European immigration. That weaving was a well-known art is well documented by large quantities of fragments (and occasionally whole examples) of pottery found in archeological sites which bear impressions of textiles on the surfaces. It is possible to determine the spin and weaving technique from such examples, which attest to a great variety of weaves. There are also a few pieces of late prehistoric or early historic textile fragments which have been preserved, usually by the presence of copper. But the extent to which weaving was practised in this region in ancient times remains poorly known.

Historic references to Indian costume are to be found in the various journals and chronicles of explorers and early Colonial travelers; they leave little question as to the variety of garments which were in common use. In many instances, of course, the bias of the writer gives an impression of inadequate dress; this was largely moral opinion, rather than esthetic or cultural. The use of animal hides, particularly deerskin, was widespread — as was the appearance of fur in winter and semi-nudity in summer. But the almost overnight acceptance of European cloth has made any clear understanding of the situation impossible.

Buckskin baby carrier band, decorated with appliqué design in natural, black, and orange dyed porcupine quillwork. Delaware. ca. 1775-1825. 7¼ × 14½ inches. Museum of the American Indian.

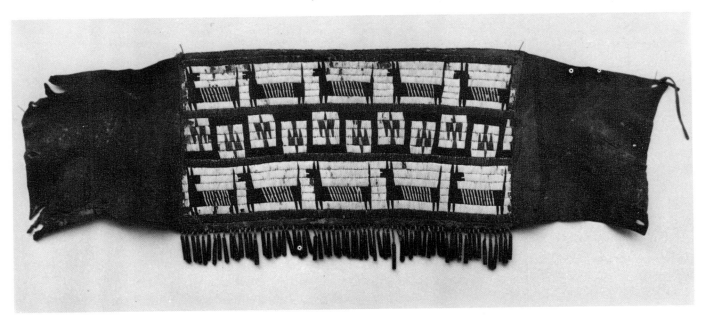

Such weaving as was practised followed pretty much the same pattern as in the Great Lakes region, with whom these northeastern people shared much in common: communal village life, a hunting and gathering economy, relative sedentary social customs, and an intensive knowledge of the general area in which the tribes lived. Coupled with this in the East was a remarkable political sense, which inevitably affected the interrelationships of the various villages with each other.

Materials used in the weaving arts were the basic plant resources supplied by nature: milkweed fiber, bast, nettle, Indian hemp, slippery elm, and similar vegetal substances. Colors came from plant and mineral dyes which provided a medium range of muted colors, primarily black, green, red-brown, light yellow, and natural buff. There is no evidence of the existence of the true loom in the East; most weaving was produced on the suspension loom and possibly the belt loom — although this latter was never as widespread as it was in the West, if it did indeed exist to any degree. The weaving of belts, sashes, and banded textiles was achieved by means of finger weaving.

That this art was highly developed is made particularly evident by the large number of belts, sashes, and tumplines which have survived from the Huron and Iroquois. Utilizing milkweed, Indian hemp, bast, and elm bark, these tightly woven strips served as "pockets" to hold one's possessions, provide support to the body, add color to the costume, and serve the many other purposes suitable to belting. They were decorated with moosehair, paint, textures of various sorts, and beads. Prior to the coming of the European, these latter were made of shell or clay; the brightly colored glass beads from Venice which came in *via* the traders quickly caught the eye of the Indian and soon replaced the native bead.

These were woven by the same technique as was common throughout the Eastern part of the country: finger weaving, suspension loom, and the horizontal single-heddle loom. This latter was an ingenious development which allowed the weaver the latitude of a true loom, but in small size. It was also useful for those sashes which were interwoven with beadwork.

Mats were of major importance to the Eastern people and were woven in the same suspension-loom technique as with the Great Lakes tribes; they were also used as coverings for dwellings, floor and bed covers, and served as wrappings. With the introduction of European trade cloth, most of these native textiles were rapidly replaced — within the course of a single generation in some areas. On occasion, the new trade cloth was raveled and re-spun, but more often it was directly introduced into the fabric as decorative or strengthening material. Tailoring was not common prior to the arrival of the European but then became a customary practice, inspired by colonial garments with large pockets, flaring skirts, and elaborated embroidery.

More recently, there has been little revival of weaving; most of the crafts movement has been expressed in the fields of pottery, silverwork, and sculpture. Among the Iroquois in particular, where a minor craft revival developed in the mid-1930s with the WPA program and again in the past

Woven hemp burden strap (tumpline) with dyed moosehair decoration. Mohawk; Canada. ca. 1775-1800. L: 197 inches. Museum of the American Indian.

decade, several outstanding artists have emerged, but none of them are weavers. Such textile activity as has been made evident tends largely to have capitalized upon appliqué, sewing, and the manipulation of trade cloth.

The Southeast

Closely allied in culture to the Eastern Woodlands people of the Northeast and Midwest, the Indians of the Greater Southeast include a variety of language families, including the so-called "Mound Builders" who once inhabited the region from Ohio to the Gulf Coast, and Georgia to Oklahoma. Among these Native Americans are some of the most

Tomochichi and his nephew Toonahawi; demonstrating the tattooing (or body painting?) designs customary at the time. Creek; Alabama. ca. *1650-1739.* Smithsonian Institution, National Anthropological Archives.

highly developed cultural patterns in prehistoric North America. Certainly the Hopewell and Adena peoples of Ohio and Illinois, the Moundville occupants of Alabama, and the Spiro Mound inhabitants in Oklahoma reflect ably this cultural high-level mark.

But again, alas, there is little evidence to be found here of what was undeniably once a rich weaving tradition. Some examples have survived, most notably from the Spiro Mound. Textile fragments have also been recovered from Ohio, Indiana, and Alabama, and the dry rock shelters and caves of Arkansas have revealed some tantalizing hints at what must have been a major art activity in early days.

But what is of particular importance in this eastern area is the large

number of pottery vessels bearing textile impressions. The use of cord-wrapped wooden paddles to produce a surface texture is widespread, and many thousands of clay examples exist demonstrating the various weaves. These include coarse and fine cordage, complete weaves, and almost every conceivable range of texture which indicates clearly that here was a sophisticated level of weaving skill enjoying wide utilization.

The rich variety of these pottery-impressed examples, together with the types of weaves they reflect so clearly gives the clearest evidence we have of the wide range of the art. Unfortunately, none of this is accompanied by any recognizable fragments of actual looms, so that we do not know for certain just what techniques were followed.

The technical excellence of these early weavers is indicated in Spanish travel accounts: when they encountered the Southeastern people in the mid-sixteenth century, they remarked in wonderment at the "fine weave of their cotton mantles." In actuality, the material was pounded bast, cleaned, whitened, and woven so finely as to deceive the European observers.

Today in the Southeast, weaving is largely a dormant art. English looms were introduced early in the White occupancy of the Cherokee country, and although it seems certain that these people already knew of the use of such implements and had achieved a high level of skill, the pressure to produce changed their earlier customs and made them into production-line weavers on these introduced looms. Even so, the

Woven collar; wild turkey feathers interworked into a woven hemp base. A modern revival of the traditional technique, by a native weaver. Pamunkey; Virginia. ca. 1920. L: 22 inches. Museum of the American Indian.

Cherokee have not only kept the weaving arts alive, but have expanded it into a rich cultural expression of their own. Not only is finger weaving widely practiced, but the loom work active in this area is a continuation of earlier textile activities. The Indian Arts and Crafts Board has been instrumental in encouraging this revival by providing managerial and technical assistance to the local people, and the efforts have been rewarded by the establishment of a crafts guild at Qualla, North Carolina, and the development of a viable cottage industry in the region. Most of the production has been in the line of shawls, sashes, bed covers, and similar soft-weave articles, but these are colorful, well-woven, and individually designed with a high degree of taste.

Wide woven wool belt with interwoven beading. Made for William McIntosh by his daughter. Creek; Georgia. ca. 1825. 10×116 inches. Museum of the American Indian.

And so we have seen the importance of weaving and its esthetic values to individual identity, prestige, and social status in many tribal groups. Cultural patterns set a visual tone in each group; the particular combination of color, line, mass, and balance which makes Pueblo art unique, for example, would never be confused with that of any other Native American tribe. Actual manifestations of artistry may thus vary greatly, in form as well as quality.

It must also be said that "Indian art is not of necessity good art;" there were just as many, if not more, poor weavers as those who excelled in the craft. The regrettable tendency to look upon anything made by ethnic artists as being *ipso facto* of superior merit does little service to the native the product, or the artist. Much of the weaving of the past and the present, is in fact only of mediocre quality, and when judged by the knowledgeable

Woven wool drawstring bag, made by Arnessa Maney. Cherokee; Qualla, North Carolina. ca. 1965. Indian Arts and Crafts Board, U.S. Department of the Interior.

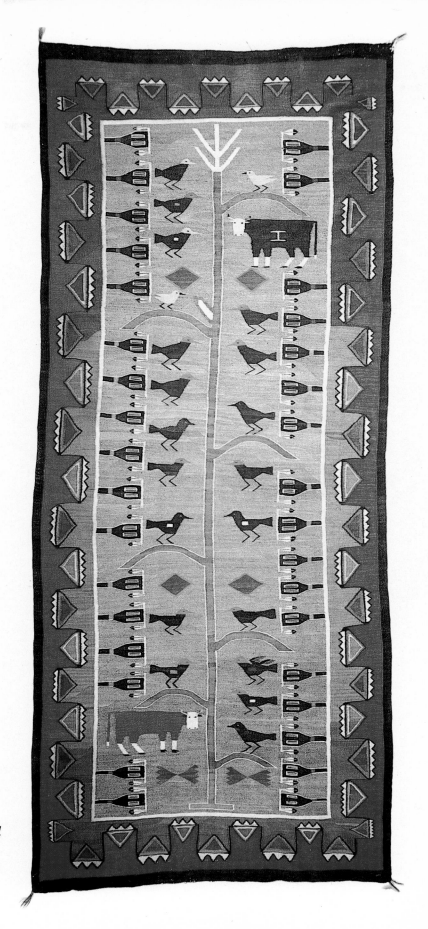

49 *Modern pictorial rug. Cornstalk and Blackbirds. Navajo, New Mexico. ca. 1920-1930. 124×51 inches. William D. Harmsen Collection.*

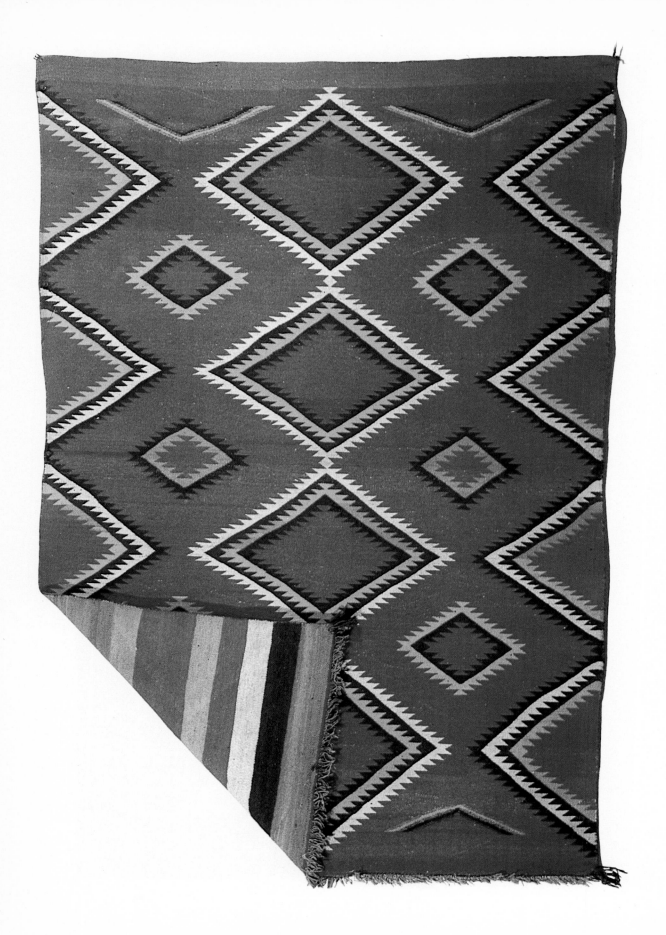

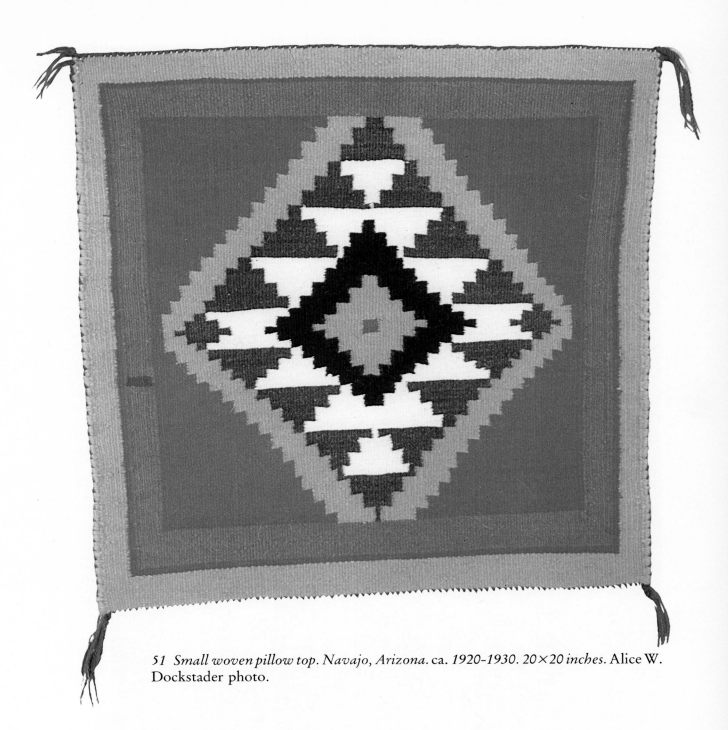

51 Small woven pillow top. Navajo, Arizona. ca. 1920-1930. 20×20 inches. Alice W. Dockstader photo.

Opposite

50 Double-faced blanket. Germantown diamond pattern on one side; horizontal stripes on the other. Navajo, New Mexico. ca. 1885-1900. 75×51½ inches. Cincinnati Art Museum.

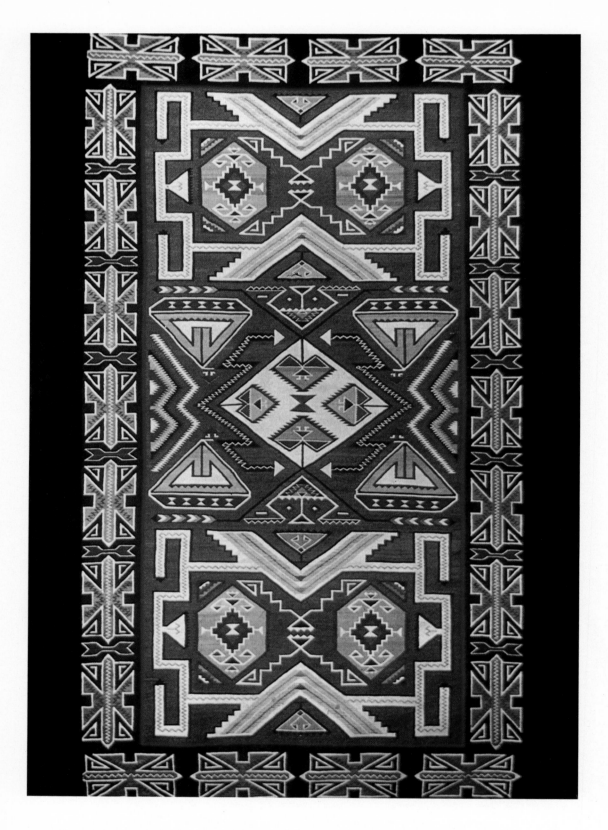

52 Modern Tees Nos Pos design. Navajo, Arizona. ca. *1960-1970.* Herb and
Dorothy McLaughlin photo.

53 *Ganado weave rug. Navajo, Arizona.* ca. *1970.* Herb and Dorothy McLaughlin photo.

Opposite

54 Modern "raised outline" textile. A recently introduced variant weave. Navajo; Coalmine Mesa, Arizona. ca. 1960-1965. 32×48 inches. Alice W. Dockstader photo. The picture above is a detailed enlargement (55).

56 *Contemporary cotton man's vest with embroidered decoration. By James Kewanwytewa, 1940. 20×24 inches. Hopi; Oraibi, Arizona.* Alice W. Dockstader photo.

Opposite

57 *Zoned vegetal dye blanket. Navajo, Arizona. ca. 1935. 24×36 inches.* Museum of the American Indian.

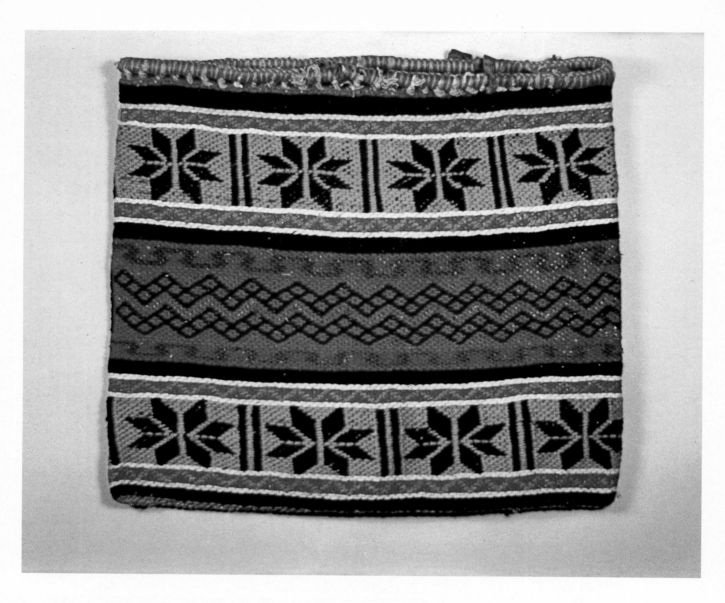

58 *String yarn medicine pouch. Geometric design. Potawatomi, Kansas.* ca. *1875.*
18×28 inches. Museum of the American Indian.

Opposite

59 *Painted caribou-hide coat with European tailoring. Naskapi, Canada.* ca.
1775-1800. L: 94 inches. Museum of the American Indian.

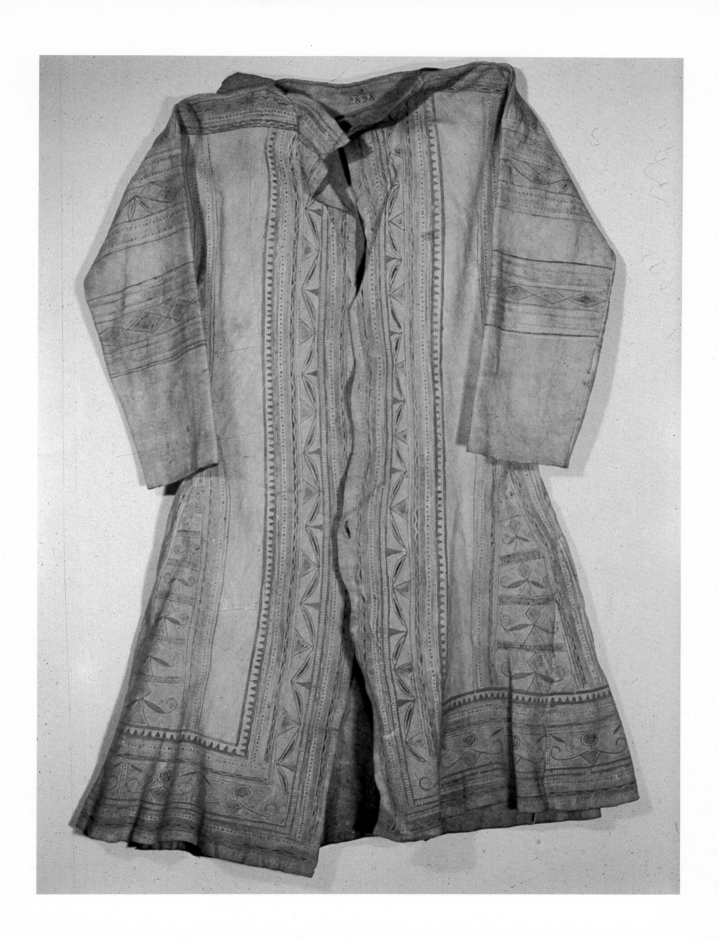

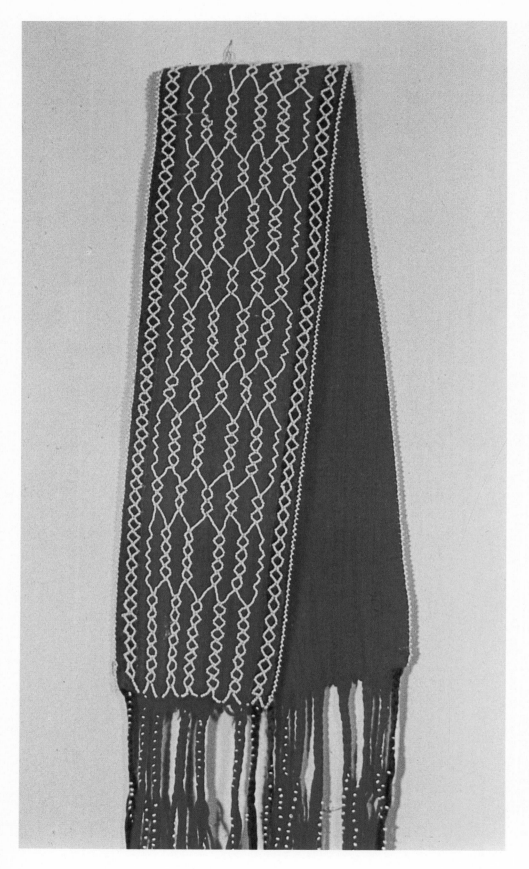

60 *Woolen belt, interwoven with trade beads. Iroquois, New York. ca. 1850. 6×20 inches.* Museum of the American Indian.

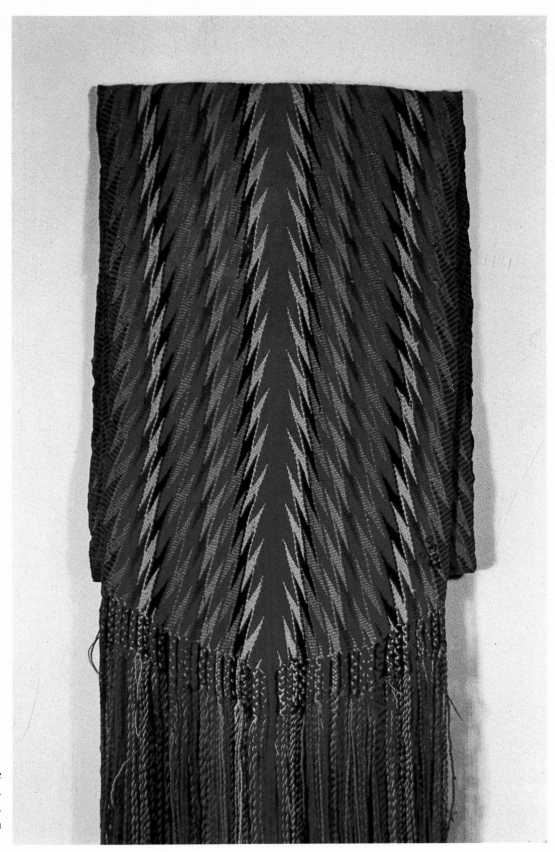

61 Wide woolen ceinture
flèche. *Iroquois, Canada.*
ca. *1800. 10×60 inches.*
Museum of the American
Indian.

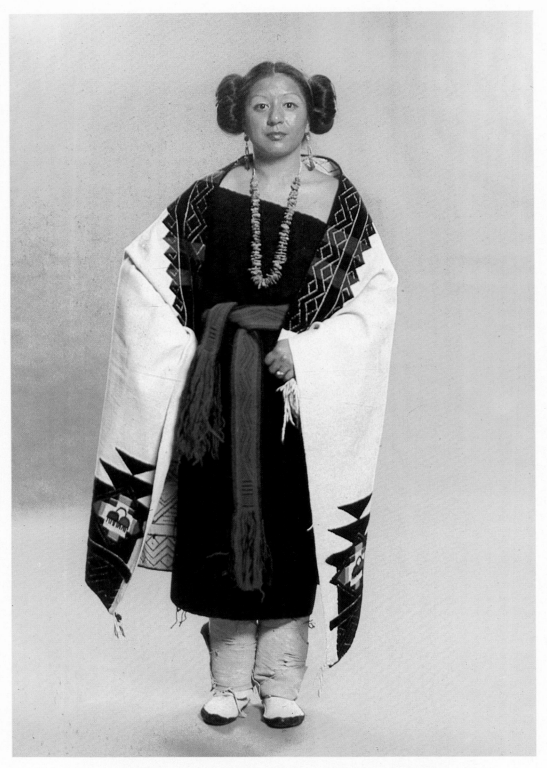

62 *Contemporary Hopi woman's costume, featuring cotton shawl and woolen dress.*

Opposite

63 *Traditional male dance costume. Hopi, Arizona.* Paul Markow photo.

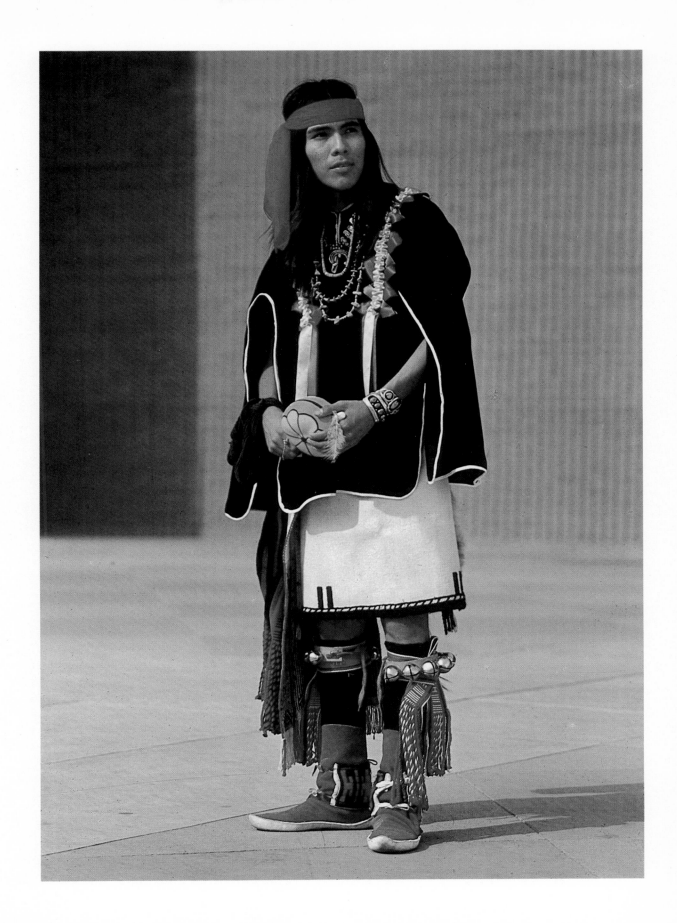

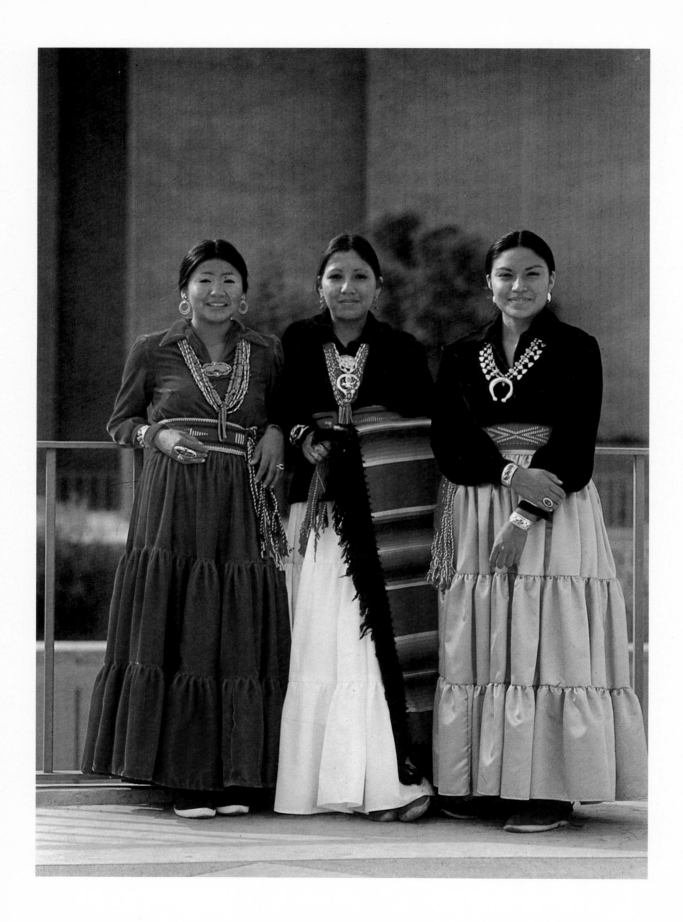

Modern woven wool weskit, by Roxie Stamper. Cherokee; Qualla, North Carolina. ca. 1965. Indian Arts and Crafts Board, U.S. Department of the Interior.

Opposite

64 Trio of Navajo girls in traditional costumes, showing European influence on native textiles. Paul Markow photo.

native consumer, would suffer abrupt rejection. When presented to a non-native, most particularly in the surroundings of glass showcases, fancy auctions, or pseudo-scholarship, a mystique sets in which establishes a false atmosphere and destroys the sense of balance which must accompany any esthetic judgment.

Another problem facing the judging of native arts is that of pseudo-chronology. The criterion of age, or the Closed Hand of the Calendar, represents an equally unfortunate limitation. Many, if not most, non-Indian viewers of the arts tend to regard anything created after a given date — usually the turn of the present century — as in itself a condemnation of quality. With eyes which automatically close to anything produced after that date, they are therefore judging antiquity rather than true quality. This is pernicious in that it denies the living artist any opportunity to have his work judged fairly and attaches a false aura of merit to a given object simply on the basis of supposed age.

In short, age, rarity, or exoticism have little, if anything, to do with esthetics; the true judgment of this quality must be based upon the combination of talent, skill, design, and taste, which are brought together in a harmonious composition. Only when this is achieved can a real masterpiece result.

193

194

6·The Contemporary Scene:
influencies, personalities, and markets today

Following the close of World War II, the domestic situation throughout the United States was of course at low ebb; most energies had gone into a successful completion of that tragic event. The arts were particularly hard hit: coupled with the Depression and followed by the Korean War, tourist travel was drastically curtailed, purchasing power declined, and many Indian traders and crafts retailers had gone out of business. Even the huge Fred Harvey Company chain was unable to weather the loss of business and ceased operations, thereby closing the door of that outlet to the Indian craftsman. And although there were several valuable innovations for the artist which came out of wartime technology, these had yet to make their appearance in any sizeable proportion.

The young Indian veterans who had seen active service abroad returned with a wholly altered perspective towards the outside world. Previously, most had avoided White contact and had usually evaded Government schools as much as possible. Now, the younger men realized the vital need to secure a sound education if they were to survive — and several astutely recognized the value that political or legal training would have in their future relationship with the White man.

The new young artists emerged at just the right time. An upswing in the post-wartime economy also coincided with a surge of concern for minority rights. This not only focussed upon the civil rights needs of the Indian people but was also accompanied by a growing fascination for the whole ethnic world, resulting in turn in a strong appreciation for native arts. Many art collectors turned their attention to what was commonly termed "primitive art," an unfortunate term which was quickly followed by many equally awkward synonyms.

As the economy strengthened and prices increased, more and more of the older collections became available; the auction houses began to make their influence felt; museums entered the picture; and finally, the younger collectors (who were, by and large, as interested in the creators of the art as in the objects) avidly pursued this new world of art. This rise in interest — and in prices — brought in an increasing number of artists. Among these were some good, some indifferent, and many whose work was simply poor. But as in earlier days, the ravenous market proved far larger than the supply. Reflecting this new interest, it became omnivorous, accepting everything on a fairly indiscriminate level in response to the

Diagonal diamond-weave saddle blanket. Navajo; New Mexico. ca. *1960. 30×48 inches.* Paul Schmolke photo; Maxwell Museum of Anthropology.

pent-up demands now present — as well as the presence of a goodly proportion of collectors whose wallets exceeded their knowledge.

Fast on their heels were the inevitable speculators. Often know-ledgeable about the art market but totally ignorant about the art, they set up shop to capitalize upon this golden opportunity. Certainly, in time some of the more intelligent acquired a degree of knowledge about the objects they were buying and selling in tremendous quantity, but most remained at a comfortable arm's length from any information-in-depth. Yet the initial flood of available works overcame these initial problems, and some remarkably fine examples of weaving changed hands, bringing to light many heretofore unknown treasures.

Albeit an integral part of this new interest, museums of the country tended, by and large, to follow rather than to lead in this excitement. For one thing, very few museums had true "primitive art" galleries already established; such material was usually held by and displayed in museums of natural history or anthropology departments of large general institutions. As a result, there were few professional curators competent to deal with the subject. Secondly, there was an unfortunate bias at work dividing native art between pre-Columbian art (in essence, that of the Maya, Aztec, Inca, and other "high cultures" of the New World) and ethnological art, often termed "ethnic" or "American Indian art" (but which never recognized the existence of a pre-Columbian North American expression), or similar euphemisms — all accompanied by a certain air of intellectual condescension.

This need for information was in part answered by a great increase in publications on the whole field of native art, both prehistoric and recent. These sold well and provided a platform for scholars communicating with a new audience. Some of these works were better than others, of course, but all of them helped this audience find itself amid the search for answers.

It is to be deeply regretted that much of this new interest had to do with dollar value, for this interfered with, or nullified, attention to the many other qualities inherent in weaving. It is certainly true that without a recognized commercial value, much of the permanent interest in a given object is sacrificed — but when this is the major focus of that interest, cultural values take second place.

This commercial interest did develop one interesting effect. Although art galleries and auction markets had certainly been in existence earlier, they were not as numerous or as active as they became in the 1950-1970 period. Insofar as the native artist was concerned, this market operated without many of the earlier precepts: no product was made and directed solely toward it (excepting, possibly, for those frauds which were being made); the function of the object was almost solely "to be looked at," or traded to another consumer; chronology was more important than condition or design (an old textile, somewhat damaged, would outsell a new one in perfect condition); judgments and pseudo-classifications were established to lend an aura of value to craftworks — and perhaps most regrettable of all, the concern was almost wholly investment value,

196

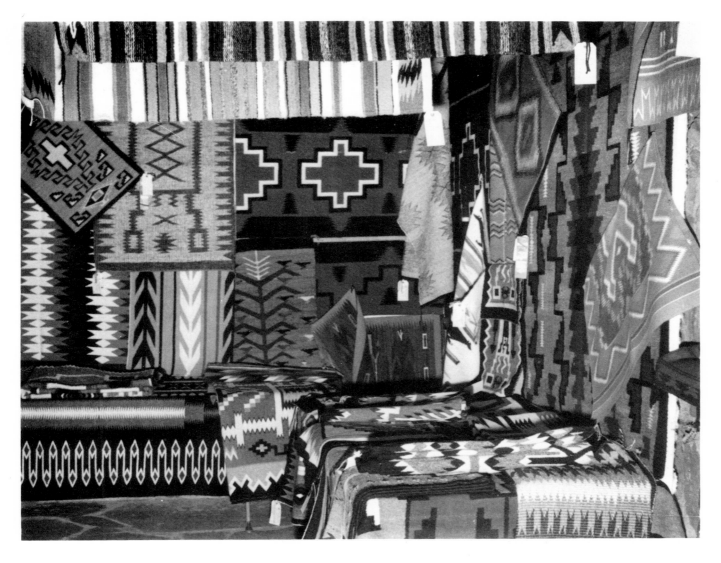

Contemporary textiles at the "Navajo Craftsman" fair. ca. 1960. Museum of Northern Arizona.

the social role of the object in the society of the market, with little concern for the problems of the producing community. Dealers were now distant from the source, and rarely were they, or the collectors, actively concerned with the "Indian Rights" issues of the period.

This artificial market made itself felt in subtle ways which the native artist resented: rarely were Indian craftsmen invited to openings featuring their works; often these were regarded as quaint expressions of a naïve culture rather than the products of a mature civilization, and the term "fine arts" came only haltingly to the tongues of the viewers. One cannot help but wonder what the effect would have been in a more genuinely concerned community.

There were other serious problems to be faced, one of which was the increasing difficulty of obtaining raw materials. This was less critical with weaving than with basketry, but some were common to both: environmental changes, overgrowth of nearby land areas, population shift, and the declining water supply. But probably the single most

197

important cause for weaving decline was the movement of Indian families to urban centers. Whereas earlier most people lived on the reservation, by the end of the 1960s more Native Americans lived in cities than on reservations. These migrants were not interested in weaving, by and large — nor were their urban apartments suitable for the craft. While it is true that most of them had probably not contributed to the art prior to moving, their departure nevertheless lost many young people to the training which might have given them mastery of that art, and a lifetime career.

Contemporary complex-pattern rug. Navajo; Tees Nos Pos, Arizona. ca. *1970. 68×80 inches.* Paul Schmolke photo; Maxwell Museum of Anthropology.

An accompanying aggravation was the fact that in moving, most of these Indian people had also resolutely turned their backs on Indian culture — and with it, an interest in maintaining any traditional forms. As a result, their presence in the cities did not significantly relate to an increased cognizance of Indian art, either by them or their White neighbors.

New materials and techniques developed during this period as the students attending art schools settled down to produce, turning their training into practice. Some of the new materials were excellent, but some

(such as gaudy yarns, or fibers ill-suited to tapestry weaving) were less successful. Techniques were included which had no "traditional" ancestry but did provide new and interesting weaves. This unfamiliarity with the more established weaving forms limited their acceptance, but they did result in some intriguing experiments.

The early tribal Coöperative Guilds took on renewed strength. Although not all of them had entirely died out, most had been in eclipse during the War, and personnel changes had given different directions to their activity, often in a renewed concern for new expressions in crafts, rather than strictly the continuance of the traditional. This of course caused some strains within the groups, but successful sales records silenced serious opposition. Some new guilds were established in areas where they had not formerly existed.

The foregoing gives a sense of the new world of the Indian artist. No longer were these textiles intended for Indian purposes — nor even for White consumers who understood those purposes. This was now a market strictly geared to, and dominated by, White concepts. This was not new, of course: since the early days of immigration from the East, crafts demands had been those of the incoming Whites, and these were even more strongly emphasized with the entry of Fred Harvey and other large-scale trading firms into the Southwest. Sizes and shapes had been markedly affected, as had designs and colors, while new raw materials gave subtly different appearances to textiles.

But with all of these changes there had been a healthy interrelationship and participation of the trader in Indian life, through his physical presence, a knowledge of sorts gained from his initiation into various aspects of native customs, and his close connection with and concern for his neighbors, upon whom he depended, as they depended upon him. In the Southwest, even more than in the East, the trader filled a particularly important role: he was not only the person who supplied many of the day-to-day needs but was also judge, advisor, banker, interpreter of an alien culture, benevolent despot, physician, and even mortician on occasion. Thus, the trusted trader became deeply embedded into the fabric of Indian life; the less trustworthy usually went bankrupt.

Now, however, the relationship is completely impersonal. No single person involved in this very extended textile trade has had such interrelated experience; the modern entrepreneur is usually related more closely to another supplier, normally White, and the interest in the object has little to do with the weaver. The lack of knowledge concerning the object is of less concern than the commercial content, although there is perhaps something of benefit in the pretentious regard attached to certain types of weavings, since this does at least draw attention to the product. Nationally, interest in Navajo weaving in particular made itself felt as exhibitions were held, gallery showings were presented, and the art received a much-needed focus. This translated into sales of the older textiles, and emphasis upon living weavers to increase their quality; they responded with magnificent examples of their artistry.

Where formerly Navajo weaving had been included, if at all, with other Amerindian arts in exhibitions of native art, they now began to enjoy special attention. Perhaps the largest such specialized exhibit was organized by the Los Angeles County Museum of Art in 1972, shown at that institution and then throughout the United States. While it was devoted to only a limited period in the weaving art, it provided an

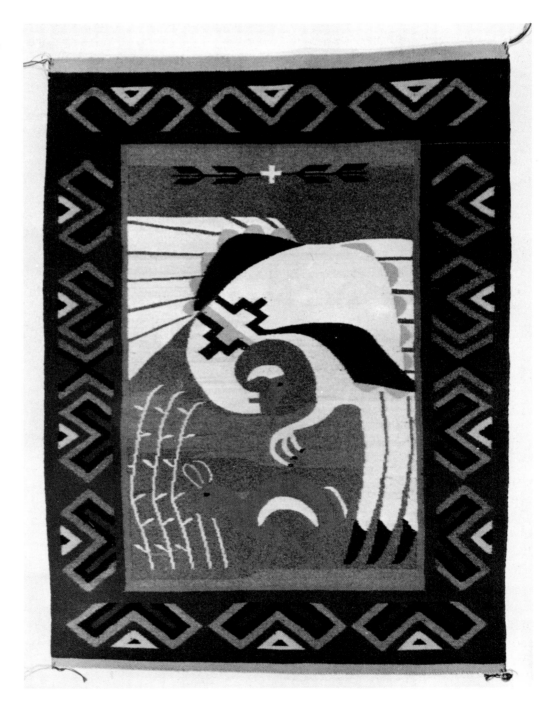

Modern wool tapestry. Direct copy of a painting by Pablita Velarde, Santa Clara artist. Woven by Atsuma Blackhorse. Navajo; New Mexico. ca. *1965. 54×39 inches.* Paul Schmolke photo, Maxwell Museum of Anthropology.

introduction to many viewers who had not previously been aware of the fine designs and brilliant coloring inherent in Navajo weaving.

As this intensity of interest transmitted itself to the West, and more particularly the Southwest, weavers began to experience an increased income, and as their work was brought more and more into the limelight, the earlier anonymity slowly disappeared — names were important to this

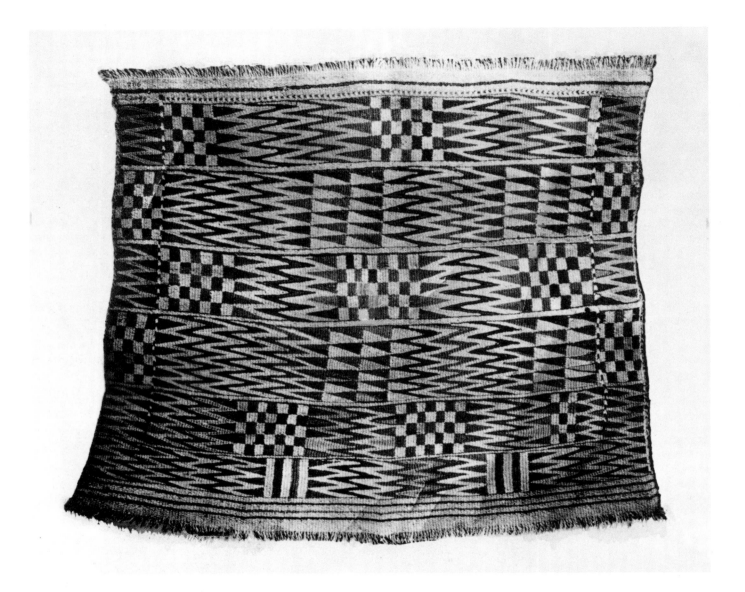

new group of art connoisseurs. A particular textile enjoyed greater reception (*read*: price) when accompanied by the name of the weaver (*read*: the signature on the canvas). This concentration upon identity brought a tremendous upsurge in pride of self and one's creation, economic improvement, and rise in Indian self-esteem. Weavers were invited to participate in exhibitions and demonstrate the art of weaving to the visiting public — no longer as objects of anthropological curiosity, but

Woven dog-hair wool "Nobility blanket". Salish; British Columbia. ca. 1800-1825. 42×46 inches. American Museum of Natural History.

202

as highly acclaimed performing artists. And the weavers sensed this change in attitude, revelling in the recognition of individual and tribe.

One still sees the results of this stimulating climate in the remarkable quality of weaving which is now more widely available than at mid-century. Where there were at most a scant handful of superior weavers on the Navajo Reservation, and fewer elsewhere, their number has greatly increased today. One reason of course is that only the best can achieve this top recognition and the income which accompanies such acknowledgment. This drives out the lesser-skilled weavers, who become only part-time workers. One regrettable feature is that designs have become more bizarre and complicated as purchasers have vied with one another for novelty — convoluted weaving takes precedence over the simple, quiet understatement. Again, this tends towards an effort to provide what the White man-thinks-is-Indian — or, to put it in the same convoluted terms of the weavings, to turn out what-the-Indian-thinks-the-White-man-thinks-is-Indian weaving.

Very sophisticated, even elaborate design can be, and often is, of remarkable magnificence and esthetic value. But it can be overdone, and in the fascination with technical skill, often does become extreme or badly expressed. Important to, but not necessarily woven into weaving, are the qualities which make any given object more beautiful — and more desirable. The esthetic factor may be a quality which is added to the completed product, or it may be of course inherent in the weave and design of a textile. The enhancement of decoration will often lead to increased worth, but this enrichment, like cosmetics, can easily be overdone. As was the case in the Southwest in the late 1890s and again in the 1920s, this can be a serious problem in Indian art. Unfortunately bad taste has no statute of limitations, nor any boundaries.

A decidedly beneficial result of this current interest in Indian arts which may be seen as a product of the increased native self-esteem, is the strong Pan-Indian movement today, whereby all share in the increased respect shown to the few. This has had an interesting new departure in the growing demand by Indian people for textiles intended for their own use. This has not yet reached the point where the Indian market has equalled its ancient role in consumption of the woven product, but it is there and is growing. Costumes, dress accessories, and similar textile products find a ready native market in many parts of the Indian country.

It must be recognized that there have been some serious negative results in recent years. The artificial raising of levels of expectancy disappointed many weavers of average skill, even though high prices became standard for meretricious work. Fascination with the weaving process led many White craftsmen to emulate the Indian product, and pseudo-Indian rugs have occasionally been offered on the market. Usually, however, these are readily recognized and as yet present no threat. And in this area of fraudulent manufacture some types of Oriental weaving were introduced as genuine American Indian work, in a deliberate effort to deceive the unwary.

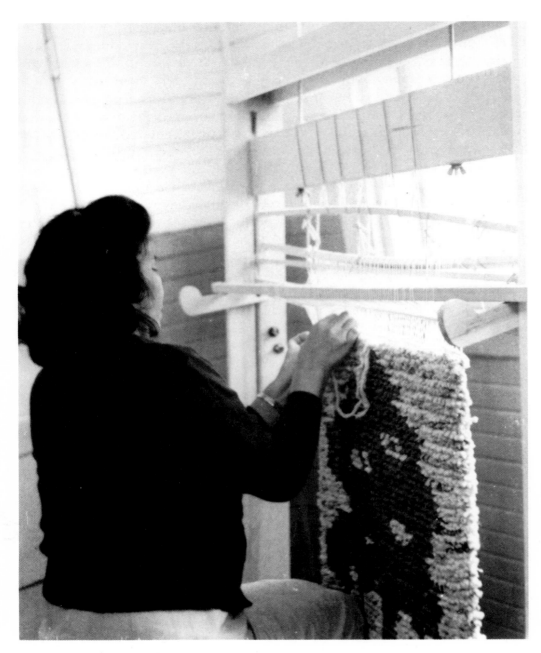

Lucile Alexander working on a loom; producing a pictorial wall hanging, and (opposite) the completed wall hanging. Alibamu; Alabama-Coushatta Reservation, Livingston, Texas. ca. *1964.* Indian Arts and Crafts Board, U.S. Department of the Interior.

But of greater concern has been the introduction in the past decade of native Mexican-woven copies of Navajo rugs. Samples were taken to Oaxaca by dealers who instructed those highly skilled weavers, using the typical horizontal loom, to duplicate the designs. They did so with remarkable effectiveness, producing textiles which at first glance will deceive all but the expert viewer. That these sell for a small proportion of the true Navajo weave is meaningless, for many are represented as North American Indian and sold at a commensurate price. This is not yet a critical factor in the Navajo rug market, but it carries the seeds of later confusion when collectors and/or museum curators are confronted with

204

some of the better imitations. If they are unfamiliar with the history of these spurious weaves, they may well label them as "Navajo," and generate a sequence of ethnological errors.

Fortunately, it is possible to detect these frauds by careful examination. The imitations are usually more loosely woven, with a warp of about six-to-the-inch; of solid color (although some Navajo weaving has a solid-color feature today); and the fringe has been knotted and threaded back into the ends of the rug to conceal them. Navajo rugs, woven on a warp which is used up, have no fringe excepting where one has been added on, as with some of the end-of-the-century Germantown weaving. Edge-binding and "lazy lines" are Navajo practices also lacking in these weaves. Thus far, the Oaxaca product has not proven to be more than a threatening nuisance, but its presence must be born in mind by any Navajo rug purchaser.

From the foregoing situation derives the current picture of high prices for high quality, even though these do not always filter down to the weaver. Unquestionably the very skilled weaver is far better off, and probably all weavers have shared to some extent this economic benefit, but weaving remains a demanding, time-consuming occupation.

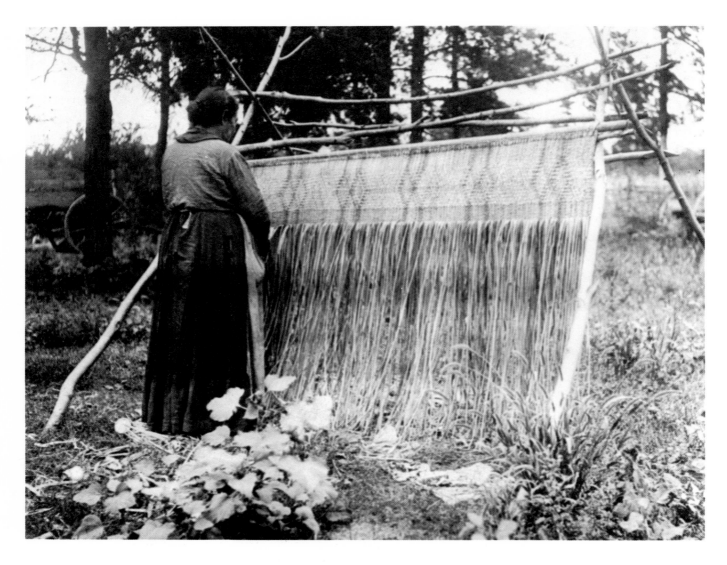

Beyond the matter of income, however, are several other improvements in the life of the weaver which are of paramount importance — pride of self and one's artistry, racial self-esteem, identification with other weavers both within and beyond the immediate tribal group, and the sense of stability which that unity produces in a person. The Indian has come a long way in the fight for equal regard, and has a long way yet to go — but it cannot be denied that accomplishment in the arts has been a major factor in achieving the recognition so long denied to the people.

Mrs. Gurneau, weaving a bullrush mat (anákun), *demonstrating suspension loom technique. Chippewa; Red Lake, Minnesota.* ca. *1920.* Frances Densmore photo; Smithonian Institution, National Anthropological Archives.

7 · Conservation and Preservation:
how to care for woven textiles

The care of American Indian textiles is vital to their longevity, vitality, and utility. To realize their maximum life and value, initial consideration should be given to what went into the original manufacture — the basic material, dyestuff, technique, and any other factors which would affect longevity. While the claim is often made that Navajo rugs are not fragile, they are not eternal and require care. The fact that the native weaver formerly buried a finished rug in damp sand to cleanse it wholly disregards more contemporary knowledge of better ways by which to achieve that end.

No native weave should be exposed to direct sunlight for any length of time; even the best quality dye will retreat from such an insult. Vegetal dyes fade quickly upon exposure to any light, and their lifetime brilliance depends completely upon the care given to the original preparation; this will vary from weaver to weaver. It is a heartbreak to see an old blanket which has been left on the floor or wall without attention for many years. One sees a fine weave but dull tones; upon turning the textile over, the explosion of original color still intact only emphasizes what has been lost through neglect.

Textiles used on the floor should always have a pad placed underneath. This not only prevents slipping but absorbs much of the shock of walking, allowing the threads to move more gently under the pressure. A floor covering ought to be rotated regularly, not only to balance the areas exposed to frequent travel but to also allow the textile to adjust under use. Wool expands and shrinks, and rotation helps balance this regular movement within the fabric. Often Navajo textiles are observed to curl at the corners; usually this is due to a tightly woven rug expanding under differing humidity or temperature conditions. To remedy this, one can simply untie the corner ties (note carefully the original way in which they were tied), then work the binding cord back towards the centers slightly to release the accumulated tension, and re-tie in the original knot.

Textiles displayed in a well-lit room using incandescent or fluorescent light will lose their original brilliance, just as those exposed to sunlight. The illumination should be soft, indirect, and preferably one which has the ultra-violet rays filtered out to insure longer color life. When hanging such textiles, never use a few nails pounded in the wall as supports. Completely aside from the fact that nails rust, this method will cause the

textile to sag in time, giving an unsightly undulating appearance which cannot be removed — the fibers will have stretched beyond recovery.

Proper hanging involves the use of a strong vertical member, either a metal rod or wooden dowel to which the textile is fastened regularly with small spacing between the fastening threads. This should be arranged in the same manner as the original weave: by the warp threads. A further "safety net" can sometimes be introduced by applying a second or third row of supporting threads perpendicular to the warp, placed strategically along the body of the rug and fastened in turn to a horizontal support. This is particularly helpful with a very heavy-weave textile. But perhaps the most ingenious method has been recently developed by the use of plastic material which has thousands of microscopic hooks applied to the surface of a tape. When two such tapes are pressed together, these hooks interlock and provide a strong bind. By sewing one tape to the textile and fastening the other to a wall or flat slat, the textile can readily be supported throughout the top edge, thereby removing any possible damage from tension at a single point.

To clean native textiles, one should never wash them. Any dye will yield to water in time, and once the color bleeds it cannot be removed; this is particularly true of the red colors. Excepting for very old, partially-damaged textiles, most modern weaves can be vacuumed to remove dirt. Even the use of a modern beater-brush implement is safe, providing care is taken in its application. One should remember to always vacuum both sides of the weave. To remove stains, the safest treatment is dry-cleaning, at the hands of a skilled operator. While this will remove the lanolin naturally present in wool, most modern dry-cleaning also includes the replacing of the lanolin if requested. This is helpful because the presence of lanolin is one of the reasons why wool wears so well — but is also one of the reasons why insects and rodents sometimes attack wool textiles.

Rugs, particularly, should never be "snapped" or whipped to clean dirt from them; such treatment breaks the threads and will result in a short time in breaks or holes in the rug. A gentle shaking will loosen any large amount of sand or dirt, but this should be done sparingly. Remember that, after all, you are handling an object made up of thousands of pieces which have been patiently fit together —the more you shake or snap it, the more you tend to separate these pieces back into their original form.

Spills or stains present serious problems and require immediate attention if they are to be successfully removed. Water or any other substance should be blotted up and removed promptly but without rough treatment — you are simply applying first aid to take away the majority of the damage. As soon as possible the rug should be taken to a competent dry-cleaner, who has an array of magic potions available for the correct handling of such stains. In this, as in any restoration of health, the curing treatment can be worse than the ailment, so one should know a skilled practitioner who has had experience with the type of weaving affected. Just any old "textile doctor" may not prove suitable.

In storing textiles, rugs, or other large-sized fabrics, these should never be folded and piled one upon the other. This simply strains the fibers; in time they will stretch and result in creases which cannot be removed. Indeed, it may completely break the threads, again starting the holes which eventually ruin any good weave. It is preferable to roll the textiles loosely upon a cylinder or large-sized roller and store them in a cool, dry place. These rolled-up textiles should be supported by end hooks or fasteners to minimize weight upon the textile itself. Bear in mind that cardboard rollers often contain acid in their manufacture, which can in time affect the textile.

Cotton itself presents minimal insect vulnerability, but wool is a delicacy for moths, and a good repellent or spray should be regularly applied to storage areas; those textiles which are displayed on the wall should be given a moth-spray treatment on both sides; frequently the exposed surface is treated, and the neglected underside provides a hidden banquet for moth larvae. Whenever new textiles are acquired, they should also be carefully treated. Many fine collections have been ruined by the thoughtless addition of an untreated example which quickly contaminates all of the earlier well-cared-for textiles.

Another problem often overlooked is the interaction of chemicals in storage. It should be realized that many dyestuffs have a chemical base which over the years can have a severe interaction, resulting in the deterioration of the fibers. Many ancient textiles show this effect clearly: black dyes often contain iron which upon oxidization disintegrates to a point where only a vacant space is left to indicate the original design.

Only regular attention to the exposure of textiles to abuse can prevent their eventual loss. Chairs carelessly placed upon rugs, with their sharp-pointed legs punching holes in the weave; the back-and-forth movement of such legs, tables, casters, or contact supporters can have only one result. The continual abuse, friction, exposure, and pounding of these hand-woven textiles will yield the owner only what he deserves.

With extremely fragile or valuable textiles, often the best remedy is to do nothing at all. Fabric can stand just so much handling — and to attempt the restoration, cleaning, or treatment of a weave without adequate training exposes that piece to future re-treating, sometimes to a degree where the skilled technician is helpless to provide the solution. Taking such a precious object to a competent conservator at a local museum or institute dedicated to art conservation is by far the best answer to such needs. There are many such institutions throughout the country; probably the Textile Museum in Washington, D.C. has been the most active in this particular area of preservation.

Bibliography

The following listing includes those studies which have been used in the preparation of this book, as well as providing an additional selection of published works on weaving. It is the hope of the writer that this will serve the reader interested in further reference. It does not pretend to be a complete compilation of such writings, but does attempt to include material for every major region discussed herein. It should be remembered that each of these titles will also include individual bibliographies, thereby placing at the disposal of the reader a great range of reference titles, both general and specific, on the subject of North American Indian weaving.

Anon., "Hand-loom Weaving in America. Part 3: Fabric Knowledge; Additional Terms for the Hand Weaver." *American Fabrics #10* (1949) 107-121.

—, *Textile Arts of the Guatemalan Natives.* Carnegie Institution of Washington, III (1935) 159-168.

—, "The Weavers of Chimayó." *New Mexico Sun Trails, II* (1954) 10-11.

Adams, William Y., "Cache of Prehistoric Implements From Northeastern Arizona." *Plateau, XXIX* (1957) 49-55.

—, "Shonto: A Study of the Role of the Trader in a Modern Navaho Community." *Bur. Amer. Ethnol. Bulletin #188* (1963) 268p.

Adrosko, Rita J., "Restoring an Old Loom for the Smithsonian Museum of History and Technology." *Handweaver and Craftsman, XV* (1964) 16-18.

Aitken, Barbara, "A Note on Pueblo Belt-weaving." *Man #49* (1949) p. 37.

Albers, Anni, *On Weaving.* Wesleyan University Press (1965) 204p.

Amsden, Charles A., "The Loom and its Prototype." *Amer. Anthro., XXXIV* (1932) 216-235.

—, *Navaho Weaving; its Technic and History.* Fine Arts (1934) 261p.

—, *Prehistoric Southwesterners from Basketmaker to Pueblo.* Southwest Museum (1949) 163p.

—, "Reviving the Navaho Blanket." *Masterkey, VI* (1932) 137-149.

—, "When the Navaho Rugs Were Blankets." *School Arts, XXXIV* (1935) 387-396.

Applegate, Frank, "If You Buy Antiques." *New Mexico Highway Journal, VII* (1929) 25-26f.

Atwater, Mary M., "What and Why of Inkle." *Handweaver and Craftsman, III* (1952) 18-21.

Bahti, Tom, *Southwestern Indian Arts and Crafts.* KC Publications (1966) 32p.

Baldwin, Gordon C., "Prehistoric Textiles in the Southwest." *Kiva, IV* (1939) 4p.

Barbeau, Marius, *The Assumption Sash.* Natl. Museum of Canada (1937) 51p.

Bartlett, Katherine, "Hopi Indian Costume." *Plateau, XXII* (1949) 1-10.
—, "Notes on the Indian Crafts of Northern Arizona." *Museum Notes, X* (1938) 21-24.
—, "Present Trends in Weaving on the Western Navajo Reservation." *Plateau, XXIII* (1950) 1-5.
Beals, Ralph, "The Comparative Ethnology of Northern Mexico Before 1750." *Ibero-América, II* (1932) 225p.
Bennett, Noël, *Are You Sure?* Window Rock (1973) 22p.
—, *The Weaver's Pathway.* Northland (1974) 64p.
—, and Tiana Bighorse, *Working With the Wool.* Northland (1971) 105p.
Bird, Junius, and Milica Dimitrijevič, "The Care and Conservation of Ethnological and Archaeological Backstrap Looms." *Curator, VII* (1964) 99-120.
Blodgett, Frederick W., *Guatemalan Jaspé Textiles: Techniques and Motives.* University of California. MA Thesis (1951) 91p.
Bloom, Lansing B., "Early Weaving in New Mexico." *New Mexico Historical Review, II* (1927) 228-238.
Blunn, Cecil T., "Navaho Sheep." *Jrnl. of Heredity, XXXI* (1940) 99-112.
Boas, Franz, "The Decorative Art of the Indians of the North Pacific Coast." *Amer. Mus. Natl. Hist., Bulletin IX* (1897) 123-176.
—, *Primitive Art.* Dover (1955) 378p.
Boyd, Dorothy E., *Navajo Pictorial Weaving; Its Past and Its Present Condition.* University of New Mexico, MA Thesis (1970) 149p.
Breazeale, John M., "An Arizona Cliff-dweller's Shawl." *Art and Archaeology, XX* (1925) 85-88.
Brugge, David M., "Imitation Navajo Rugs." *Washington Archaeologist, XVI* (1972) 1-3.
Bryan, Nonabah G., and Stella Young, *Navajo Native Dyes; Their Preparation and Use.* Bureau of Indian Affairs (1940) 75p.
Burnett, Edwin K., "The Spiro Mound Collection in the Museum." *Museum of the American Indian, Contrib. XIV* (1945) 47p.
Burnham, Harold B., "Four Looms." *Royal Ontario Museum Annual* (1940) 75p.
Burton, Henrietta K., *The Re-establishment of the Indians in Their Pueblo Life Through the Revival of Their Traditional Crafts.* Columbia University Press (1936) 96p.
Bushnell, David I., "The Choctaw of Bayou Lacomb, St. Tammany Parish, Louisiana." *Bur. Amer. Ethnol., Bulletin #48* (1909) 37p.
—, "Various Uses of Buffalo Hair by the North American Indian." *Amer. Anthro., XI* (1909) 401-425.
Carr, Lucien, "Dress and Ornament of Certain American Indians." *Amer. Antiquarian Socy., Proc. II* (1898) 381-454.
Carstens, Annafreddie, "Hand-loom Fabrics in America." *American Fabrics, VIII-X* (1948-1949) var. pages.
Carter, B. F., "The Weaving Technic of Winnebago Bags." *Wisconsin Archaeologist, XII* (1933) 33-47
Casey, Pearle R., "Chimayó, the Ageless Village." *Southwestern Lore, I* (1936) 12-13.
Catlin, George, *The North American Indians.* Grant (1926) 2vols.
Cerny, Charlene, *Navajo Pictorial Weaving.* Museum of New Mexico (1975) 32p.
Clark, Neil M., "They Want No Progress in Chimayó." *Saturday Evening Post* (May 8, 1953) 38-39f.

Cocks, Joel E., *Colonial Beginnings of the Mexican Textile Industry*. University of Florida, MS Thesis (1951) 122p.

Cole, Ellis P., "Navajo Weaving With Two- or Four-harness Looms." *Weaver, II* (1937) 11-13.

Cole, Fay-Cooper, *Kincaid: A Prehistoric Illinois Metropolis*. Univ. Chicago (1951) 385p.

Colton, Mary-Russell F., "The Arts and Crafts of the Hopi Indians." *Museum Notes, XII* (1938) 1-24.

—, "Hopi Dyes." *Museum No. Arizona, Bulletin #41* (1965) 87p.

—, "Techniques of the Major Hopi Crafts." *Museum Notes, III* (1931) 1-7.

—, "Wool for our Weavers—What Shall it be?" *Museum Notes, IV* (1932) 1-5.

Conner, Veda N., "The Weavers of Chimayó." *New Mexico, XXIX* (1951) 19*ff.*

Coolidge, Dane and Mary, *The Navajo Indians*. Houghton Mifflin (1930) 309p.

Cordry, Donald B., and Dorothy, *Mexican Indian Costumes*. University of Texas Press (1968) 373p.

Coulter, Doris M., "Cherokee Weavers Used Looms Over 2,000 Years Ago." *Handweaver, XVIII* (1967) 17-18.

Crawford, Morris deC., *5,000 Years of Fibers and Fabrics*. Brooklyn Museum of Art (1946).

—, "The Loom in the New World." *Amer. Museum Jrnl., XVI* (1916) 381-387.

Curtin, Leonora S. M., *By the Prophet of the Earth*. San Vicente Foundation (1949) 158p.

Davidson, Daniel S., "Knotless Netting in America and Oceania." *Amer. Anthro., XXXVII* (1935) 117-134.

deDelgado, Hilda Schmidt, *Aboriginal Guatemalan Handweaving and Costume*. Indiana University, PhD Dissertation (1963).

Dedera, Don, *Navajo Rugs*. Northland (1975) 114p.

Dickey, Roland F., *New Mexico Village Arts*. Univ. New Mexico (1949) 266p.

Dixon, Keith, *Hidden House*. Museum No. Arizona, Bulletin #29 (1956) 90p.

Douglas, Frederic H., "A Choctaw Pack Basket." *Denver Art Museum, Leaflet, #4* (1937) 15-18.

—, "Acoma Pueblo Weaving and Embroidery." *Denver Art Museum, Leaflet #89* (1939) 153-156.

—, "An Embroidered Cotton Garment from Acoma." *Denver Art Museum, Notes #1* (1937) 4p.

—, "Hopi Indian Weaving." *Denver Art Museum, Leaflet #18* (1931) 4p.

—, "Indian Cloth-making; Looms, Technics and Kinds of Fabrics." *Denver Art Museum, Leaflet #59-60* (1933) 33-40.

—, "Main Types of Pueblo Cotton Textiles." *Denver Art Museum, Leaflet #92-93* (1940) 165-172.

—, "Main Types of Pueblo Woolen Textiles." *Denver Art Museum, Leaflet #94-95* (1940) 173-180.

—, "Navaho Wearing Blankets." *Denver Art Museum, Leaflet #115* (1951) 4p.

—, "Notes on Hopi Brocading." *Museum No. Arizona, Notes XI* (1938) 35-38.

—, "An Osage Yarn Bag." *Denver Art Museum, Notes #7* (1938) 4p.

—, "Southwestern Weaving Materials." *Denver Art Museum, Leaflet #116* (1953) 4p.

—, "Weaving at Zuni Pueblo." *Denver Art Museum, Leaflet #96-97* (1940) 181-182.

—, "Weaving in the Tewa Pueblos." *Denver Art Museum, Leaflet #90* (1939) 157-160.

—, "Weaving of the Keres Pueblos and Weaving of the Tiwa Pueblos and Jémez." *Denver Art Museum, Leaflet #91* (1939) 161-164.

—, and René d'Harnoncourt, *Indian Art of the United States.* Museum of Modern Art (1941) 219p.

Duclos, Antoinette C., "Navajo Warp and Woof." *Arizona Highways* (1942).

Dutton, Bertha P., *Navajo Weaving Today.* Museum of New Mexico (1961) 40p.

Elmore, Francis H., *Ethnobotany of the Navajo.* School of American Research (1944) 136pp.

Emery, Irene, "Northeastern Arizona Textiles of Problematical Origin." *El Palacio, LVI* (1949) 195-201.

—, *The Primary Structure of Fabrics.* Textile Museum (1966) 340p.

Emmons, George, "The Chilkat Blanket." *Amer. Mus. Natl. Hist., Memoir III* (1907) 329-400.

—, "The Use of the Chilkat Blanket." *Amer. Mus. Jrnl., VII* (1907) 65-70.

Erickson, Jon T., and H. Thomas Cain, *Navajo Textiles from the Read Mullan Collection.* Heard Museum (1976) 80p.

Estep, Margaret C., *Ring Weaving.* University of California, MA Thesis (1940) 43p.

Faris, Chester T., "The Indian as a Wool Grower." *Wool Grower, XV* (1925) 23-25.

Foreman, Carolyn T., *Cherokee Weaving and Basketry.* Starr (1948) 34p.

Franciscan Fathers, *Ethnological Dictionary of the Navaho Language.* St. Michael's (1910) 536p.

Garfield, Viola, *The Tsimshian, Their Arts and Music.* J. J. Augustin (1951) 290p.

Gibbs, George, "Tribes of Western Washington and Northwestern Oregon." *Contrib. to No. Amer. Ethnology, I* (1877) 157-241.

Goddard, Pliny E., "Navaho Blankets." *Amer. Mus. Jrnl., X* (1910) 201-211.

Goggin, John M., "Louisiana Choctaw Basketry." *El Palacio, XLVI* (1939) 121-123.

Grandstaff, James O., *Wool Characteristics in Relation to Navaho Weaving.* U. S. Dept. Agriculture, Technical Bulletin #790 (1942) 36p.

Green, Edward C., "Navajo Rugs," *Southwestern Lore, XXIV* (1958) 17-24.

Grossman, Ellin, "An Ancient Peruvian Loom." *Handweaver and Craftsman, IX* (1958) 20-21f.

—, "Textiles and Looms from Guatemala and the Elsie McDougall Collection." *Handweaver and Craftsman, VII* (1955) 6-11.

Hanks, Mona, "Indian Vegetable Dyes, Part II." *Denver Art Museum, Leaflet #71* (1936) 81-84.

d'Harcourt, Raoul, *Textiles of Ancient Peru and Their Techniques.* University of Washington Press (1962) 186p.

Harrington, M. R. "Ancient Nevada Pueblo Cotton." *Masterkey, XI* (1937) 5-7.

—, *The Ozark Bluff-dwellers.* Mus. American Indian (1960) 185p.

Hatch, David P., "Mexico: Land of Weavers." *Handweaver and Craftsman, VI* (1955) 10-13.

Haury, Emil W., *The Stratigraphy and Archaeology of Ventana Cave.* University of Arizona (1950) 599p.

Hawthorne, Audrey, *Art of the Kwakiutl Indians.* University of Washington (1967) 410p.

Hedges, Ken, *A Rabbitskin Blanket from San Diego County.* Ballena (1973) 12p.

Heizer, Robert F., and Irmgard W. Johnson, "A Prehistoric Sling from Lovelock Cave, Nevada." *Amer. Antiquity, XVIII* (1951) 139-147.

Herchold, Mary J., *A Study of Several Textile Techniques Used in Pre-Conquest Peru.* University of San Diego, MA Thesis (1964) 58p.

Hilger, Mary Inez, "Indian Women Preparing Bullrush Mats." *Indians at Work, II* (1935) 41*f.*

Hill-Tout, Charles, *The Salish Tribes of the Coast and Lower Fraser Delta.* Ontario Provincial Museum (1905).

Hirabayashi, J., "The Chilkat Weaving Complex." *Davidson Jrnl. of Anthropology, I* (1955) 43-61.

Hollister, Uriah S., *The Navajo and His Blanket.* Tannen (1903) 144p.

Holmes, William H., "A Study of the Textile Art in its Relation to the Development of Form and Ornament." *Bur. Amer. Ethnol., Annl. Rept. VI* (1889) 189-252.

—, "Prehistoric Textile Art of the Eastern United States." *Bur. Amer. Ethnol., Annl. Rept. XIII* (1896) 3-46.

—, "Prehistoric Textile Fabrics of the United States." *Bur. Amer. Ethnol., Annl. Rept. III* (1885) 393-425.

—, "Use of Textiles in Pottery Making and Embellishment." *Amer. Anthro., III* (1901) 397-403.

Hooper, Luther, *Hand Loom Weaving; Plain and Ornamental.* Macmillan (1910) 338p.

—, "The Loom and Spindle." *Smithsonian Inst., Annl. Rept.* (1914) 629-678.

—, *The New Draw-loom, its Construction and Operation Described for the Use of Handicraft Pattern Weavers.* Pitman (1932) 219p.

Hough, Walter, "The Hopi Indian Collection in the United States National Museum." *U. S. Natl. Mus., Proc. #54* (1919) 235-296.

Howay, Frederic W., "The Dog's Hair Blanket of the Coast Salish." *Washington Hist. Socy. Qtly., IX* (1918) 83-92.

Hummel, John J., *The Dyeing of Textile Fabrics.* Cassell (1885) 534p.

Hunt, James G., "Report on a Fragment of Cloth Taken From a Mound in Ohio." *U.S. Natl. Mus., Proc. VI* (1884) 101-102.

Hurt, Amy P., "Chimayó, the Village Time has Blest." *New Mexico, XII* (1934) 10-12*f.*

Innes, R. A., *Non-European Looms in the Collection at Bankfield Museum, Halifax.* Halifax Museum (1959).

James, George W., *Indian Basketry.* Author: Pasadena (1903) 271p.

—, *Indian Blankets and Their Makers,* A. C. McClurg (1914) 213p.

James, H. L., *Posts and Rugs; the Story of Navajo Rugs and Their Homes.* Southwest Parks & Monuments (1976) 126p.

—, "The Romance of Navajo Weaving." *New Mexico, LII* (1974) 8p.

Jeançon, Jean A., and Frederic H. Douglas, "Navaho Spinning, Dyeing and Weaving." *Denver Art Museum, Leaflet #3* (1930) 4p.

Johnson, Irmgard W., *Twine-plaiting; a Historical, Technical and Comparative Study.* Univ. California, MA Thesis (1950) 168p.

—, "Twine-plaiting in the New World." *XXXII Intl. Congress of Americanists, Proc.* (1958) 198-213.

Jones, Courtney R., "Spindle-spinning Navajo Style." *Plateau, XVIII* (1946) 43-51.

Jones, Volney H., "A New and Unusual Navajo Dye *(Endothia Singularis)."* *Plateau, XXI* (1948) 17-24.

—, "Notes on the Manufacture of Cedar-bark Mats by the Chippewa Indians." *Michigan Acad. Science, Arts & Letters, Papers XXXII* (1948) 341-363.

—, "Notes on the Manufacture of Rush Mats Among the Chippewa." *Michigan Acad. Science, Arts & Letters, Papers XXVII* (1941) 525-538.

—, "Notes on the Preparation and Uses of Basswood Fibers by the Indians of the

Great Lakes Region." *Michigan Acad. Science, Arts & Letters, Papers XXII* (1936) 1-14.

—, "A Summary of Data on Aboriginal Cotton of the Southwest." *Univ. New Mexico, Bulletin #296* (1936) 51-64.

Kaemlein, Wilma, "A Prehistoric Twined-woven Bag from the Trigo Mountains, Arizona." *Kiva, XXVIII* (1963) 1-13.

Kahlenberg, Mary H., *The Navajo Blanket.* Praeger (1972) 112p.

Kent, Kate P., "The Braiding of a Hopi Wedding Sash." *Plateau, XII* (1940) 46-52.

—, "A Comparision of Pre-historic and Modern Pueblo Weaving." *Kiva, X* (1945) 14-19.

—, "The Cultivation and Weaving of Cotton in the Prehistoric Southwestern United States." *Amer. Phil. Soc., Trans. XLVII* (1957) 457-732.

—, "Notes on the Weaving of Prehistoric Pueblo Textiles." *Plateau, XIV* (1941) 1-11.

—, "The Story of Navaho Weaving." *Heard Museum* (1961) 48p.

Kissell, Mary L., "Aboriginal American Weaving." *Natl. Assoc. of Cotton Manufacturers, Trans. LXXXVIII* (1910) 195-215.

—, "The Early Geometric Patterned Chilkat." *Amer. Anthro., XXX* (1928) 116-120.

—, "Indian Weaving." *Exposition of Indian Tribal Arts* (1931) 2 vols.

—, "A New Type of Spinning in North America." *Amer. Anthro., XVIII* (1916) 264-270.

—, "Organized Salish Blanket Pattern." *Amer. Anthro., XXXI* (1929) 85-88.

Krause, Aurel, *The Tlingit Indians.* Univ. Washington (1956) 310p.

Latour, A., "Textile Arts of the North American Indians." *Ciba Review #90* (1952) 3230-3254.

Laughlin, Ruth Alexander, *Caballeros.* Caxton (1945) 418p.

—, "The Craft of Chimayó." *El Palacio, XXVIII* (1930) 161-173.

Leechman, Douglas, "The Chilkat Blanket." *Canadian Geographical Jrnl., XLVIII* (1953) 83.

Leftwich, Rodney L., *Arts and Crafts of the Cherokees.* Land of the Sky (1970) 160p.

Lesch, Alma, *Vegetable Dyeing.* Watson-Guptill (1970) 146p.

Lewton, Frederick L., "The Cotton of the Hopi Indians." *Smithsonian Inst., Misc. Coll. #60* (1913) 1-10.

Lowell, Guy, "Accident and Design: the Story of a Navajo Blanket." *Antiques, X* (1926) 37-40.

Luomala, Katherine, "Navajo Weaving." *El Palacio, LXXX* (1974).

Lyford, Carrie, *Iroquois Crafts.* Bur. Indian Affairs (1942) 97p.

—, *Ojibwa Crafts.* Bur. Indian Affairs (1943) 216p.

MacLeish, Kenneth, "Notes on Hopi Belt-weaving of Moenkopi." *Amer. Anthro., XLII* (1940) 291-310.

McGregor, John C., "Prehistoric Cotton Fabrics of Arizona." *Museum Notes, IV* (1931) 1-4.

—, *Southwestern Archaeology.* Univ. Illinois (1965) 511p.

McNitt, Frank, *The Indian Traders.* Univ. Oklahoma (1962) 393p.

—, "Two Gray Hills-America's Costliest Rugs." *New Mexico, XXXVII* (1959).

Mason, Otis T., "A Primitive Frame for Weaving Narrow Fabrics." *U. S. Natl. Museum, Annl. Rept.* (1899) 485-511.

Matson, Jessie, "Indian Vegetable Dyes; Part II." *Denver Art Museum, Leaflet #63* (1934) 49-52.

Matthews, Washington, "A Two-faced Navajo Blanket." *Amer. Anthro., II* (1900) 638-642.

—, "Navajo Dye Stuffs." *Smithsonian Inst., Annl. Rept.* (1891) 613-615.

—, "Navajo Weavers." *Bur. Amer. Ethnol., Annl. Rept. III* (1885) 371-391.

—, "The Navajo Yellow Dye." *Amer. Anthro., VI* (1904) 194p.

Maxwell, Gilbert S., *Navajo Rugs; Past, Present and Future.* Desert-Southwest Press (1963) 72p.

Means, Phillip A., *A Study of Peruvian Textiles.* Boston Museum of Fine Art (1932) 83p.

—, "The Origin of Tapestry Technique in Pre-Spanish Peru." *Metropolitan Museum of Art, Museum Studies III* (1930) 22-37.

Mera, Harry P., *The Alfred I. Barton Collection of Southwestern Textiles.* San Vicente Fndtn. (1949) 99p.

—, *Banded-background Blankets.* Laboratory of Anthropology, #7 (1939) 13p.

—, *The Chinle Rug.* Lab. Anthro. #13 (1942) 13p.

—, *Cloth-strip Blankets of the Navajo.* Lab. Anthro., #16 (1945) 7p.

—, *Navajo Blankets of the "Classic" Period.* Lab. Anthro., #3 (1938) 6p.

—, *Navajo Rugs of the Crystal and Two Gray Hills Type.* Lab. Anthro., #10 (1940) 13p.

—, *Navajo Textile Arts.* Lab. Anthro. (1947) 102p.

—, *Navajo Twilled Weaving.* Lab. Anthro., #14 (1943) 14p.

—, *Navajo Woven Dresses.* Lab. Anthro., #15 (1945) 13p.

—, *Pictorial Blankets.* Lab. Anthro., #6 (1938) 6p.

—, *Pueblo Indian Embroidery.* Univ. New Mexico (1943) 73p.

—, *The Serrate Designs of Navajo Blanketry.* Lab. Anthro., #11 (1940) 13p.

—, *The "Slave Blanket."* Lab. Anthro., #5 (1938) 7p.

—, *The So-called "Chief Blanket."* Lab. Anthro., #2 (1938) 7p.

—, *Wedge-weave Blankets.* Lab. Anthro., #9 (1939) 13p.

—, *The Zoning Treatment in Navajo Blanket Design.* Lab. Anthro., #12 (1940) 13p.

Merry, Edward S., "So You Want to Buy a Navajo Rug?" *Indian Life, XXXVIII* (1960) 30-35.

Meyer, Marilyn H., *A Study of the Textiles of the Indians of Oaxaca, Mexico.* University of Iowa, MA Thesis (1960) 197p.

Miner, Horace, "The Importance of Textiles in Archaeology of the Eastern United States." *Amer. Antiquity, I* (1936) 181-192.

Moore, John Bradford, *The Navajo.* Crystal, N.M. (1911) 32p.

Morgan, Lewis H., "The Fabrics of the Iroquois-American." *Quarterly Register and Magazine, IV* (1850) 319-343.

Mott, Dorothy C., "Prehistoric Textiles." *Kiva, V* (1940) 4p.

Niblack, Albert P., "The Coast Indians of Southern Alaska and Northern British Columbia." *U. S. Natl. Museum, Annl. Rept.* (1888) 225-270.

Oglesby, Catharine, *Modern Primitive Arts of Mexico, Guatemala, and the Southwest.* McGraw-Hill (1939) 226p.

Olson, Donald D., "The Possible Middle American Origin of Northwest Coast Weaving." *Amer. Anthro., XXXI* (1929) 114-131.

Orchard, William C., "A Chilkat Blanket and a Haida "Copper"." *Indian Notes, IV.* (1927) 33-40.

—, "Mohawk Burden Straps." *Indian Notes, VI* (1929) 351-359.

—, and George G. Heye, "A Rare Salish Blanket." *Museum of the American Indian, Leaflet V* (1926) 15p.

Osborne, Carolyn M., "The Preparation of Yucca Fibers; an Experimental Study." *Soc. Amer. Archaeology, Memoir #19* (1965) 45-50.

—, Lilly deJongh, *Indian Crafts of Guatemala and El Salvador.* University of Oklahoma Press (1965) 278p.

Paz, Octavio, *In Praise of Hands; Contemporary Crafts of the World.* World Crafts Council (1974) 223p.

Pendleton, Mary, *Navajo and Hopi Weaving Techniques.* Macmillan (1974) 158p.

Pepper, George, "The Making of a Navaho Blanket." *Everybody's* (1902) 23-56.

—, "Native Navajo Dyes." *The Papoose, I* (1903) 1-11.

Peters, J. Henry, "Dyeing, Spinning and Weaving by the Comanches, Navajoes, and Other Indians of New Mexico." *U. S. Patent Comm., Annl. Rept.* (1850) 8p.

Peterson, Karen D., "Chippewa Mat-making Techniques." *Bur. Amer. Ethnol., Bulletin #186* (1963) 217-286.

Rachlin, Carol K., "The Historic Position of the Proto-Cree Textiles in the Eastern Fabric Complex; an Ethnological-Archaeological Correlation." *Natl. Museum of Canada* (1958) 79-89.

Reichard, Gladys, "Color in Navajo Weaving." *Arizona Histl. Review, XII* (1936) 19-30.

—, *Dezba, Woman of the Desert.* J. J. Augustin (1939) 161p.

—, *Navajo Shepherd and Weaver.* J. J. Augustin (1936) 222p.

—, *Spider Woman.* Macmillan (1934) 287p.

Robbins, Wilfred W., J. P. Harrington, and Barbara Freire-Marreco, "Ethnobotany of the Tewa Indians." *Bur. Amer. Ethnol., Bulletin #55* (1916) 124p.

Rodee, Marian E., *Southwestern Weaving.* University of New Mexico (1977) 176p.

Roediger, Virginia M., *Ceremonial Costumes of the Pueblo Indians.* University of California Press (1941) 251p.

Ross, Patricia, "Village of Many Blessings." *Travel, LXVI* (1935) 35-37f.

Roth, Henry L., "Studies in a Loom from Iquitos." *Man, XX* (1920) 123-125.

—, *Studies in Primitive Looms.* Halifax: F. King & Sons (1934) 150p.

Rozaire, Charles E., *Twined Weaving and Western North American Prehistory.* University of California, Los Angeles, PhD Dissertation (1957) 161p.

Russell, Frank, "The Pima Indians." *Bur. Amer. Ethnol., Annl. Rept. XXVI* (1908) 3-389.

Ruyl, Beatrice B., "Primitive and Antique Loom." *Needle and Bobbin Club, Bulletin III* (1919) 29-31.

Sapir, Edward, "A Navaho Sand Painting Blanket." *Amer. Anthro., XXXVII* (1935) 609-616.

Sayce, Roderick U., *Primitive Arts and Crafts.* Cambridge Univ. (1933) 291p.

Schaefer, Gustav and W. Born, "The Loom." *Ciba Review #16* (1938) 542-577.

Shawley, Stephen D., "Hemp & Cornhusk Bags of the Plateau Indians." *Indian America, IX* (1975) 25-29f.

Shufeldt, Robert W., "The Navajo Belt-weaver." *U. S. Natl. Museum, Proc. XIV* (1892) 391-393.

Skinner, Alanson, "Iroquois Burden Strap." *Amer. Museum Natl. Hist., Papers IV* (1910 278-281.

Skinner Milica D., *"The Archaeological Looms from Peru in the American Museum of Natural History Collection."* Textile Museum (1974) 67-76.

Smith, Watson, "Kiva Mural Decorations at Awátovi and Kawaika-a." *Harvard Univ., Peabody Mus. Papers, XXXVII* (1952) 363p.

Speck, Frank G., "Huron Moose Hair Embroidery." *Amer. Anthro., XIII* (1911) 1-14.

Spiegelberg, Abraham F., "Navajo Blankets." *Out West, XX* (1904) 447-448.
—, "The Navajo Blanket." *Old Santa Fe, II* (1915) 323-337.
Spier, Leslie, "Zuni Weaving." *El Palacio, XVI* (1924) 183-187.
—, "Zuni Weaving Technique." *Amer. Anthro., XXVI* (1924) 64-85.
Starr, Laura B., "Ancient and Modern Looms." *Arts & Decoration* (1960) 208-211.
Steen, Charlie R., "Slit Tapestry from the Upper Salt River Valley, Arizona." *Amer. Anthrop., XXXVII* (1935) 458-459.
Stephen, Alexander M., *Hopi Journal.* Columbia University Press (1936) 2 vols.
Stevenson, Matilda C., "Ethnobotany of the Zuni Indians." *Bur. Amer. Ethnol., Annl. Rept. XXX* (1915) 31-102.
—, *Pueblo Indian Clothing.* MS in Denver Art Museum Library.
—, "The Zuni Indians." *Bur. Amer. Ethnol., Annl. Rept. XXIII* (1905) 608p.
Swanton, John R., "Aboriginal Culture of the Southeast." *Bur. Amer. Ethnol., Annl. Rept. XLII* (1928) 673-726.
—, "An Early Account of the Choctaw Indians." *Amer. Anthro. Assoc., Memoir V* (1918) 51-72.
—, "Indians of the Southeastern United States," *Bur. Amer. Ethnol., Bulletin #137* (1946) 943p.
Tanner, Clara Lee, *Prehistoric Southwestern Craft Arts.* University of Arizona (1976) 226p.
—, *Southwestern Craft Arts.* University of Arizona (1968) 206p.
Tax, Sol, *Penny Capitalism; A Guatemalan Indian Economy.* Smithsonian Inst. Social Anthro. (1953) 230p.
Teit, James A., "The Salishan Tribes of the Western Plateaus." *Bur. Amer. Ethnol., Annl. Rept. XLV* (1930) 23-396.
Tidball, Harriett, "Weaving Inkle Bands." *Shuttle Craft* (1969).
—, "Two-Harness Textiles; the Loom-Controlled Weaves." *Shuttle Craft.*
Tilley, Martha, *3 Textile Traditions: Pueblo, Navaho & Rio Grande.* Taylor Museum (1967) 32p.
Tozzer, Alfred M., "A Comparative Study of the Mayas and the Lacandones." *Harvard Univ. Peabody Museum Paps., L* (1907) 195p.
Underhill, Ruth, *Pueblo Crafts.* Bur. Indian Affairs (1944) 147p.
—, *Workaday Life of the Pueblos.* Bur. Indian Affairs (1946) 174p.
Utley, Robert M., "The Reservation Trader in Navajo History." *El Palacio, XLVIII* (1961) 5-27.
Vanderberg, Joanne, *Chilkat and Salish Weaving.* University of Washington, MA Thesis (1953) 119p.
Vargas-Barón, Emily A., *Development and Change of Rural Artistry; Weaving Industries of the Oaxaca Valley, Mexico.* Stanford University, PhD Dissertation (1968) 270p.
Vestal, Paul, "Ethnobotany of the Ramah Navaho." *Harvard Univ. Peabody Museum Paps., XL* (1952) 1-104p.
Wace, A. J. B., "Weaving or Embroidery?" *Amer. Jrnl. of Archaeology, LII* (1948) 51-55.
Wade, Edwin L., *The History of the Southwest Indian Ethnic Art Market.* University of Washington, PhD Dissertation (1976) 297p.
—, and David Evans, "The Kachina Sash; a Native Model of the Hopi World." *Western Folklore, XXXII* (1973).
Watson, Editha L., "Navajo Rugs." *Arizona Highways, XXXIII* (1957).
Wedel, Waldo, "Archaeological Materials From the Vicinity of Mobridge, South Dakota." *Bur. Amer. Ethnol., Bulletin #157* (1955) 69-188.

Wells, Oliver N., "Return of the Salish Loom." *The Beaver* (1966) 40-45.

—, *Salish Weaving; Primitive and Modern.* The Author (1969) 36p.

Weyl, Charles G., "Cloth Weaving of the Dakota." *Wisconsin Archaeologist, III* (1924) 22-23.

Wheat, Joe Ben, "The Navajo Chief Blanket." *American Indian Art, I* (1976) 44-53.

—, *Patterns and Sources of Navajo Weaving.* Harmsen (1975) 68p.

— ,"Spanish-American and Navajo Weaving, 1600 to Now." *New Mexico Archaeol. Soc., Papers III* (1976) 199-226.

—, "Three Centuries of Navajo Weaving." *Arizona Highways, L*(1974) 22-24f.

Whiteford, Andrew H., "Fiber Bags of the Great Lakes Indians." *American Indian Art, II* (1977) 52-64f.

Whitford, A. C., "Textile Fibers Used in Eastern Aboriginal North America." *Amer. Mus. Natl. Hist., XXXVIII* (1941) 1-22.

Whiting, Alfred, "The Bride Wore White." *Plateau, XXXVII* (1965) 128-140.

—, "The Ethnobotany of the Hopi." *Mus. No Arizona, Bulletin #15* (1939) 120p.

Whittemore, Mary, "Participation in Navajo Weaving." *Plateau, XIII* (1941) 49-52.

Willoughby, Charles C., "Feather Mantles of California." *Amer. Anthro., XXIV* (1922) 432-437.

—, "A New Type of Ceremonial Blanket from the Northwest Coast." *Amer. Anthro., XII* (1910) 1-10.

—, "Textile Fabrics from the Burial Mounds of the Great Earthworks of Ohio." *Ohio State Archaeol. Qtly., XLVII* (1938) 273-287.

—, "Textile Fabrics from the Spiro Mound." *Missouri Archaeologist, XIV* (1952) 107-118.

—, "Textile Fabrics of the New England Indians." *Amer. Anthro., VII* (1905) 85-93.

—, "Twined Weaving." *Amer. Anthro., III* (1901) 201-202.

Wood, Josephine, and Lilly deJongh Osborne, *Indian Costumes of Guatemala.* Akademische Druck (1966) 154p.

Wyman, Anne, "Cornhusk Bags of the Nez Percé Indians." *Masterkey, IX* (1935) 89-95.

—, Leland, and Charles A. Amsden, "A Patchwork Cloak." *Masterkey, VIII* (1934) 133-137.

Yealth, Sarah, "The Making of Navajo Blankets.". *El Palacio, XL* (1936) 7-9ff.

Index

Produced: James J. Kery
Designed: Ian Craig
Edited: Elsa von Bergen
Editorial assistance: Pat Kery and Lindsay Roberts
Printed and bound by Printer industria gráfica sa
Barcelona, Spain